# Foreword

*Prints Abound,* which explores the phenomenal outpouring of artists' printed images in Paris in the 1890s, celebrates an extraordinary gift and promise to the National Gallery from Virginia and Ira Jackson. This gift, a phenomenal outpouring of its own sort, comprises nearly eight hundred drawings, watercolors, and prints.

The National Gallery has long had a special interest in French art of the nineteenth century, beginning with Joseph Widener's 1942 gift of eight paintings by Corot, Manet, Degas, and Renoir. The Chester Dale collection expanded upon this exponentially with a survey of more than 150 French paintings from Gericault to Matisse. Lessing J. Rosenwald's vast collection, which includes exceptionally fine groups of prints by Daumier, Degas, and Toulouse-Lautrec, brought depth to the Gallery's holdings of nineteenth-century French prints and drawings. Ailsa Mellon Bruce and Mr. and Mrs. Paul Mellon added French masterpieces in all media. Within this context, the Jackson collection, rich in works by Pierre Bonnard and the Nabis, beautifully complements the Gallery's strength in this area and enhances it enormously.

Virginia and Ira Jackson began collecting art in the 1960s, concentrating on prints by Nabi artists and those in their circle, including outstanding examples by Gauguin, Denis, Signac, and many others. Included in the collection are works by more than 125 artists, many never before represented at the National Gallery. At its core is a thoughtfully assembled and extensive survey of prints and related drawings by Pierre Bonnard, including color lithographs for albums; original prints for journals; designs for illustrated books; posters; and a magnificent four-panel screen, *Promenade*

OPPOSITE

**Pierre Bonnard,** Poster for France-Champagne, **1891. Virginia and Ira Jackson Collection, Promised Gift to the National Gallery of Art (no. 5)**

| 7 |

*des nourrices,* one of the artist's greatest achievements. Bonnard is representative of an entire group of late nineteenth-century avant-garde artists who seized upon new and diverse forums for their art. It is this phenomenon that *Prints Abound* addresses.

Within the last twenty-five years, much has been published in the United States and Europe on printmaking in France at the close of the nineteenth century. Studies have focused on prints by major and lesser-known artists and on specific printmaking media. Even the distinctive role of posters and theater programs in fin-de-siècle Paris has been explored, including our own 1998 exhibition, *Artists and the Avant-Garde Theater in Paris, 1887–1900: The Martin and Liane W. Atlas Collection.* Yet there is still much to learn about the profusion of printed imagery of this period. Phillip Dennis Cate, director of the Jane Voorhees Zimmerli Art Museum at Rutgers University, has written extensively on late nineteenth-century printmaking in France. We are deeply grateful to him and to Judith Brodie, associate curator of prints and drawings at the National Gallery, for co-curating this splendid exhibition. We are also indebted to Mr. Cate for writing the principal essay in this catalogue and enlisting the talents of Gale B. Murray and Richard Thomson. These authors have undertaken new research and produced insightful findings. To each of them, we extend our appreciation.

I would also like to thank the private collectors, all long-standing supporters of the National Gallery, who generously agreed to lend works of art to this exhibition: Alexandra Baer, the Epstein Family, Mrs. Helena Gunnarsson, and Mrs. Paul Mellon.

Our greatest thanks, however, go to Virginia and Ira Jackson. The Jacksons have given generously, not only in terms of their gift, but also in terms of their time, energy, and knowledge. Without their support and trust, this catalogue and the accompanying exhibition would not have been possible.

Earl A. Powell III
*Director*
*National Gallery of Art*

# Acknowledgments

Many individuals have contributed to the success of this undertaking. In particular I would like to thank Phillip Dennis Cate, whose sweeping knowledge of late nineteenth-century printmaking in France is a constant source of enlightenment. I am also grateful to Gale B. Murray and Richard Thomson for their thoughtful essays.

A pledge as significant as the Jackson's requires purposeful dialogue, and in that regard, credit goes to Elizabeth Glassman, Ruth E. Fine, Andrew Robison, and Alan Shestack. These individuals were deeply involved in the conversations that led the Jacksons to choose the National Gallery as a repository for their remarkable collection.

This catalogue is a cooperative enterprise between many talented individuals. Susan Higman edited the text with intelligence and a receptive ear to each author's voice. Wendy Schleicher Smith is responsible for the handsome and sensitive design of this catalogue. Lee Ewing photographed the majority of works reproduced; his consummate skill as a photographer accounts for the superb quality of the reproductions.

Presenting works of art to their best advantage is an art form in itself. Hugh Phibbs, coordinator of matting and framing at the National Gallery, brought his considerable talents to bear on the fabrication of numerous book mounts and the framing of the works. For the handsome installation design, I am deeply indebted to Mark Leithauser and Donna Kwederis.

Many others at the National Gallery also deserve special mention: Gordon Anson, Bethann Barressi, Dean Beasom, William Bowser, Jennifer Fletcher Cipriano, Rebecca Donnan, Lisa Farrell, Shelley Fletcher, Sally Freitag, Douglas

Jackson, Laura Neal, Daniel Randall, Virginia Ritchie, Jane Rodgers, Sara Sanders-Buell, Melissa Stegeman, Jamie Stout, Yoonjoo Strumfels, D. Dodge Thompson, Elaine Vamos, Judith Walsh, and Jonathan Walz.

At the Jane Voorhees Zimmerli Art Museum, Lynn Ferrara was especially helpful, as were Mary Cason and Carmen Vendelin, graduate students at Rutgers University. Their assistance was greatly appreciated.

On a personal note, I would like to thank Virginia and Ira Jackson. Preparing a project of this scope takes many years, and the Jacksons have been supportive in countless ways — as gracious hosts, eager collaborators, and knowledgeable collectors. I have enjoyed their good humor, warmth, and friendship, and I thank them for the trust they placed in me. I hope it has not gone unfounded.

Judith Brodie
*Associate Curator of Prints and Drawings*
*National Gallery of Art*

## Note to the Reader

The catalogue and checklist are organized approximately as follows: periodicals and posters (nos. 1–18); multi-artist albums (nos. 19–44); single-artist albums (nos. 45–76); and illustrated books and ephemera (nos. 77–138). This arrangement generally reflects the order of works in the exhibition.

Each entry in the checklist cites the artist and/or author's name, nationality and life dates, French title of the work followed by the English translation, and series title when applicable. For published works, the publisher and place and date of publication are cited in parentheses following the title. An exception is Bonnard's *Quelques aspects de la vie de Paris* (nos. 59–67), for which dates of execution are also included.

Full citations for abbreviated references are listed in the bibliography.

Dimensions of works are given in centimeters, height preceding width, with inches in parentheses. Unless otherwise noted, dimensions refer to sheet size.

All photographs of works from the Jackson collection were taken at the National Gallery of Art, with the exception of Bonnard's *Promenade des nourrices, frise des fiacres* (no. 75), which was photographed by Michael Bodycomb, Houston, Texas. All photographs of works from the Jane Voorhees Zimmerli Art Museum were taken by Jack Abraham.

VOYAGE 2.    = 0.25 Cent    15 JANVIER 1897

# L'OMNIBUS DE CORINTHE

### VEHICULE ILLUSTRÉ &ᶜᵈ IDÉES GÉNÉRALES

#### DÉPART TOUS LES TROIS MOIS

ÉCRIRE AU
DIRECTEUR
86 rue Blanche
PARIS

LE VOYAGE ANNUEL
UN FRANC
ÉDITION JAPON: TROIS Fᶜˢ

— Vous avez faim ?... Pourquoi ne postulez-vous pas
un emploi de rédacteur à l'omnibus de Corinthe ?

DESSIN DE JOSSOT

# **Prints** Abound

PARIS IN THE 1890S

In 1888, twenty-year-old Edouard Vuillard wrote to Marc Mouclier, friend and fellow student at the Ecole des Beaux-Arts, of his frustration with the Salon of the Society of French Artists: "The least talented painter of the 18th century produced stronger work than all these brave people who exhibit at the Salon.... Now that I have an idea what a *painting* is, I am stunned to observe that during our time one no longer does any of it and instead works like a dog with the pretension of recreating nature."[1]

Vuillard was not alone in his frustration. During the last quarter of the nineteenth century, French artists were increasingly losing confidence in the institutional systems of promotion and support of the arts. After the Franco-Prussian War of 1870, the government-sponsored annual Salon no longer provided artists with the degree of financial security and prestige it had under Napoleon III. In 1880 the Third Republic relinquished its authority over the Salon to the newly founded Society of French Artists, whose Academic members dominated the selection jury and, thus, upheld conservative standards.[2] The Salon had become an antiquated institution with little relevance for innovative artists. In the face of this dissatisfaction, artists began looking to nontraditional and nonacademic ways to promote their art and to earn a living. Vuillard, Mouclier, and their mutual friend Pierre Bonnard were among those who soon turned to printmaking as an attractive alternative.

Both commercial and traditional printmaking had been undergoing dynamic technological, economic, and ideological transformations that would forever heighten artistic possibilities and public visibility of the medium. The evolution

13

of old and the invention of new technologies simultaneously reached a critical mass, fostering an explosive proliferation of artists' printed images. André Mellerio's statement that "Any Method or process which an artist develops to express himself is, for that very reason, legitimate" was written in 1898 specifically in support of artists' efforts to induce the Society of French Artists to accept color prints (not only black and white ones) to its annual Salon.[3] At the time, the war between academic and avant-garde circles over freedom of artistic expression was still being waged. One of the longest running battles concerned the printed image, fought between those who gave free rein to artists and those who clung to printmaking's traditional turf.

---

*Any Method or process which an artist develops*
*to express himself is, for that very reason, legitimate.*

**ANDRÉ MELLERIO, 1898**

---

In the mid-nineteenth century, the role and thus the livelihood of reproductive printmakers had been threatened by photography, which had become a viable means of reproducing paintings for mass dissemination. Academic polemicists argued that photographic reproductions lacked the aesthetics of the original, and that only the keen, interpretive eye of the reproductive engraver, etcher, or lithographer could achieve its graphic equivalent.[4] But in 1861, to defend traditional concepts of "originality" against both photography and reproductive printmaking, the dealer Alfred Cadart, in collaboration with the printer Auguste Delâtre, founded La Société des aquafortistes (Society of Etchers), which championed etching as the most spontaneous, original, and artistic of the printmaking processes.[5] For five years (1862–1867), the society published monthly, multi-artist albums. Each contained five limited-edition etchings by such artists as Eugène Delacroix, Charles-François Daubigny, Edouard Manet, Jean-Baptiste-Camille Corot, Félix Bracquemond, and many others. In 1867, Cadart introduced a new series of etching albums, *L'Illustration nouvelle*, followed in 1874 by the annual *L'Eaux-Forte en ....* (Cadart died in 1875, but his firm continued to promote and publish artists' etchings until 1881.) His publishing efforts increasingly focused public attention on the issue of the creative and unique qualities of artists' original prints versus the mechanical nature of reproductions.

In 1869, Alphonse Lemerre published *Sonnets et eaux-fortes*, a multi-artist album of forty-two etchings accompanied by an equal number of poems. Manet's contribution, which accompanies Armand Renaud's *Fleur exotique* (fig. 1), stands out as a striking, modernist statement; in its bold aquatint, simple abstraction, and reference to elegant, Spanish costume, Manet's print pays homage to Goya. Although most of his prints are etchings, in the 1860s Manet also ventured into lithography, which critics as well as artists vilified as a nonartistic, commercial, and reproductive process.[6] But

Manet, who had an open-minded attitude toward printmaking and its commercial role, took a decidedly innovative approach to lithography. This willingness to experiment with various printmaking media and forums became the standard a generation later with Bonnard and many of his colleagues. In fact, Manet paved the way by working, at least once, in almost every genre of printed image that was available to progressive artists of the 1890s: the poster, the music-sheet cover, multi-artist albums, single-artist albums, book covers, and text illustrations. His *Polichinelle* of 1874 is the first instance of a French artist using color lithography to create an artistic print (fig. 2). Although Jules Chéret's popular posters undoubtedly inspired Manet to experiment with color lithography, the apparently political parody and double entendre of *Polichinelle*, which lampoons President MacMahon, and his earlier black and white lithographs *Le Ballon* (1862) and *La Barricade* (1871), are in the tradition of the social-political commentary established by Goya and Honoré Daumier.7

Before 1850, French books and journals were illustrated with lithographs — as typified by Daumier's caricatures for the journal *Le Charivari* (fig. 3) — and wood engravings. Lithography, which mirrors exactly what the artist draws on the stone, is the more aesthetically accurate of the two, but because it is a planographic process — that is, it prints from a flat matrix — lithographs cannot be pulled from a letterpress, which is a relief matrix. Thus, journals and books that used lithog-

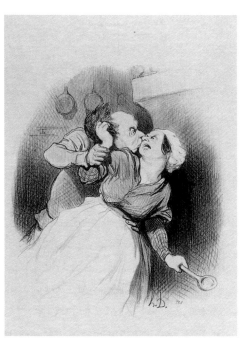

raphy to illustrate texts had to be printed twice from different presses — an expensive undertaking. Wood engraving, a relief process, allowed images and texts to be printed simultaneously from one letterpress, which was efficient and economical. Its basic drawback and inevitable downfall was that it required a highly skilled craftsman to engrave the block. The result is not a precise rendering but rather an interpretation of the artist's aesthetic intent. But in 1850 Firmin Gillot invented an efficient, nonphotomechanical system that transformed line drawings and lithographic and etched images into relief zinc plates that could be economically printed on a letterpress. "Gillotage" was revolutionary in that it enabled an artist's lithographic, etched, or drawn image to be transferred directly to a plate without an intermediary. This technical breakthrough inspired others to take out patents for similar processes.

Not everyone was won over. In 1867, the art critic and etching connoisseur Philippe Burty criticized photography and processes such as Gillotage as "agents provocateurs," because their reproductive capabilities enticed the public away from the original print.[8] Eight years later, in his continued effort to support original printmaking, Burty championed the "belle épreuve" — the limited or one-of-a-kind variant of a print — declaring it to be unique to artistic printmaking.[9] Camille Pissarro and Edgar Degas had embraced the same concept under the tutelage of Bracquemond at the end of the 1870s and early 1880s. Yet unlike Pissarro, Degas' fascination with the "belle épreuve" did not preclude his admiration for the newly invented relief processes. Degas realized the practical and aesthetic benefits of nontraditional media, and he may even have planned to combine photo-relief prints with limited-edition etchings in *Le Jour et la nuit*, the multi-artist album that he, Bracquemond, Pissarro, and Mary Cassatt, among others, had begun to conceptualize in 1879 but which was, alas, never realized.[10]

———————

*The [photo] mechanical processes are excellent*
*when it is a true artist who employs them.*

**LOUIS MORIN, 1900**

———————

In the mid 1870s, Charles Gillot adapted his father's invention to include photography, a major development for the commercial printing industry. For the first time, a relief plate based on a photograph of an artist's line drawing could be printed from a typographical press simultaneously — and therefore inexpensively — with text.[11] With artists able to easily supply line drawings for books and journals, the quantity of illustrations rose dramatically.

Concurrently with these breakthroughs in printing, new and far-reaching freedom-of-the-press laws were passed in 1881 by the progressively liberal government of the Third Republic.[12] This legislative initiative favored an artistic and

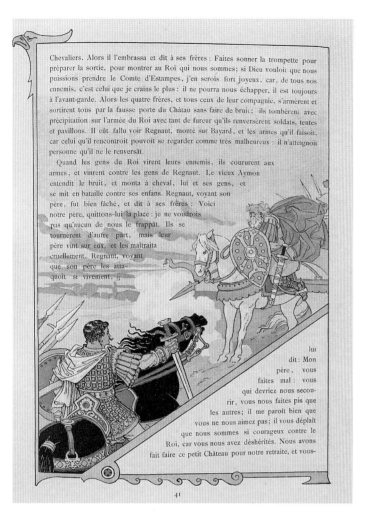

entrepreneurial press and served as a catalyst for collaboration among artists and writers in the production of illustrated books and journals. Beginning at the end of the 1870s, drawings by Auguste Renoir, Degas, Manet, Claude Monet, and other avant-garde artists were reproduced in catalogues, books, and journals such as *L'Impressioniste*, *La Vie moderne*, and *L'Art moderne* using the new photo-relief printing process. The publication in 1883 of Eugène Grasset's spectacular color rendition of the medieval tale *Histoire des quatre fils Aymon* (fig. 4) was achieved by Charles Gillot augmenting his basic black-line, photo-relief process with a new system of color-relief printing (chromotypogravure), in which the plates for each color were made by chromists who, relying on their eyes alone, color separated the watercolor designs.[13]

One conspicuous anomaly of the French press during the 1870s is Richard Lesclide's *Paris à l'eau-forte*. This sixteen-page weekly, in operation from April 1873 until December 1876, was illustrated exclusively with traditional etchings. As with the etching albums published by Cadart, Delâtre was the printer. For the first fifty-two issues miniature etchings by such artists as Félix Régamy and Henri Guérard were printed on china paper, glued onto the pages of the journal, and interspersed throughout the typographically printed text. This labor-intensive system of integrating text and image was exorbitantly expensive. Beginning with the first issue of the second year, each etching by artists such as Guérard, Henri Somm, Félix Buhot, and Norbert Goeneutte was printed in a larger format on individual, full sheets of paper and inserted between the pages of text. In the December 1876 issue of *Paris à l'eau-forte*, Lesclide acknowledged that the cost of commissioning and printing etchings for the journal was a losing proposition. His 1875 collaboration with Manet and Stéphane Mallarmé in the interpretation of Edgar Allan Poe's *The Raven* was, however, a great financial and aesthetic success. The medium for Manet's illustrations was transfer lithography — more expedient than etching — and the four principal images were printed on loose sheets.

The seemingly contradictory activities of the 1860s, 1870s, and 1880s, which supported, in turn, either original printmaking or mass-dissemination technology, were in fact the impetus for the founding in 1888 of La Société de l'estampe originale and in 1889 of the first exhibition of "peintres-graveurs." During 1888 and 1889, Auguste Lepère published two multi-artist albums of ten prints each entitled *L'Estampe*

4

Eugène Grasset, illustration in *Histoire des quatre fils Aymon*, 1883, color photo-relief. Jane Voorhees Zimmerli Art Museum, Rutgers, The State University of New Jersey, Acquired with the Herbert D. and Ruth Schimmel Museum Library Fund

*originale*, not to be confused with André Marty's larger and more important print publication of 1893–1895 of the same title.[14] While advocating the artistic significance of printmaking in general, Lepère's primary goal was to promote the "original," limited-edition wood-engraved print — of which he was a practitioner — and which a decade earlier had been made obsolete with the production of illustrated books and journals using Charles Gillot's less expensive, photomechanical relief-printing process. Lepère's two albums were not a financial success. Of the projected edition of one hundred and

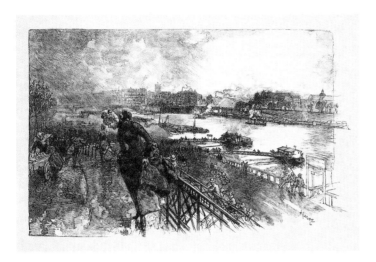

fifty, hardly fifty, if that many, were published. The six artists selected for the first album were competent, well-known printmakers: Bracquemond (etching), Henri Boutet (drypoint), Daniel Vierge (etching), Tony Beltrand (two wood engravings), Henri-Patrice Dillon (two lithographs), and Lepère (two wood engravings; fig. 5). Aesthetically the work did not break new ground, but conceptually it clearly sets forth the arguments in favor of original printmaking, namely, the artist's control of media and printing.

5

Lepère's publication set the stage for the intense, decade-long dialogue on the "original print" between artists, critics, and publishers.

While many considered the new photo processes to be a threat to traditional media, the success achieved by a number of artists with photomechanical processes reinforced, ironically, their interest in individual prints and print albums — unrelated to a text — using woodcut, etching, and lithography. Grasset, Théophile Alexandre Steinlen, Henri Rivière, Henri de Toulouse-Lautrec, Vuillard, Bonnard, Félix Vallotton, Hermann-Paul, and Henri-Gabriel Ibels all created innovative work with both photomechanical relief-printed imagery and limited-edition traditional printmaking processes. Indeed, the practical goals of these artists were to disseminate their art to the broadest public possible, to earn income, and to explore new processes for aesthetic purposes. Mid-century conflicts between photography and traditional printmaking introduced the concept of "originality" not so much as an artistic issue, but as one of economics. As Michel Melot has made clear in his study on impressionist printmakers, during the 1850s and 1860s it was usually the publisher — not the artist — who wished to rarefy and elevate the status, and thus the price, of prints by limiting edition size and canceling the plate.[15] After the mid-nineteenth century, artists — under the influence of British printmaker Seymour Hayden — began to sign their prints in pen or pencil on the margin. The system of numbering prints was later added to the rarefaction process. By 1889, with the organization of the Société des peintres-graveurs (Society of Painters-Printmakers), the limited-edition, signed, and numbered print became the standard for guaranteeing the artistic status of a print and, thus, its commercial value.

The first exhibition of Painters-Printmakers took place in early 1889 at the Durand-Ruel Gallery and included 353 paintings, drawings, and prints in all media by thirty-nine artists. In Burty's preface to the exhibition catalogue, he equates the fundamental premise of Lepère's *L'Estampe originale* to that of the Painters-Printmakers exhibition:

Several months ago, I received the first issue of a brand-new publication, *L'Estampe originale*. It starts with a statement by Mr. Roger Marx setting forth a program that is full of sense and of confidence in the future. The concept guiding the exhibition of Painters-Printmakers is thus in the forefront of everyone's mind at this moment; more emphasis than ever must be placed on the individuality of the original engraving. No reproduction of someone else's work by any method whatsoever is accepted for this exhibition.[16]

By the early 1890s, the terms "l'estampe originale," "l'épreuve," and "peintres-graveurs" had fully evolved within the fine art lexicon to describe the genre of printed image that most closely paralleled the inherent individualistic qualities of painting and sculpture. The implicit meaning of these terms emphasizes the creative over the reproductive potential of printmaking, which, by its very nature, is duplicative or multiple.

––––––––––

*If one only has a few hundred francs to spend on a painting,*
*it will be quite mediocre, signed by some obscure hack*
*and in the future will only diminish in value.*
*On the contrary, however high the quality may be, an original print,*
*that is to say an unpublished composition executed directly*
*by the artist on copper, stone, or wood without the assistance*
*of an unreliable intermediary, is always at a relatively modest price.*
*For twenty francs, fifty francs at the most,*
*one may acquire a work signed by a well-recognized artist*
*and with a sure guarantee of increased value in the future.*

**ANDRÉ MARTY, 1894**

––––––––––

Following *L'Estampe originale*, there were eight multi-artist print publications between 1892 and 1900 that met with varying degrees of artistic and financial success; of these the most important are four that took as or incorporated into their titles "L'Estampe originale," "L'Epreuve," and "Peintres-Graveurs":[17]

6

**1892 – 1897** *Les Peintres-Lithographes* (fig. 6), seven albums of ten "original" lithographs each, by more than sixty artists; published by the journal *L'Artiste* under the direction of artist-lithographer Henri-Patrice Dillon.

**1893 – 1895** André Marty's *L'Estampe originale* (nos. 19 – 31), nine albums of ten prints each (the last album had fourteen), in a variety of media by seventy-four artists; published in an edition of one hundred by *Journal des artistes.*

**1894 – 1895** *L'Epreuve* (nos. 32 – 33), twelve albums of ten prints each in a variety of media by sixty artists; published in a regular edition of two hundred and a deluxe edition of fifteen by Maurice Dumont.

**1896** *Etudes de femmes,* four albums of three lithographs each, by twelve artists; published in an edition of one hundred by Marty's *La Livre vert: L'Estampe originale.*

**1896** *Album des peintres-graveurs* (nos. 34 – 37), album of twenty-two prints in a variety of media by twenty artists; published by Ambroise Vollard.

**1897** *Album d'estampes originales de la Galerie Vollard* (nos. 38 – 44), album of thirty-two prints in a variety of media by thirty-two artists; published by Vollard.

**1897 – 1899** *L'Estampe moderne*, twenty-four albums of four prints each, in a variety of media by numerous artists; published in an edition of one hundred and fifty by Charles Masson and H. Piazza.

**1899** *Germinal,* an album of twenty prints in a variety of media by twenty artists; published in an edition of one hundred by La Maison moderne.

André Marty, director of *Journal des artistes*, like Roger Marx, art critic and government inspector of museums, was an active proponent of the arts and crafts movement introduced by William Morris in England in the 1850s. Morris emphasized that the aesthetics of functional objects (i.e., the decorative arts) should be valued just as highly as that of the fine arts of painting and sculpture. Printmaking played an important role in Marty and Marx's vision of the decorative arts in the democratic, egalitarian society of Third Republic France. The physical manifestation of this vision was Marty's *L'Estampe originale*, a quarterly publication initiated in March of 1893.[18] Marty bought the rights to the title from Lepère, and as with Lepère's first album, Marx wrote the preface for the first year's issues. While Marx's 1888 preface for Lepère's publication sets forth the ideal tenets of original printmaking — stressing its creative, nonreproductive nature in which the artist maintains control of quality by means of limiting the edition — the twenty known, realist, and anecdotal prints in Lepère's *L'Estampe originale* do not live up to the standards preached by Marx.

Only with Marty's publication did the quality and innovation promised by Marx finally materialize. Most important for this metamorphosis was Marty's selection of the seventy-four artists whose ninety-four prints make up the nine albums of the 1893–1895 *L'Estampe originale*: established figures such as Odilon Redon, Lepère, and James McNeill Whistler; emerging avant-garde artists Paul Signac (no. 25) and Toulouse-Lautrec (no. 19); and Nabi artists Paul Ranson (no. 22), Bonnard (no. 20), Ker Xavier Roussel (no. 23), Vallotton (no. 24), and their mentor Paul Gauguin (no. 29). But in addition, during the four years between Lepère's *L'Estampe originale* (1889) and that of Marty's (1893), a number of propitious events, developments, and broadening of attitudes within the world of printmaking took place in Paris. For instance, complementing the first 1889 Painters-Printmakers show was Gauguin's Café Volpini exhibition, organized on the grounds of the International Exposition, which included his influential series of lithographs printed from zinc plates (zincographs; nos. 45–47). This was soon followed by the Ecole des Beaux-Arts' comprehensive exhibitions of Japanese prints (1890) and the history of lithography (1891). The former reinforced the aesthetic significance of color printmaking, and the latter gave credibility to the artistic versus the industrial nature of lithography. Rivière's two series of color woodblock prints — *Paysage Bretons* (1889–1894) and *La Mer* (1890–1892) — and Cassatt's set of color etchings (1891; fig. 7) make obvious references to Japanese woodblock prints and confirm the significant role of color in printmaking. Beginning in 1890, Théâtre Libre commissioned more and more young artists such as Rivière, Ibels, Abel-Truchet (no. 133), and Vuillard (no. 134) to create color lithographic theater programs.[19] The following activities also took place: the production of the first color-lithographic posters by Bonnard (no. 5), Toulouse-Lautrec, Maurice Denis (no. 4), and others (1891–1892); the production of artists' lithographs for the albums of *Les Peintres-Lithographes* (1892); and the publication of Edouard Duchatel's *Traité de lithographie artistique* (1893), a detailed instructional manual with examples of lithographic inks, textures, papers, as well as a series of progressive proofs for a four-color image. Following the lead of Edmond Sagot, who beginning in the 1880s became the first art dealer to specialize in contemporary prints and posters, a number of contemporary print dealers emerged in the early 1890s: Gustave Pellet, Edouard Kleinmann, and A. Arnould, followed soon after by Vollard, who served as the essential market-

7

6

Alexandre Lunois, cover for Les Peintres-Lithographes, 1894, lithograph. Jane Voorhees Zimmerli Art Museum, Rutgers, The State University of New Jersey, Herbert Littman Purchase Fund

7

Mary Cassatt, Woman Bathing, 1890–1891, color drypoint and aquatint. National Gallery of Art, Rosenwald Collection

ing force that commissioned, sold, and promoted the prints of contemporary artists.[20] Artists also began to recognize and use the color lithography printing studios of Eugène Verneau and Edouard Ancourt, in particular, and the color-etching studio of Eugène Delâtre. Thus, within an extraordinarily brief period practical tools for artist-printmakers, artistic precedents, financial incentives, and an experimental artistic climate all evolved to the critical point, encouraging and supporting Marty's eclectic, entrepreneurial, and, ultimately, modern vision of original printmaking.

The most obvious elements that mark the transition between the traditional appearance of Lepère's albums and the modernist image of Marty's are the latter's predominance of color and their synthetist/Nabi aesthetics. Marty's publication is characterized by an antinaturalistic use of color and an emphasis on the two-dimensional, decorative qualities of line and interlocking planes. These features are most evident in Marty's first album in the color lithographs of Bonnard, Denis, and Ibels. Whereas Lepère's albums only include one hand-colored etching (by Boutet), nearly forty percent of the prints in Marty's *L'Estampe originale* are in color — primarily color lithography, which was quickly becoming the favored medium of progressive artists. In his 1893 preface to Marty's *L'Estampe originale*, Marx predicted that the publication would "serve as evidence before history of the art of our time." Five years later, in *La Lithographie en couleurs* (no. 89), Mellerio, editor of *L'Estampe et l'affiche*, observed that "It seems to us that color lithography has not existed before in the conditions in which we recently have seen it bloom and, consequently, is the distinctive artistic form of our time."[21] These are grand but ultimately accurate statements by two of the most visionary, contemporary critics of the fin de siècle. The historian Henri Bouchot made an equally observant but reactionary evaluation of Marty's albums in 1895:

*L'Estampe originale*, which has become the monitor of lithographic impudence, exposes a quite unexpected state of mind. One suspects that an entire category of artists has fallen victim to adolescent mirages and become inclined toward unusual sensation. These are cases of extremely rarefied pathologies or of strange desires to poke fun at popular taste. Most of these enthusiasts favor coloring that is cruel, violent, and color-blind.

Witness Ibels and his circus ring; Toulouse-Lautrec and his polychrome rudimentary sensations; Nicholson and his black blobs, which are very black, or his blues, which are too blue; Guilloux, an ocher and Prussian-blue landscape artist; and Paul Signac, a hare-brained painter of dots and commas.[22]

Bouchot's criticism of avant-garde aesthetics and the "color-blind" use of pigments was an academic view that resented the encroachment of commercial processes and standards into the realm of art. Ironically, under other circumstances Bouchot's suggestion that these artists had "fallen victim to adolescent mirages and become inclined toward unusual sensation" would have been received by the Nabis and other symbolists as a sensitive evaluation of their work, rather than as the intended condemnation.

Marty's *L'Estampe originale*, Dumont's *L'Epreuve*, and the two albums published by Vollard in 1896 and 1897 provided the best means for print buy-

ers to acquire an intelligently edited collection that reflected the eclectic and dynamic visions of contemporary French art. With full appreciation of the significant contribution these print albums made to fin-de-siècle art, one must also be aware that none of the publications completely lives up to the claim implied by its title: Puvis de Chavannes is represented in both *L'Estampe originale* and *L'Epreuve* not with original prints but with photolithographic prints after his drawings. With an edition of 200 for the 121 prints published in the regular edition, it was hardly possible for the prints published in *L'Epreuve* to be "proofs," those one or two artist's trial prints. However, beyond the edition of 200, there were 15 deluxe editions of *L'Epreuve*, which included an extra 13 prints, and most significantly two and sometimes even three proof impressions of almost all the prints (nos. 32 A, B, E, F). That brought the total number of impressions within the complete deluxe series to 255 — more than twice the number of sheets in the regular edition.[23]

Vollard's *Album des peintres-graveurs* and *Album d'estampes originales de la Galerie Vollard* (nos. 34–44), with twenty-two and thirty-two prints, respectively, each contain such extraordinary works as the diagonally oriented, tour de force color lithographs in the 1896 album by Bonnard (no. 34) and Vuillard (no. 35), and in 1897 by Toulouse-Lautrec (no. 41), in which pigment and paper merge to extend the range of abstraction in the description of urban and rural landscapes; Vollard's albums include prints by some artists not represented in Marty's *L'Estampe originale*, such as Paul Cézanne, Henri Martin, Suzanne Valadon, Edvard Munch (no. 37), József Rippl-Rónai (no. 36), James Pitcairn-Knowles, and Jan Toorop, thereby expanding the aesthetic and international scope of Paris print publications. In at least some cases, however, Vollard's printer Auguste Clot reverted to the traditional approach of a reproductive printmaker translating a watercolor or pastel submitted by an artist such as Alfred Sisley, Redon, Théophile Pierre Wagner, or Cézanne into a color lithographic print.[24] Clot began his printing apprenticeship in the 1860s in the firm of Lemercier, and in 1874 was directly responsible for the production of Manet's only color lithograph, *Polichinelle* (fig. 2). In the case of the Manet, however, and Cézanne's *Bathers* for Vollard's second album (no. 39), it is likely that although the two artists actually drew the black-line lithographic proofs, they only advised Clot on the application of color. This is similar to the way Grasset worked with the chromists at Charles Gillot's photomechanical printing company, where the artist hand-colored photo-relief proofs of his black-line drawings for his 1883 book *Histoire des quatre fils Aymon* as a guide for Gillot's craftsmen (fig. 4). They, in turn, color separated Grasset's color design to create individual relief plates — one for each color. The artist then consulted with the chromists, made corrections, and ultimately approved trial proofs made from printing all the various relief plates in succession on one sheet of paper. Thus, conceptually, the color photo-relief images by Grasset were no more or less original than the color lithographs of a number of artists, including Cézanne's *Bathers* and Manet's *Polichinelle*. In fact, many fin-de-siècle artists were able to fully maintain their artistic integrity while working in a variety of commercial, mass-produced formats by manipulating and exploiting printing media — photo-based and otherwise. One of the seemingly ironic anomalies of Marty's *L'Estampe originale* is Grasset's dynamic 1894 image of a jealous

woman, *La Vitrioleuse* (The Acid Thrower) (no. 28), which is a relief print created photographically after a line drawing by the artist and then stencil colored. As are all prints in *L'Estampe originale*, *La Vitrioleuse* is signed by the artist and numbered, but it also contains the monogram of the photomechanical printing company, Verdouc, Ducourtiaux, and Huillard. Similarly, beginning in 1895 the Paris print dealer Kleinmann published on special paper signed and numbered limited editions of the mass-produced, color photo-relief images created by Lautrec, Hermann-Paul, and others for the journal *Le Rire*.[25] In just the reverse manner, Kleinmann also sold, in editions of fifty, signed, numbered, and sometimes stencil-colored lithographs by Steinlen, Bonnard, Ibels, Hermann-Paul, and Lautrec that were created by the artists specifically to be photomechanically reproduced as illustrations for the journals *Le Chambard* (1893), in the case of Steinlen, and *L'Escarmouche* (1894; no. 9). There must have been some public confusion about the use of the term "original print" — if, in fact, beyond the rhetoric of the few critics and publishers there was a public concern at all. Yet the artist and the public both benefited from artists' adaptation of the photo-relief printing process with stenciled or printed color. Such mass-media images could be transformed easily into limited-edition prints and compete in the art market with those in traditional media.

———————

*Today, the [graphic] document triumphs, and one can affirm*
*that the twentieth century will undergo the great revolution of which some*
*of its first manifestations we now experience: graphic Language,*
*the Image, goes as a pair with the literary language, Writing.*

**JOHN GRAND-CARTERER, 1893**

———————

      Both the printed image and the printed word, are, in reality, pigment on paper that defines an arrangement of lines and/or shapes and which has been predetermined and transferred under pressure from the fixed matrix of one surface (relief, intaglio, planographic) onto another (paper). Historically, artists' prints have existed in some degree of partnership with text as, for instance, an illustration of or complement to a narrative. But the association of "image" and "writing" became especially significant at the end of the nineteenth century in France. At that time numerous artists, especially Bonnard, played a dynamic role in illustrating books and journals and in combining words and images in the design of posters, theater programs, menus, and other ephemera. This intense activity marks the genesis of aspects of the modern aesthetics of conceptual art that places a premium on the visual affect of letters and words and on the manipulation of meaning.

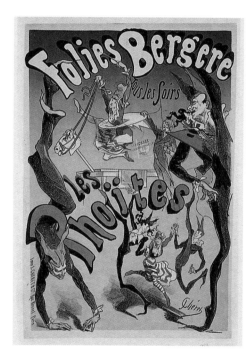

Bonnard's 1894 poster for *La Revue blanche* (no. 1) is an early example of the extension or manipulation of words or letters as active components of visual imagery at the expense of readability. Bonnard's and Alfred Jarry's typographical designs for *Répertoire des pantins* (nos. 123–131) deconstruct words to the point of nearly obliterating their ability to communicate. It is with Mallarmé's 1897 concrete poem *Un Coup de dés* that word and image became one and the same; the boundaries of literature and the visual arts were completely dissolved (fig. 8).

During the 1870s and 1880s, in particular, Chéret's color-lithographic posters and book covers dramatically and almost single-handedly brought art to the advertising industry (fig. 9). The innovative designs, the incorporation of text and image, and the inventive solutions to the application of color in Chéret's work not only influenced the art of such figures as Manet and Georges Seurat, but also inspired a generation of artists to enter the potentially lucrative field of commercial design.[26] Among the most influential of the new breed were Bonnard, Lautrec, Ibels, Vuillard, and Vallotton, all of whose printed images in the 1890s transformed the European aesthetics from one traditionally based upon three-dimensional illusion to one essentially conceived two-dimensionally in terms of color, line, and shape — and often in terms of written language.

8

Stéphane Mallarmé, Un Coup de dés jamais n'abolira le hasard, **in** Cosmopolis, **no. 17, May 1897. Jane Voorhees Zimmerli Art Museum, Rutgers, The State University of New Jersey, Acquired with the Herbert D. and Ruth Schimmel Museum Library Fund**

9

Jules Chéret, Folies Bergère: Les Phoïtes, **1879, color lithograph. Jane Voorhees Zimmerli Art Museum, Rutgers, The State University of New Jersey, Mindy and Ramon Tublitz Purchase Fund**

In the 1880s and 1890s, photomechanically illustrated journals such as *Le Chat noir*, *Le Courrier français*, *Gil Blas illustré*, and *Le Rire*, among others, gave artists a financial opportunity and an outlet for artistic expression. Artists were increasingly commissioned to create prints as special supplements (*L'Art moderne*, *La Revue blanche*, *La Plume*, *La Vie artistique*, *L'Ymagier*, *La Centaure*, etc.) or as limited editions for subscribers (*La Revue indépendante* and *L'Estampe et l'affiche*). Marx's *L'Estampe et l'affiche* (1897–1899) and John Grand-Carterer's *Le Livre et l'image* (1893–1894) were specifically geared toward documenting and championing prints and printed ephemera. Léon Deschamps' journal *La Plume*, André Marty's *Journal des artistes*, and the Natanson brothers' *La Revue blanche* (nos. 2–3) actively promoted and commissioned prints and posters, contributing immensely to the public awareness of and accessibility to original prints. Two extraordinary "journals" of the mid-1890s, little known today, are Hermann-Paul's *Le Fond de bain* and Mouclier's *L'Omnibus de Corinthe* (nos. 16–18), which are hand drawn and scribed, lithographically printed serial publications; in fact, each journal has no other function than to be an artwork in itself.[27] They, thus, take the intimate relationship between fin-de-siècle journals and prints to the extreme. These two journals also literally spell out on the back page of each issue the various components — journals, artists, dealers, lithographic printers — of the close-knit system that fueled the proliferation of artists' prints in Paris during the 1890s. A synergy developed — specifically, with the journals *La Revue blanche*, *Journal des artistes*, and *La Plume*; the printers Ancourt and Clot; and the dealers Pellet, Kleinmann, Sagot, and Vollard — that was particularly effective in the increase and promotion of prints and posters by Bonnard and the Nabis as well as by their associates Toulouse-Lautrec and Hermann-Paul.

———

*This fin-de-siècle so much discredited, qualified so readily as decadent,*
*will remain for the original print a distinguished époque,*
*a period of veritable efflorescence....[the original print will] serve*
*as evidence before history of the art of our time.*

**ROGER MARX, 1893**

———

The editors of these new Paris art/literature journals sought to outline a "program" that distinguished their journal from others and promoted their own modernistic orientation. These primarily literary publications — *L'Art moderne* (1882–1883), *La Revue indépendante* (1886–1888), *La Plume* (1889–1901; fig. 10), *La Revue blanche* (1891–1903) — promoted an eclecticism with no allegiance to any one school and with an openness to both established writers and artists as well as new talents. They are, in effect, the journalistic equivalents to Marty's *L'Estampe originale*:

We are "L'Art moderne," and nothing which is artistic will be foreign to us. And as we are not
indebted to any school, to any group, all interesting communications will be met in our
columns with the greatest hospitality.... Here the admirers of Hugo and the fanatics of Zola,
the last romantics and the aspiring naturalists, the linearist and the colorists, the formalists
and the impressionists, the melodists and the harmonists will be equally well received.[28]

"La Revue indépendante" remains faithful to its program: a publication consecrated to
art under all its forms...and will stay truly independent, independent no less from academic
traditions as from the vain agitations of decadents.[29]

"La Plume" wants no other program than the following: to do alone what all the other
[reviews] have neither known or wanted to do.[30]

Each journal demonstrated its commitment to "modern" art
by incorporating original prints, in one form or another, within its pages, helping
to initiate and sustain for printmaking, in the words of Roger Marx, "a period
of veritable efflorescence."

*L'Art moderne*, not to be confused with its more radical, literary
Belgian counterpart from whence it took its name, existed for only eight issues, one
each month, from December 1882 through July 1883. Each sixteen-page issue is aug-
mented with an etching, also available
separately at the journal's office, usually
by the review's art editor, Boutet, and
with a number of photo-relief illustrations
after drawings by Lepère and others
who like Boutet are represented in the 1888
and 1889 albums of *L'Estampe originale*.
While relatively conservative, *L'Art moderne*
did offer full-page photo-relief illustra-
tions and reviews of work by the impres-
sionists Monet and Renoir. More sig-
nificant from the perspective of literary
content, longevity, and print production
is *La Revue indépendante*, founded in
November 1886 by the symbolist poet
Edouard Dujardin and the influential
avant-garde critic Félix Fénéon. *La Revue
indépendante* published twenty-six monthly
issues principally of literary criticism,
installments of unpublished manuscripts,
and book reviews. Yet, for its elite one
hundred-franc annual subscribers (*Fond-
ateurs-Patrons*), of which there were only
forty-eight for the first issue, the review
was printed on a variety of deluxe papers

10

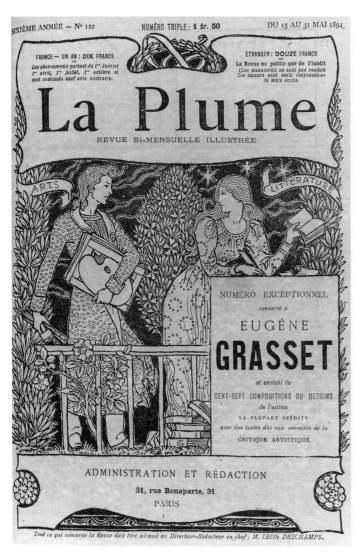

10

Eugène Grasset, cover for
La Plume, **15 – 31 May 1894,
photo-relief. Jane Voorhees
Zimmerli Art Museum,
Rutgers, The State University
of New Jersey**

and included supplements of original prints or photomechanical reproductions of art. The first issue, for instance, included photo-relief facsimiles of two drawings of dancers by Whistler; these photo reproductions, however, are endowed with a sense of "la belle épreuve" by means of having each image printed twice — once on japan paper and once on china — as if they were rare, old master proofs. In addition to photomechanical reproductions after drawings by Seurat, Jean François Raffaëlli, and Paul-César Helleu, *La Revue indépendante* published one lithograph each by Redon, Maximilien Luce, Signac

11

(fig. 11), and Chéret; a woodcut by Lucien Pissarro and a woodcut after Renoir; as well as three etchings by Albert Besnard, four by John Lewis Brown, one by Jacques Louis Blanche, and four by Camille Pissarro. While the overall selection of artists is diverse, the inclusion of the Pissarros, Signac, Luce, and Redon tips the balance in favor of socially radical artists and reflects the journal's literary leanings.

In the early 1890s, *La Plume* and *La Revue blanche* continued, at least theoretically, a commitment to multiple schools of art and literature; in 1891, a few months before *La Revue blanche* officially moved its offices from Liège to Paris, its editor, Pierre Royer-Collard, summarized the position of *La Revue blanche*: "We do not fear the ridicule of passing for eclectics."[31] It was not, however, until 1893 that the two journals began a concerted effort to literally represent contemporary trends in the visual arts within their pages. From its inception *La Plume*'s articles dealing with literary groups such as the participants at the Chat Noir cabaret or movements such as anarchism were well illustrated with photomechanical reproductions of artists' drawings, including those by Camille Pissarro (who had disdained them earlier), Ibels (the "Nabi Journalist"), and Luce; plus with most issues there was a photo-relief printed portrait of a leading figure. The first issues for 1892 and 1893 include, respectively, a drypoint by Dumont and an etching by Boutet as frontispieces. In the February and October issues of 1893, color finally plays a role in *La Plume*'s illustrations with inserts of photo-relief images after the work of Ibels, while its November special issue on posters has a color-lithographic cover by Chéret. On the other hand, there are no illustrations in *La Revue blanche* until the July–August issue of 1893, in which the journal publishes an original lithograph by Vuillard, initiating a series of seventeen monthly inserts, some in color, by Redon, Toulouse-Lautrec, and the Nabis.

The purpose of the relatively modest visual enhancements introduced by *La Plume* and *La Revue blanche* was not to compete with the popular illustrated journals such as *Paris illustré* and *Gil Blas illustré*, which had been presenting photomechanically and in color the work of contemporary artists since 1883 and 1891,

respectively. Rather, the print supplements of *La Plume* and *La Revue blanche* added the caché of connoisseurship for their readers. Unlike *La Revue indépendante*, which limited its supplements to its few "founding patrons," those of *La Plume* and *La Revue blanche* were available to whomever purchased the journal at its regular price of fifty centimes and one franc, respectively. The reader automatically became a consumer of "original" contemporary art. Not only did the journals promote the democratization of art, which was a major interest of printmaking supporters such as Roger Marx, but in the case of *La Revue blanche* advocated most ardently for the modernist aesthetics of the Nabis, which, at least for that journal, encompassed the art of Redon and Lautrec. The journal's initial commitment to eclecticism was, thus, greatly diminished. Instead, its owner and director Alexandre Natanson and its chief editor Fénéon confirmed their dedication to the Nabi school by commissioning Bonnard (no. 1) and Lautrec to create posters for the journal; by publishing in 1895 the *Album de La Revue blanche*, a deluxe reedition of twelve prints that had appeared in the journal earlier; and by augmenting the journal in 1895 with three supplements, all entitled *Nib*, separately illustrated by Bonnard, Vallotton, and Lautrec.

---

*For the last twenty years, artistic posters have taken a prominent place on the walls of Paris. Our best designers have used their crayons. The most sympathetic among them, M. Jules Chéret, lending to them a magnificence of unparalleled talent, has put them in fashion.*

**ERNEST MAINDRON, 1886**

---

Throughout the 1890s, *La Plume* also consistently promoted the graphic arts with special issues dedicated to artists-printmakers, posters, and illustrated books.[32] In 1894 its founding editor, Deschamps, inaugurated a series of exhibitions, eclectic in nature, entitled the Salon des cent (no. 8), which, by the time of its demise in 1901, accounted for nearly fifty monographic and group exhibitions of the most innovative artists of the decade. The fifth Salon was dubbed "a review of prints"; the fourteenth through twentieth Salons were dedicated to displays of international posters. The first presentation of Toulouse-Lautrec's *Elles* series took place in the spring of 1896 at the twentieth Salon des cent exhibition, for which the *Elles* frontispiece served as the poster (no. 51). In addition to commissioning more than forty Salon des cent posters by artists such as Bonnard, Lautrec, and Alphonse Mucha, *La Plume* also published, among other works, Gauguin's *Noa Noa*, as well as limited-edition, lithographic albums by Hermann-Paul, creator of *Le Fond de bain*, and *L'Epreuve*'s Dumont, and also marketed hundreds of prints and posters from its office and gallery at 31 rue Bonaparte.

**11**

Paul Signac, supplement to *La Revue indépendante*, no. 15, January 1888, lithograph. Jane Voorhees Zimmerli Art Museum, Rutgers, The State University of New Jersey

Even the posters that, beginning in the 1880s, transformed the streets of Paris into a brilliantly colored proletarian museum became, in reduced format, a genre of artistic prints. In 1886 Ernest Maindron published *Les Affiches illustrées*, the first comprehensive study of the history and art of posters, illustrated with full-page color-lithographic reductions of twenty of Chéret's works. The reductions were based on photographs of the posters that were used as guides by craftsmen ("chromists") to copy the essential composition. The chromists then color separated by eye, basing their judgments on the original poster, and produced lithographic plates or stones for each color from which to print the reduced version. This system inaugurated the color-lithographic poster as a print-size image perfect for book illustration or as an insert for such journals as *Le Courrier français*, which had a circulation of sixteen thousand. Maindron's subsequent 1896 *Les Affiches illustrées, 1886–1895* and his *Les Affiches étrangères* of 1897 are abundantly illustrated with reduced versions of color lithographic posters. But it was the publication of the monthly albums of *Les Maîtres de l'affiche*, at the end of 1895, which for the next five years converted the images of 240 posters into small color-lithographic prints, which brought almost instant popularity to selected artists and greatly boosted the proliferation of illustrated printed ephemera.[33] And just as poster mania inspired Maindron's publications as well as the albums of *Les Maîtres de l'affiche*, the popular interest in an entire range of artist-illustrated printed matter prompted Léon Maillard in 1898 to publish *Les Menus et programmes illustrés* with numerous color-lithographic facsimiles and reductions after contemporary models.[34]

In addition to color-lithographic supplements, photo-relief printed and stencil-colored reduced versions of posters also appeared in a variety of publications such as *La Plume*, which included a reduction of the Nabi artist Ibels' 1892 poster *Mévisto* (fig. 12) as a supplement to its 15 January 1893 issue featuring Ibels in an article by Charles Saunier. It was relatively inexpensive to insert supplements printed in various media — traditional and photomechanical — because they did not need to be printed simultaneously from the same letterpress as the journal itself. At times even special paper was used for these mass-issued prints. While art publications such as *La Revue indépendante* and *L'Estampe et l'affiche* restricted their supplements or *primes* to a limited number of high-level subscribers, supplements for *Le Courrier français* and *La Plume* were printed in the same large edition as their journal — in the thousands. Entire runs of some journals were printed on expensive papers in limited editions, aimed at collectors.[35] Indeed, the concept of the cheaply printed illustrated rag is subverted by these efforts to elevate —

12

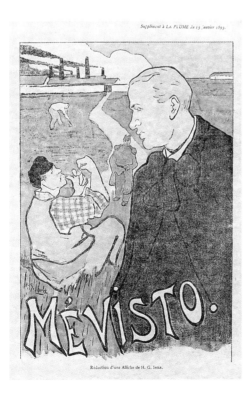

Supplément à LA PLUME du 15 Janvier 1893.

MÉVISTO.

Réduction d'une Affiche de H. G. Ibels.

**13**

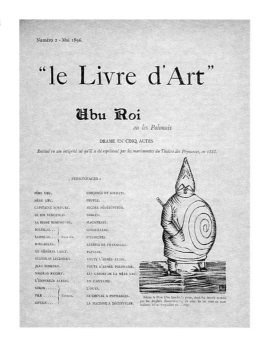

like the limited-edition color proofs of *Le Rire* — to precious and rare that which was initially mass produced.

The phenomenon of the print-size poster was complemented in the 1890s by the production of numerous large, interior wall prints by such artists as Chéret, Steinlen, Adolphe Willette, Rivière, Grasset, Puvis de Chavannes, Mucha, and Bonnard. Referred to as either *estampes murales, estampes décoratives, placards décoratifs*, or *panneau décoratifs*, these large-scale prints were usually printed in editions of five hundred to two thousand and used to decorate homes, schools, and other public spaces as a means of democratizing Third Republic art.[36] In some cases, however, such as Bonnard's four-panel color-lithographic screen of 1895, *Promenade des nourrices* (no. 75), the edition size was much more limited; the one hundred and ten impressions of Bonnard's screen were offered for sale at forty francs unmounted or sixty francs mounted, which, although not inexpensive, fall within or just above Marty's suggested range of twenty to fifty francs for a high-quality "original print."[37]

Three short-lived journals literally went against the grain of industrial technology by illustrating their pages with woodblock images. Jarry and Remy de Gourmont's *L'Ymagier* (1895–1896), Paul Fort's *Le Livre d'art* (1896), and Marx's *L'Image* (1897) idealistically promoted the traditional media of woodcut and wood engraving over the new photo processes. *L'Ymagier* and *Le Livre d'art* are esoteric, literary/artistic journals; the former has a mystical-Christian focus and includes historical and contemporary prints (mostly woodcuts) by Jarry, Pont Aven artists such as Emile Bernard and Charles Feliger, the only print ever made by Henri Rousseau (a lithograph), popular folk prints from Asia and France, as well as restrikes and reproductions after medieval woodblocks.[38] *Le Livre d'art*, which sold for one and a half francs an issue, is the purest of the three publications in that it published, along with original manuscripts, only original woodblock prints and decorative vignettes. Its goals were to promote "the modern, industrial decorative arts movement" and to support young writers and artists, as well as maintain respect for the previous generation of modernists.[39] *Le Livre d'art* lasted for only four issues, but it contains the first published version of Jarry's groundbreaking play *Ubu Roi*, illustrated with the first printing of his famous woodblock the *Véritable Portrait de Monsieur Ubu* (fig. 13).[40] Dumont, Guérard, Georges Jeanniot, Charles Huard, and Denis also provided woodblock prints and vignettes, some of which were issued previously as single works in *L'Epreuve*.

Published by La Corporation Française des graveurs sur bois, under the literary direction of Marx and Jules Rais and the artistic direction of the wood engravers Lepère, Beltrand, and Léon Ruffe, *L'Image* had as its primary purpose the

**12**

Henri-Gabriel Ibels, Mévisto, from La Plume, **no. 90,** **15 January 1893, stencil-colored photo-relief.** Jane Voorhees Zimmerli Art Museum, Rutgers, The State University of New Jersey

**13**

Alfred Jarry, Véritable Portrait de Monsieur Ubu, in Le Livre d'art, **no. 2, May 1896,** woodcut. Jane Voorhees Zimmerli Art Museum, Rutgers, The State University of New Jersey

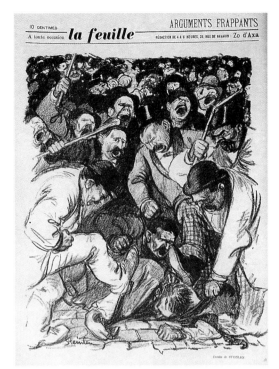

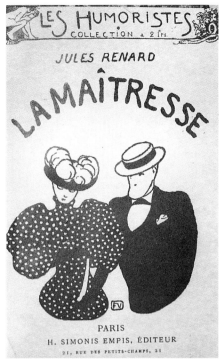

championing of wood engraving — original and reproductive — by illustrating each issue with wood-engraved text illustrations, supplemented by a wood-engraved or cut print. This elegant publication sold for two and a half francs, and each month's cover was designed by a different artist and was typically printed in color from two blocks; a limited number were even printed on different sizes of china paper. *L'Image* was the last-gasp effort by wood engravers such as Lepère and Beltrand to revive interest in the medium as a viable, artistic means of illustrating text, but it folded after a year. It was just too expensive for journalistic publications to be illustrated completely by such labor-intensive, traditional techniques.

The anarchist-socialist Steinlen, a notable contributor to *L'Image*, created a woodblock illustration for the journal. Steinlen's printed work was, in fact, one of the most visibly pervasive and influential artistic phenomena of the 1890s and early twentieth century — perhaps even more so than the posters of Chéret and Toulouse-Lautrec. His photo-relief printed images, colored by stencil or by relief plates, could be found each week on the covers and in the pages of such journals as *Le Mirliton, Le Chambard, Gil Blas illustré, Le Rire, La Feuille* (fig. 14), *Le Canard sauvage, Le Sourire,* and *L'Assiette au beurre*.[41] Steinlen's social and political images are, at times, truly radical in message and aesthetics, other times, humorous or sentimental and conventional in style. But they reached thousands upon thousands of members of the working class, of the bourgeoisie, and of the intelligentsia, alike. The early work of artists such as the young Pablo Picasso from Spain and Edward Hopper from the United States derives in part from exposure to Steinlen's journal illustrations either before or after their first visit to Paris.[42] Steinlen, with his ubiquitous output of posters, music sheets, theater programs, journal illustrations, and book covers is an extreme example of fin-de-siècle artists who innovatively explored traditional media — lithography, woodcut, etching, and even the *belle épreuve* — while exploiting to the utmost the aesthetic and, in some cases, the propagandistic possibilities of the mass media.

Gordon Ray's *The Art of the French Illustrated Book, 1700 to 1914* documents in two volumes the proliferation of artist-illustrated books in fin-de-siècle France, especially the limited-edition *livre d'artiste*, published by such societies as Les Bibliophiles contemporains, Les Cents bibliophiles, and Les XX.[43] In the production of book covers and book illustrations of the 1890s, avant-garde artists shifted back and forth with ease between traditional — mainly lithography — and photo-relief processes. Primary examples of the small number of books illustrated with lithography throughout include Denis' *Le Voyage d'Urien* (1893; nos. 77 A–B); Rippl-Rónai's *Les Vierges* (1895; no. 79); Ibels' *La Terre* (1897); Toulouse-Lautrec's *Au pied de Sinaï* (1898; no. 90) and *Histoires naturelles* (1899); Bonnard's *Parallèlement* (1900; nos. 91 A–B) and *Daphnis et Chloé* (1902; nos. 92 A–B), both published by Vollard; and Toulouse-Lautrec's album *Yvette Guilbert* (1894; no. 76), published by Marty. On the other hand, Vallotton's *La Maîtresse* (1896; fig. 15), Steinlen's *Dans la rue* (1895), Ibels' *Les Demi Cabot* (1895), Bonnard's *Marie* (1898; nos. 83 A–B), and Hermann-Paul's *Deux cents dessins* (1899) — the last two published by *La Revue blanche* — typify the many three-and-a-half-franc photo-relief illustrated books. Even Vallotton's *Rassemblements* (1896; no. 81), published by Bibliophiles indépendants in an edition of 220, on special paper, is not printed in the traditional manner from woodblocks but rather from relief plates most likely made by means of a photo process.[44] Then there are the two important examples of hybrid technology — Bonnard's *Petit solfège illustré* (1893; nos. 104, 106 A–H) and *Almanach illustré du Père Ubu* (1901; nos. 87–88) — in which, although printed from either lithographic stones or zinc plates, the images were put in relief during the preparation of the plates to add the durability necessary for the printing of their relatively large editions: two thousand copies of *Petit solfège illustré* and one thousand of *Almanach*.[45]

———

*Picture mania is on its decline, and the public of publishing houses*
*and bookshops will soon happily benefit from the formidable*
*onrush of painters who little by little are preparing themselves.*

**OCTAVE UZANNE, 1886**

———

While the images in the books mentioned reflect, in one form or another, the modernist aesthetics of flat, decorative simplification of naturalistic elements, Bonnard's designs for *Parallèlement* (nos. 91 A–B) and *Almanach illustré du Père Ubu*, both published by Vollard, are the most innovative with regard to the integration of image and text. In those books Bonnard rejected completely the traditional systems of book illustration, in which prints are either inserted as separate pages or images are printed onto a page within a framing border; instead, his 109 rose-colored lithographs

14

Théophile Alexandre Steinlen, cover for La Feuille, 21 January 1898, photo-relief. Jane Voorhees Zimmerli Art Museum, Rutgers, The State University of New Jersey

15

Félix Vallotton, cover for Jules Renard's La Maîtresse, 1896, photo-relief. Jane Voorhees Zimmerli Art Museum, Rutgers, The State University of New Jersey, Acquired with the Herbert D. and Ruth Schimmel Museum Library Fund

for *Parallèlement*, Paul Verlaine's collection of sexually charged verses, sprawl over the pages, at times in continuous action from one page to another. The text itself is visually deemphasized and superimposed onto the page somewhat in the manner of subtitles on a film. Bonnard's lithographs challenge the literary primacy of text over image. The volume serves as the artist's sketchbook, in which the eroticism of Verlaine's verse is amply suggested but, more importantly, in which a constant metamorphosis between the pure two-dimensional abstract texture of the lithographic crayon and its sometimes illusionistic rendering of nature and voluptuous bodies is played out on the surface of the white paper. This pictorial duality — the reality of the medium versus the medium's illusion of reality — is at the crux of modernist concerns. While *Parallèlement* is decidedly modern and is considered to be one of the greatest *livres d'artiste* of the twentieth century, it is a less radical break with traditional book design than Bonnard's and Jarry's collaborative work, the outrageous, parodical *Almanach illustré du Père Ubu*.[46] The *Almanach*'s text is not in the elegant, italic Garamond font that one finds subtly printed from a letterpress over Bonnard's lithographic images in *Parallèlement*. Rather, there are instances in which Jarry's type expands and contracts in size, challenging the pictorial role of Bonnard's images, which in turn assume the role of text. The brash antiestablishment word blows of Jarry's puns and absurdities visually resonate with the red and blue infantile images formed by jots, dabs, and spats of ink, which aggressively and freely insert themselves within the typography. There is, at least, a twenty-year evolution in French book design that offers antecedents to Bonnard's achievements in breaking out of the boundaries of traditional book illustration. Much of this early history is related to books inventively illustrated with the new photographic processes, such as *Dans les nuages* (1878), by Sarah Bernhardt and Georges Clarin; *Un Drame dans une carafe* (1882), by Edouard de Beaumont and Louis Leloir; *Paris rose* (1884), by Georges Lorin; the color-illustrated *L'Ombrelle* (1883), by Octave Uzanne and Paul Avril; and, of course, Grasset's masterpiece in color, *Histoire des quatre fils Aymon* (1883; fig. 4).[47]

Yet, it was Bonnard's *Petit solfège illustré* of 1893, a music primer for children, that set off the most profound attack on French book design. The extreme abstraction and the interplay between text and image may have been used to appeal to the book's audience, yet the same flatness, childlike drawing, and integration of type with image occurs in his cover for *Reine de joie* (1892; no. 82) and his 1894 poster for *La Revue blanche* (no. 1), both of which are aimed at adults. Bonnard, like his *Almanach* collaborator, Jarry, anticipated the future surrealists by consciously seeking to emulate the untrained, nonacademic qualities of children's art. Bonnard's images for *Almanach illustré du Père Ubu* opened the twentieth century with an innovative, psychosexual, visual vocabulary that predicted the stylistic and contextual concerns of Picasso and Henri Matisse.[48]

In *Almanach illustré du Père Ubu*, Jarry and Bonnard based a parody and visual pun on the French government's confusion and embarrassment concerning the printing of Verlaine's *Parallèlement* by the Imprimerie Nationale. As the story goes, the printing was authorized only because officials, at first, thought — based on the title — that the book's subject was geometry; however, once the ministry of justice declared that the book was indecent and that it was scandalous for the logo of the

Imprimerie Nationale to appear on its title page, Vollard was required to replace the title page in order to preserve the dignity of the government print shop.[49] Indeed, censorship, and this was censorship of a sort, was a continual issue for fin-de-siècle writers and illustrators even with enactment of the liberal law of 1881. Almost immediately after the law was passed, there was "a virtual flood of cheap, obscene publications the presentation of which dishonored the promenades most frequented by the public with the cries and commentaries of the vendors." This immoderate response to newfound publishing freedom resulted on 2 August 1882 in a modification of the laws that aimed at "the repression of outrages to morality...."[50]

------------

*Slightly improper, all right;*

*vile, never. Its essence does not allow it. It excludes all vulgarity or,*

*rather, vulgarity forcibly excludes it. It throws on all subjects, even the most indecent,*

*a veil that transfigures and idealizes it....These miserable caricatures*

*are all simply the oeuvre—if, however, "oeuvre" can be applied to them—*

*of the Marquis de Sade of drawing.*

LAGRIFFE, 1883

------------

With regard to art, obscenity was legally defined along the lines of basic Academic standards: "obscenity exists where, whatever be the type or diversity of schools, art does not reach for the ideal; when the appeal to instincts, to gross appetites is not contradicted or overcome by any more powerful sentiment."[51] An Academic painting of a nude was not considered obscene, even if sexually suggestive, if it had an allegorical, historical, or biblical reference. On the other hand, if the nude depicted left the ideal, nontemporal realm of allegory and entered that of actuality, or even worse an illicit reality that referred to prostitution, morality was threatened. In the same manner, nude images combined with text in a book were not judged obscene if the text and images served a high moral or scientific purpose. In fact, in 1884 a French court judged that Léo Taxil and his wife were guilty of obscenity when they sold separately to the public prints that served as illustrations for a serial publication on "La Prostitution contemporaine." Context, thus, determined the legal status of printed images. Obscenity and "l'esprit français" walked a thin line. The latter existed and was acceptable when it was "incarnated in a period of time, in certain masterpieces of literature, painting, crayon in which *l'esprit français* sketches without achieving, underlines without supporting, and states less than it leaves to question."[52]

In essence, Bonnard's images for *Parallèlement* emulate a type of rococo *l'esprit français* with a flirting sexuality à la Watteau and Boucher. As such they are very much akin to the many humorous sex-laden journal illustrations of the

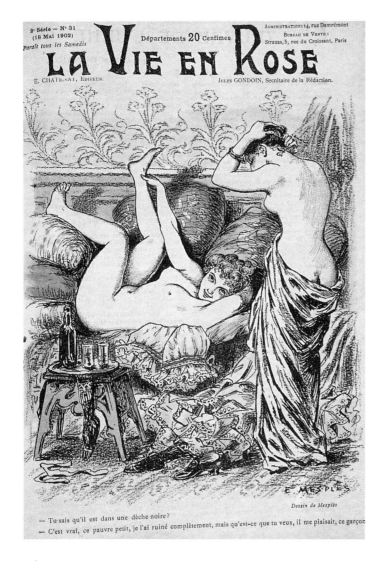

— Tu sais qu'il est dans une dèche noire?
— C'est vrai, ce pauvre petit, je l'ai ruiné complètement, mais qu'est-ce que tu veux, il me plaisait, ce garçon

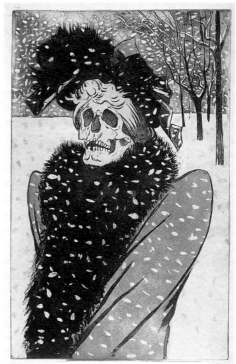

time by Willette, Jean-Louis Forain, Louis Legrand, Morin, and others, which were constantly under attack by the self-proclaimed censor of the Third Republic, René Bérenger and his League against Licentiousness in the Street. While artists viewed their own work as *l'esprit français*, Bérenger saw it as obscene. On the other hand, artists such as Morin, who in 1902 were the subject of a lawsuit brought by Bérenger against the journal *La Vie en rose* because of its titillating cover illustrations (fig. 16), declared that the figure of Bérenger "is the synthesis of the social and political moral thought of the sovereign bourgeoisie," and that the goal of Bérengerism "is the destruction of French art, neither more nor less."[53]

At the turn of the nineteenth century, systems of camouflage, innuendo, and rationalization ruled the industry of illustrated literature, and this was no more apparent than when prostitution was its theme. During the second half of the century, among the writers and artists who died of syphilis were such notable figures as Charles Baudelaire, Jules de Goncourt, Guy de Maupassant, Manet, Lautrec, and Gauguin.[54] By the end of the century this health crisis had generated the most sustained and prolific outpouring ever of art and literature dealing with the subject of prostitution. Though not limited to cities, syphilis was most pervasive in urban environments; fin-de-siècle writers referred to Paris as the new Gomorrah, and as *Paris impur*. Woman as prostitute was *la femme fatale*; she was death incarnate, the cause of it all (fig. 17). However, as victims of sexually transmitted diseases, women were marginalized as statistics used to codify official government policies regulating prostitution.[55] The laws enacted during the first half of the nineteenth century to control

and isolate prostitution, which were administered by the Régime de moeurs (morality regime), protected the male population while simultaneously inhibiting the freedom and daily lives of women, all of whom were suspect of becoming prostitutes if their often fragile economic bases failed them.

By the end of the Second Empire in 1870, the radical effect of industrialization and urbanization on the socioeconomic status of Parisian women had resulted in a gradual structural reorganization of prostitution in the city from one based essentially on a system of government-approved brothels housing registered prostitutes, to a system in which clandestine (i.e., unregistered) prostitutes dominated the business. As women, in general, gained greater economic independence and social mobility, the ranks of prostitution became much more diverse, less controlled, and less easily recognizable. This breakdown of traditional means of isolating and identifying prostitutes not only enhanced male anxieties over sexually transmitted diseases but also reflected the overall social instability that plagued France after the collapse of the Second Empire and the country's humiliating defeat in the Franco-Prussian War.

———————

*In the haste of our electric life, which accelerates day by day,*
*written thought becomes too slow a process of dissemination.*
*Because of that the press tends to become a tool of information rather*
*than of discussion. The bicycle, the automobile, all modern*
*inventions overtake the taste of readers—bookstores and writers know it well.*
*To the citizens of the xxth century who run and fly, it will be necessary*
*to speak in a language as rapid as electricity. And what language is*
*faster than drawing, especially, drawing in color which attracts the eye….*

**LOUIS MORIN, 1902**

———————

By the mid 1880s the expression "la femme honnête et l'autre" (The Honest Woman and the Other) became for the Incohérents, a group of avant-garde, proto-dada artists and writers, a facetious means of referring to the ambiguity that existed between the outward appearance of a respectable married member of the bourgeoisie and that of a clandestine prostitute; yet it also served as a humorous metaphor for the perceived deceptiveness and hypocrisy of bourgeois society.[56] In fact, the phrase "la femme honnête et l'autre" was simply shorthand for the literary *esquisse naturaliste* or "naturalist sketch," which was initiated by the Goncourts, Emile Zola, and Joris-Karl Huysmans in the previous decade and which investigates *les moeurs parisiens* with specific emphasis on prostitution.

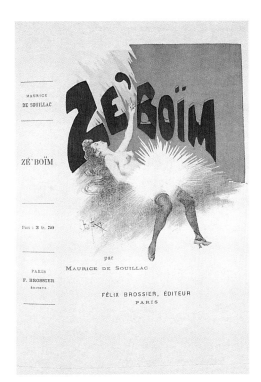

In 1884 the publishing house of Ed. Monnier, in particular, combined the talents of little known artists and writers to produce photomechanically illustrated, sexually suggestive stories inspired by the themes of contemporary prostitution in the naturalist novels of Huysmans, Edmond de Goncourt, and Zola.[57] The titillating, illustrated Gothic novel or *roman de moeurs* of the 1880s and 1890s thus evolved in the name of art under the pretext of naturalism: an investigation of *les moeurs parisiens*. An important radical innovation of these forerunners of today's popular romance paperbacks was the introduction of splashy, slightly risqué, illustrated covers, photomechanically produced and stencil-colored; prior to this, novels — even illustrated ones — were often bound in plain wrappers with text but usually without a cover image. By 1886, many of Monnier's illustrated *romans de moeurs* were so popular that they were already out of print and considered rare collectors' items.[58] By 1890 ever more daring books appeared on the market, bearing such exotic titles as *Femmes honnêtes*, by the Rosicrucian J. Peladan; the explosive *Zé' Boïm* (fig. 18), *La Grande Névrose, Masques modernes, Don Juan, Le Grappin, En Marge de la censure*; the very suggestive *La Sauce*; and the audacious series *Les Voluptueuses* by Jean Larocque, which included *Fausta*, *Daphné*, *Isey*, and *Odile*.

In 1888, as the *roman de moeurs* was reaching its peak of popularity with lurid covers illustrated by realistic drawings, Armand Silvestre inaugurated his annual *Le Nu au salon* on the pretext of promoting the classical beauty of the female nude.[59] For more than fifteen years Silvestre's publication discussed and illustrated his favorite nude paintings and sculpture exhibited at the Salon (fig. 19). Many of his images, however, relate more closely to the nudes depicted on the covers of the *romans de moeurs* than to the classical ideal. Whatever the pretext — naturalism or idealism — by 1890 a new industry of printed erotica or soft pornography had fully emerged before the law came crashing down on these early daring efforts of the publishing world.

The first *roman de moeurs* to be censored for cover and text was *Zé' Boïm*, a novel of lesbian love by a woman writing as Maurice de Souillac.[60] Unlike Verlaine's *Parallèlement*, Souillac's text is not shrouded in allegory; Madeleine, the heroine, is no Greek nymph but clearly a contemporary woman expressing taboo thoughts. First published in 1887, without an illustrated cover, the book escaped the notice of official censors. But two years later, the publisher Félix Brossier commissioned José Roy to design a cover for a new edition. Roy's startling image, in which the vulgar middle-finger gesture of Madeleine — dressed wantonly in black stockings and high heels — leaves little doubt that a masturbatory act is in progress, went beyond suggestion and ultimately attracted the attention of the censors.

———————

*For lovers of nudes, there is a particular selection of academic paintings.*
*Photographs represent nymphs, Bacchants, Ledas and swans more or less impassioned,*
*Danaes, Venuses or Sirens, form a virtual tapestry of nudity, a spectacle*
*which excites the old and troubles the alarmed and susceptible senses of youth....*
*These young woman pose at the photographer's in short skirts pulled up*
*in a vulgar and equivocal gesture, in tacky costumes, in a Grévin negligee,*
*as indecent as possible, in a nightdress if necessary.*

*Excited by all this nudity which is cast in bright streetlights, the*
*public presses against the window displays, where the burst of gas light*
*softens the silky tints of the photographs, and foreigners,*
*surprised and troubled by this exhibition of barely clothed forms,*
*consider Paris the number one market of women in Europe....*

**GEORGES SERVIÈRES, 1883**

———————

In the spring of 1890 the Court of Assizes of the Seine investigated *Zé' Boïm* as well as four other works published by Brossier — *Odile, Fausta, Daphné,* and *Viviane* — all with cover illustrations by Roy. Ironically, Roy was not penalized, but the publisher and the authors were sent to prison and fined: Brossier for fifteen days and one thousand francs, Lefébvre (alias Souillac) for one month and one hundred francs, Larocque for three months and one hundred francs. This harsh treatment served to temper, at least for the next decade, the visual presentation of erotic literature.

Eighteen ninety was also the year that the young writer Victor Joze integrated the *roman de moeurs* within the avant-garde world of painting. With *Lever de rideau*, a group of erotic short stories, Joze announced a series of novels under the general title of *La Ménagerie sociale*.[61] His intent was to relate all the human

comedies and dramas in which he, himself, was a participant. On the title page, Joze announces that the second in the series, *L'Homme à femmes, roman parisien* (1890; fig. 20), with cover illustration by Seurat, is under press and that the third, *Reine de joie, moeurs du demi-monde* (1892), with cover illustration by Pierre Bonnard (no. 82) and poster by Lautrec, is in preparation. The fourth in the series, *Babylone d'Allemagne, moeurs berlinoises* (1894; fig. 21), with cover and poster by Lautrec, is not yet announced. All in all Joze's series greatly elevated the artistic quality of the illustrated cover for the *roman de moeurs* by introducing Seurat, Bonnard, and Lautrec to the medium, which, like print and postermaking, became a rich and innovative art form during the 1890s. For Seurat, who died in 1891, it would be his only venture into the field of book illustration, but for Bonnard and Lautrec it was an important extension of their rapidly emerging and multifaceted involvement in printed images. While both these artists are naturalists in the sense that their art deals with modern life, à la Baudelaire and Manet, their designs for Joze's books are exceptional because they represent a modernist style that moves beyond the photographic-like rendition of gratuitous nudity typical of the *roman de moeurs*. Unlike earlier covers in which the purpose of the image is to titillate, the cover designs by Seurat, Bonnard, and Lautrec not only refer to Joze's story line but also reflect the autobiographical nature of his text. This is made evident in Richard Thomson's 1985 analysis of Seurat's cover for *L'Homme à femmes*, in which he states:

Seurat's cover…identified the central characters of Joze's novel, representing them as types: Charles de Montfort, naturalist writer, "the ladies' man" himself; the shop-girl Louise Berton whom he seduces and disastrously takes up; the anonymous streetwalker with whom he is first unfaithful to Louise; the lewd cafe-concert singer Alice Lamy, his partner in a passionate affair; and the baronne de Scheidlein, wife of the man who keeps Alice and who becomes de Monfort's long-term mistress.[62]

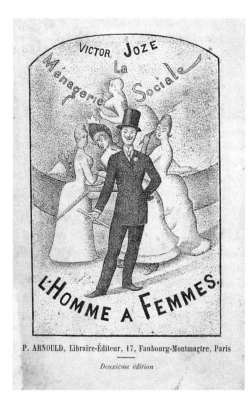

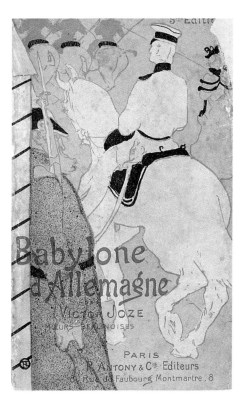

The story is obviously complicated with amorous entanglements in which the "Honest Woman and the Other" is an important subtheme. As Thomson points out, some of the characters are from life, such as the realist writers Paul Alexis and Oscar Méténier, while others such as the symbolist Dujardin are only thinly disguised. Most importantly Thomson convincingly demonstrates that the second main character — an impressionist painter named Georges Legrand — is in fact Georges Seurat.[63]

With this in mind I think the case can also be made that the book's main protagonist, the fictional naturalist writer Charles de Montfort — "the ladies' man" depicted by Seurat on the cover of *L'Homme à femmes* — is a stand-in for Joze himself. Joze most likely is also the dandy in *Reine de joie* depicted by Bonnard (no. 82) and Toulouse-Lautrec on the book's cover and poster, respectively.[64] Joze also proclaims in his introduction a commitment to scientific naturalism à la Honoré de Balzac, Gustave Flaubert, the Goncourts, and Zola. Joze's form of naturalism is, thus, autobiographical in the same manner as that of his avant-garde painter counterparts, whose depictions of "Modern Life" concentrate on their Paris surroundings and literary-artistic circle of friends.[65]

Beginning in 1893 Joze became the editor of the slightly salacious journal *Fin-de-siècle*, which already had promoted such *romans de moeurs* as Larocque's censored *Les Voluptueuses* series and Joze's own *Reine de joie*. *Fin-de-siècle* also published such books as *Les Prostituées à Paris: notes et souvenirs d'un ancien agent des moeurs*, an official parallel to the then-current, popular studies on prostitution such as *L'Amour à Paris*, and *Paris impur*.[66] As editor of the journal, and as a sort of pre-twentieth-century Hugh Hefner, Joze pressed strenuously for "la liberté de l'art" and used the journal as a forum to strike out against censors such as Bérenger and his League against Licentiousness in the Streets.

Until the mid-1890s, most of the *romans de moeurs* and related genre of books were illustrated with photo-relief prints after drawings. The exceptions are Silvestre's *Le Nu au salon*, in which paintings and sculpture are reproduced photolithographically (collotype process) after photographs of the originals, and Bonnard's and Lautrec's covers for Joze's *Reine de joie* and *Babylone d'Allemagne*, which are traditional color lithographs. Both artists, of course, had produced color lithographic posters in 1891; now their first book covers made the following year continued the practice established by Chéret in the 1880s of exploring the numerous exciting options offered by color lithography in the design of image and text.

Illegal pornographic photographs had been available to a very few, at a high price since the 1840s, but in the mid 1890s, with improved photomechanical printing technology, the general public could easily and inexpensively enjoy or abhor the relatively innocent but suggestive images of live models found in picture books such as *Le Panorama, Paris la nuit* of 1898 and on the cover of salacious novels such as *Chez Satan* (fig. 22).[67] By the turn of the century, publishers had devised the perfect way of filling the need of an ever-increasing market for soft-core pornography while dodging the censor. It was under the guise of art and the pretext of studying classical beauty that so-called instructional books for artists too poor to hire models emerged. These books reproduced photographs of nude models — male, female, and children,

20

Georges Seurat, cover for Victor Joze's *L'Homme à femmes*, 1890, photo-relief. Jane Voorhees Zimmerli Art Museum, Rutgers, The State University of New Jersey

21

Henri de Toulouse-Lautrec, cover for Victor Joze's *Babylone d'Allemagne*, 1894, color lithograph. Jane Voorhees Zimmerli Art Museum, Rutgers, The State University of New Jersey

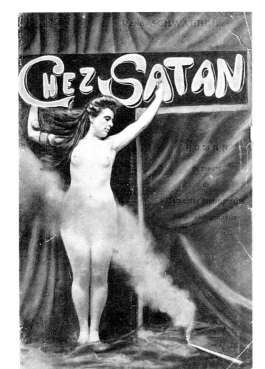

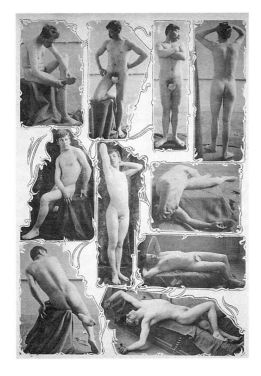

but mostly all female — affecting various academic poses meant to represent classical allegorical figures or elaborate tableaux vivants (fig. 23). Books like *Le Nu anecdotique* and its various incarnations, such as *Le Nu dans la fable*, *dans la bible*, etc., and serial publications such as *Mes modeles*, allowed the male bourgeois a respectable rationale for observing female nudity.[68] This fact was not overlooked by polemicists of the day. In his book *…la beauté s'en va…* of 1905, Paul Diffloth laments:

the nude is widespread and has been powerfully aided in its diffusion by photography. Complaisant models recruited from god knows where make us pass without transition from the museum to the secret museum, from the nude of the Salon to the nude of the boudoir and elsewhere. We would like to forget all of the publications — unhappily too numerous — in which the concern for art is only a pretext for the presentation of offensive nudity.[69]

Diffloth regrets the sale of all such titillating publications, including that of Silvestre's *Le Nu au salon*, because, as he said, "they appeal to the esthetics of an excited school boy."[70]

Similarly, Lucien Descave stated that "our *romans de moeurs parisiennes* present Parisian morality as falsely as the albums which are produced in photography studios."[71] In its own defense, *Le Nu anecdotique* proposed that a "conseil de l'ordre" for artists be established, because existing laws were incapable of defining pornography.[72] This council of order — a kind of National Endowment for the Arts — would comprise members of the Society of French Artists and the National Society of Fine Arts so that such judgments could be handed down by artists' peers. Yet it was difficult to fully accept the argument — that these books were about art and not sex — when such other books as Victor Leca's two guides to Paris prostitutes — *Pour s'amuser* (fig. 24) of 1905 and *Dames d'amour* of about 1906 — were illustrated with the very same kind of nude photography.[73] Indeed, it was evident by all accounts that the distinction

between the Honest Woman and the Other, or in this case the Honest Model or the Other, was indistinguishable. At the beginning of the twentieth century this only increased male anxiety over sexually transmitted diseases and reinforced the gravity of the ambiguity between the Honest Woman and the Other. This ambiguity was medically reinforced in the 1901 publication *La Prostitution contemporaine à Paris, en Province et en Algérie*, which states that there exists no physical difference between the sexual parts of a married woman and those of a prostitute, no matter the level of sexual activity.[74]

Undoubtedly, of all the many nude photo publications at the beginning of the century, *Le Nu esthétique*, which came out once a month from October 1902 through September 1907, had the greatest authority.[75] Directed by the painter Jean-Léon Gérôme and dedicated to his distinguished colleague William-Adolphe Bouguereau, each issue described in depth various attributes of the ideal academic nude. The presentation of the folio size, loose-leaf studies evolved over the publication's four-year existence in its degree of brazenness, from chaste poses by models in fig leaves to almost wanton acrobatics (fig. 25). One complaint by subscribers was that many of the models had physical faults; Gérôme answered that while it was difficult to find individuals who were physically perfect in all respects, each was an example of perfection of one part of the body.[76] Diffloth argued that the photographs dedicated to the female nude were for the most part of a flagrant imperfection. He also criticized what he called "the ultra-modern schools of art," which under the pretext of realism or impressionism promoted the triumph of ugliness.[77] From Diffloth's nationalistic view of beauty, he stated that "the esthetic patrimony of a nation is as precious to preserve as its past and its traditions....A race is becoming decadent when it has lost its physical ideal."[78] Diffloth recommended establishing a Society for the Protection of French Beauty just as there was a Society for the Protection of the French Landscape. He also advocated choosing from the various classes of French society "ethnic-pure types" and placing these people of pure race and ethnic superiority into a favorable social condition, thus promoting procreation with the aim of repopulating France with physically ideal, hygienically and morally pure individuals.[79]

In 1904 a major and highly controversial victory was won by opponents of the police system of regulated prostitution. The Régime de moeurs, which con-

24

CE VOLUME CONTIENT DES PRIMES

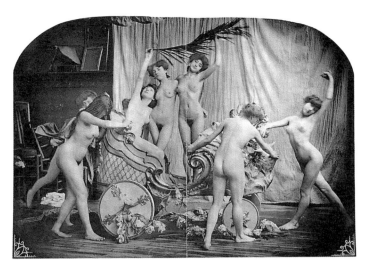

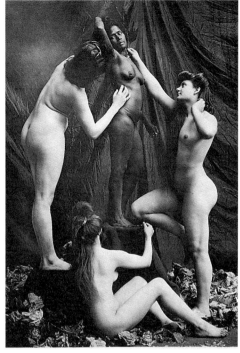

25
—
26
27

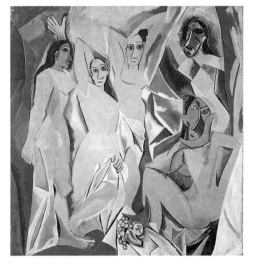

trolled registered prostitutes, was essentially disbanded after more than fifty years of often overzealous abridgment of the legal rights of regulated prostitutes and of abuses of power in which "honest" women were often mistaken by the police as "the other," and thus subject to temporary imprisonment and/or humiliating physical inspection.[80] Within two years Picasso, who in 1902 had contracted some form of venereal disease, was preoccupied with the completion of *Les Demoiselles d'Avignon*, depicting prostitutes in a brothel (fig. 26). Picasso's goal was to make a major innovative artistic statement about modern life in the tradition of Manet and Seurat and with references to the art of Cézanne. By creating a new vocabulary of pictorial representation based on pre-classical Western art and on African sculpture, Picasso shattered all existing concepts of ideal and natural beauty and challenged theories of ethnic purity such as those advanced by Diffloth. It is intriguing to compare Picasso's 1907 painting of *Les Demoiselles d'Avignon* with a somewhat similar photographic image from *Le Nu esthétique* of 1905 (fig. 27). While Picasso's cubist style desexualized the female nude and took his art from the realm of the sensual to the intellectual, his painting still maintains elemental references to academic conventions — such as the poses and backdrop. In addition, within the context of the 1904 deregulation in which all prostitutes were now potentially clandestine, the subject of Picasso's painting was essentially anachronistic or, at the very least, nostalgic. Nevertheless, Picasso's new aesthetics inaugurated the twentieth century by clearly disassociating modernist art from the many depictions of eroticized naturalistic nudes that catered to the male bourgeoisie and which dominated not only the annual Salons, but also contemporary photographic publications and the printed covers of popular *romans de moeurs*.

During the 1890s, the artist's traditional role in defining "the look" of printed images emerged intact. However, as photo-printing processes and especially photo-color separation processes became more sophisticated and economical in the first decade of the twentieth century, the close visual parallels found in the 1890s between work created by traditional printmaking processes and by the mass media waned. The aesthetics of fauvism and cubism, for instance, never permeated to any great extent the mass media of its time. It was not until after the Russian Revolution of 1917 that the relationship between avant-garde aesthetics and printing technology — this time led by the photomontages of Gustav Klutsis, El Lissitzky, and Alexander Rodchenko — became nearly as symbiotic as it was a generation earlier when the primary vehicle of progressive Paris art was the printed image.

———————

1 Unpublished letter from Edouard Vuillard to Marc Mouclier, dated "Dimanche 19 Avril" [1888], in the possession of Arsène and Anne Bonafous-Murat, Paris. All translations by author, unless otherwise noted.

2 For an in-depth history of the French Salon during the Third Republic, see Patricia Mainardi, *The End of the Salon: Art and the State in the Early Third Republic* (Cambridge, 1993).

3 Phillip Dennis Cate and Sinclair Hamilton Hitchings, *The Color Revolution: Color Lithography in France 1890–1900* [exh. cat., Rutgers University Art Gallery, New Brunswick] (Santa Barbara and Salt Lake City, 1978), 1.

4 Aaron Scharf, *Art and Photography* (Baltimore, 1974), 161.

5 For a full history and discussion of La Société des aquafortistes, see Janine Bailly-Herzberg, *L'Eau-forte de peintre au dix-neuvième siècle, La Société des aquafortistes* (Paris, 1972).

6 Michel Melot, *The Impressionist Print* (New Haven, 1996), 61. *Le Ballon*, Manet's first lithograph, was created in 1862 at the instigation of Alfred Cadart for the never-realized multi-artist *Album lithographique*.

7 For Manet's prints, see Jay McKean Fisher, *The Prints of Edouard Manet* [exh. cat., International Exhibitions Foundation] (Washington, 1985).

8 Bailly-Herzberg 1972, 259.

9 Philippe Burty, "La Belle Epreuve," preface to Cadart's album *L'Eau-Forte en 1875*.

10 Melot 1996, 54.

11 Phillip Dennis Cate, "Printing in France, 1850–1900: The Artist and New Technologies," *The Gazette of the Grolier Club* 28–29 (June–December 1978), 61. In this process a photographic negative of the drawing would be placed over a photosensitized zinc plate and exposed to light, permitting the positive image of the drawing to harden and adhere to the plate; through the chemical action of acid the drawing would be placed in relief on the zinc plate ready to be printed from a typographical press (letterpress) simultaneously and, thus, inexpensively with text.

12 For the full wording of the 29 July 1881 freedom of the press laws and amendments through 1895, see Henri Avenel, *Les Mondes des journaux en 1895* (Paris, 1895), 34–56. "…la loi de 1881 a fait table rase de toutes les mesures préventives de l'ancienne législation. Elle se borne à réglementer, sans la restreindre, la liberté d'exprimer et de communiquer la pensée par le livre, le journal, l'affiche, ou tout autre instrument de publication." Avenel 1895, 3.

13 Cate 1978, 63–64.

14 Marty acquired from Bracquemond and Lepère the rights to the title *L'Estampe originale*. Phillip Dennis Cate and Patricia Eckert Boyer, *L'Estampe originale: Artistic Printmaking in France, 1893–95* [exh. cat., Van Gogh Museum] (Amsterdam, 1991), 30.

15 Melot 1996, 89.

16 Philippe Burty, *Exposition des peintres-graveurs* (Paris, 1889), 8. The second Exposition des peintres-graveurs took place in March 1890. By 1891, the Société des peintres-graveurs français was established and held five more exhibitions through 1900, but restricted participants to French-born artists. Thus, Camille Pissarro and Mary Cassatt, who were included in the first two exhibitions, were excluded from those after 1890.

17 For a discussion of these publications see exh. cat. New Brunswick 1978.

18 For a history of this publication, see exh. cat. Amsterdam 1991.

19 Patricia Eckert Boyer, *Artists and the Avant-Garde Theater in Paris, 1887–1900* [exh. cat., National Gallery of Art] (Washington, 1998).

20 Exh. cat. New Brunswick 1978, 19–20.

21 Exh. cat. New Brunswick 1978, 79.

22 Henri Bouchot, *La Lithographie* (Paris, 1895), 208.

23 I wish to thank Judith Brodie, associate curator of prints and drawings at the National Gallery of Art, for this analysis of the Jackson collection's deluxe edition of *L'Epreuve*. See also Jean-Pierre Seguin, *Maurice Dumont, 1869–1899: Peintre-graveur, illustrateur, poète et éditeur de L'Epreuve* [exh. cat., Bibliothèque historique de la ville de Paris] (Paris, 1991), and

Cydna B. Mercer, "A Study of *L'Epreuve, Journal-Album d'art, 1894–1895*," master's thesis, University of Michigan, 1981.

**24** *Lasting Impressions: Lithography as Art*, ed. Pat Gilmour (Canberra, 1988), 160–163; Gilmour's essay, "Cher Monsieur Clot…Auguste Clot and His Role as a Colour Lithographer," offers an in-depth analysis of Clot's contributions to color lithography of the 1890s and of his collaboration with artists involved with Vollard's albums of 1896 and 1897.

**25** Patricia Eckert Boyer, "The Artist as Illustrator in Fin-de-Siècle Paris," in *The Graphic Arts and French Society, 1871–1914*, ed. Phillip Dennis Cate (New Brunswick, 1988), 123.

**26** For Chéret's influence on the art of Seurat, see Ségolène Le Men, *Seurat et Chéret, le peintre, le cirque et l'affiche* (Paris, 1994).

**27** Phillip Dennis Cate, "Forums of the Absurd: Three Avant-Garde Lithographic Publications at the Turn of the Last Century," *The Tamarind Papers* 16 (1996), 27–35.

**28** *L'Art moderne* 1 (1 December 1882), 2.

**29** *La Revue indépendante* (November 1886), 7.

**30** *La Plume* (15 April 1889), 1.

**31** Pierre Paul Royer-Collard, *La Revue blanche* (12 March 1891), 1.

**32** For a history of *La Plume*, see exh. cat. New Brunswick 1978, 30–31.

**33** For information on *Les Maîtres de l'affiche* and reproductions of posters in the albums, see *Masters of the Poster, 1896–1900* (New York, 1977).

**34** Léon Maillard, *Les Menus et programmes illustrés* (Paris, 1898).

**35** The Jane Voorhees Zimmerli Art Museum at Rutgers University owns, among other rare examples of this type, two editions of the anti-Dreyfus journal *P'sst* (1898–1899), illustrated by Caran d'Ache and Jean-Louis Forain: the trade edition and a deluxe edition on imperial japan paper signed and dedicated in pen and ink by Forain.

**36** Exh. cat. New Brunswick 1978, 28–29.

**37** Colta Ives, *Pierre Bonnard: The Graphic Art* (New York, 1990), 115–116.

**38** For a description of *L'Ymagier*, see Stephen H. Goddard, *Ubu's Almanac: Alfred Jarry and The Graphic Arts* (Lawrence, 1998), 2–8.

**39** *Le Livre d'art* 1 (April 1896), 2.

**40** Alfred Jarry, "Ubu Roi ou les Polonais," *Le Livre d'art* 2 (May 1896), 25–33; *Le Livre d'art* 3 (25 May–25 June 1896), 62–72.

**41** Ernest de Crauzat, *L'Oeuvre gravé et lithographié de Steinlen* (Paris, 1913).

**42** Phillip Dennis Cate and Susan Gill, *Théophile-Alexandre Steinlen* [exh. cat., Rutgers University Art Gallery, New Brunswick] (Salt Lake City, 1982), 128–137.

**43** Gordon N. Ray, *The Art of the French Illustrated Book, 1700 to 1914* (New York, 1982), vol. 2.

**44** Richard S. Field, "Exteriors and Interiors, Vallotton's Printed Oeuvre," in *Félix Vallotton*, ed. Sasha M. Newman [exh. cat., Yale University Art Gallery] (New Haven, 1991), 68, n. 25. I agree with Field's argument that these relief-printed images were produced by means of a photo process. He refers to the prints as "Gillo-types," a term, however, that I do not believe was used at the time to refer to photo-relief prints produced by Charles Gillot's process. Field's essay reproduces black and white preliminary ink drawings for Vallotton's plates in *Rassemblements* and states that there are, however, no known drawings which are identical to the printed images and, thus, which would have been the basis for the photographic negatives used in the production of the plates. This suggests that the printer considered the drawings only as a means to an end and discarded them at the completion of the task. While this may be the case, there are many drawings that still exist today by, for instance, Steinlen, Toulouse-Lautrec, and Jacques Villon that were created for photo reproduction in journals or books. It is curious that Vallotton, himself, would not have kept the original drawings as he did for the preliminary studies. It is a mystery still to be solved.

**45** When examined under magnification, the surface of the printed lines of the images for these two publications has the typical relief-printed characteristic in which ink is pushed to the periphery, forming ridges of densely accumulated ink rather than the normally even application of ink of the planographic, that is, lithographic, process. In the lithographic process, once the drawing is made upon the stone, the latter is slightly etched overall to rid the surface of accidents and to fortify the surface for inking and printing. Indeed, since *Petit solfège* and *Almanach* were printed in relatively large editions, the stones were etched more deeply than usual and the images placed in relief to give extra durability for the printing process. This was a normal practice at the time and is described by Frédéric Hesse in *La Chromolithographie et la photochromolithographie* (Paris, 1897), 87–89. I wish to thank Arsène Bonafous-Murat for bringing this publication to my attention.

**46** Sasha M. Newman, "Nudes and Landscapes," in *Pierre Bonnard: The Graphic Art*, ed. Colta Ives [exh. cat., The Metropolitan Museum of Art] (New York, 1989), 166.

**47** Sarah Bernhardt, *Dans les nuages* (Paris, 1878), with black and white photo-relief illustrations, some with an added tint plate; Edouard de Beaumont, *Un Drame dans une carafe* (Paris, 1882), with photo-relief black and white illustrations by Louis Leloir; Octave Uzanne, *L'Ombrelle, le gant, le manchon* (Paris, 1883), with photo-relief and photo-engraved illustrations in black and white and in color by Paul Avril; Georges Lorin, *Paris rose* (Paris, 1884), with black and white photo-relief illustrations by the author.

**48** Cate 1996, 34.

**49** Ray 1982, 498.

**50** Avenel 1895, 6.

**51** From the judgment of the correctional tribunal of Paris, 11 June 1884, against Mr. and Mrs. Léo Taxil, quoted in *Le Bibliophile* (Paris, 1884), 118.

**52** *Le Bibliophile* 1884, 118.

**53** Louis Morin, "Réquisitoire de Louis Morin contre Bérenger," *La Vie en rose* 40 (20 July 1902), unpaginated.

**54** Mary Mathews Gedo proposes that medical evidence indicates today that although Manet and his peers assumed that Manet's illness was neurosyphilis, he more likely suffered and died from multiple sclerosis. Mary Mathews Gedo, *Looking at Art from the Inside Out* (Cambridge, 1994), 7–8.

**55** For such statistics see Parent-Duchatelet and Urbain Ricard, *La Prostitution contemporaine à Paris, en Province et en Algérie* (Paris, 1901).

**56** *The Spirit of Montmartre: Cabarets, Humor and the Avant-garde, 1875–1905*, ed. Phillip Dennis Cate and Mary Shaw [exh. cat., Jane Voorhees Zimmerli Art Museum, New Brunswick] (New Brunswick, 1996), 40–53.

**57** Joris-Karl Huysmans' *Marthe*, 1876; Edmond de Goncourt's *La Fille Elisa*, 1877; Emile Zola's *Nana*, 1880.

**58** Ed. Monnier, de Brunhoff et cie. *Editeurs, Catalogue illustré* (Paris, n.d. [1886]).

**59** Armand Silvestre, *Le Nu au salon* (Paris, 1888). On page six of his preface Silvestre declares that "…ce spectacle [the classical nude] est le plus admirable du monde et je ne comprends vraiment pas pourquoi les artistes contemporains se préoccupent de le moderniser. Moderne! Mais il l'est, l'a toujours été et le sera éternellement." The Salon paintings reproduced in this publication were created by the planographic, photogelatin printing process called collotype.

**60** The history of *Zé' Boïm* as presented here may be found in *L'Arrivée des Marsiens* (no. 143), the 1995 sale catalogue of Paris book dealer Pierre Saunier.

**61** Victor Joze, *Lever de rideau, esquisses naturalistes* (Paris, 1890), photo-relief illustration by Myrton; other works in Joze's ménagerie sociale series are *L'Homme à femmes, roman parisien* (Paris, 1890), photo-relief cover illustration by Georges Seurat; *Reine de joie, moeurs du demi-monde* (1892), lithographic cover illustration by Pierre Bonnard; *Babylone d'Allemagne, moeurs berlinoises* (Paris, 1894), lithographic cover illustration by Henri de Toulouse-Lautrec; *Paris-Gomorrhe, moeurs du jour* (Paris, 1894), photo-relief cover illustration after Jack Abeillé; *Les Soeurs Vachette* (Paris, 1896), photo-relief illustration after G. Made; *La Tribu d'Isidore* (Paris, 1897), lithographic cover by Henri de Toulouse-Lautrec; *La Cantharide* (Paris, 1897), photo-relief cover illustration after Louis Malatesta.

**62** Richard Thomson, *Seurat* (Oxford, 1985), 214.

**63** Thomson 1985, 214.

**64** For a discussion on the anti-Semitic implications of Joze's *La Reine de joie*, see Gale Murray, "Toulouse-Lautrec's Illustrations for Victor Joze and Georges Clémenceau and Their Relationship to French Anti-Semitism of the 1890's," in *The Jew in the Text: Modernity and the Construction of Identity*, ed. Linda Nochlin and Tamar Garb (London, 1995), 58–60.

**65** Phillip Dennis Cate and Patricia Eckert Boyer, *The Circle of Toulouse-Lautrec* [exh. cat., Jane Voorhees Zimmerli Art Museum, New Brunswick] (New Brunswick, 1985).

**66** J. Davray, *L'Amour à Paris* (Paris, 1890) and Charles Virmaître, *Paris impur* (Paris, 1889). L. Vallet created the photo-relief printed cover illustrations for both books.

**67** *Le Panorama, Paris la nuit* (Paris, n.d. [1898]); René Schwaeblé, *Chez Satan, roman de moeurs de satanistes contemporains* (Paris, n.d. [c. 1898]).

**68** *Le Nu anecdotique* (Paris, n.d. [c. 1905]). "Ouvrage documentaire à l'usage des artistes illustré par le nu photographique intégral." *Le Nu anecdotique* is one in the series of small publications that fall under the general heading of "Academia" and which include *Le Nu dans la fable, Le Nu dans la Bible, Le Nu paien, Le Nu symbolique*, etc.

**69** Paul Diffloth, *…la Beauté s'en va…des méthodes propres à la rénovation de la beauté féminine* (Paris, 1905), 305, 304.

**70** Diffloth 1905, 305.

**71** Lucien Descave as quoted in Diffloth 1905, 306.

**72** *Le Nu anecdotique*, 13–14.

**73** Victor Leca, *Pour s'amuser* (Paris, 1905) and *Dames d'amours* (Paris, n.d. [c. 1906]).

**74** O. Commenge, *La Prostitution clandestine à Paris* (Paris, 1904), 96.

**75** See Hélène Pinet, "De L'Etude d'après nature au nu esthétique," in *L'Art du nu au XIXe siècle* [exh. cat., Bibliothèque nationale] (Paris, 1997), 30–37.

**76** *Le Nu esthétique* 37 (October 1905), 1.

**77** Diffloth 1905, 303.

**78** Diffloth 1905, 315–316.

**79** Diffloth 1905, 316.

**80** Jill Harsin, *Policing Prostitution in Nineteenth-Century Paris* (Princeton, 1885), 342–343.

## Sources of quoted material

p. 14: *La Lithographie en couleurs* (Paris, 1898), 5; p. 16: *L'Oeuvre et l'image* 1 (November 1900), 7; p. 19: prospectus for *L'Estampe originale catalogue trimestriel pour juillet-septembre* (Paris, 1894), 6; p. 24: *Le Livre & l'image* 1 (March–July 1893), 2; p. 26: preface to the catalogue of the 1891 exhibition of Peintres-Graveurs, and preface to *L'Estampe originale*, 1893; p. 29: *Les Affiches illustrées* (Paris, 1886), viii; p. 33: *Nos Amis, les livres* (Paris, 1886), 117; p. 35: "Sus aux estampes," *L'Art moderne* (January 1883), 2; p. 37: "Réquisitoire de Louis Morin contre Bérenger," *La Vie en rose* 40 (20 July 1902); p. 39: "Marche de femmes," *L'Art moderne* (February 1883), 4, 6

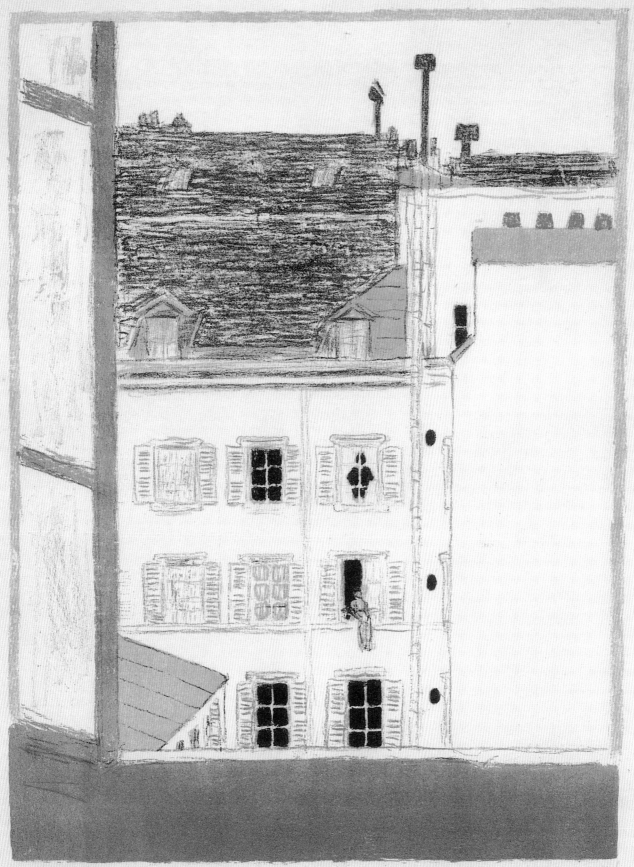

*Richard Thomson*

# **Styling** the City

OBSERVATION AND PERCEPTION IN PRINT ALBUMS OF THE 1890S

The 1890s witnessed an extraordinary flowering of the artist's print in France, and with it many print albums appeared on the art market. These albums varied in format and identity. Some, like the celebrated *L'Estampe originale*, offered work by a number of artists and prints of different style, size, and subject.[1] Others concentrated on a single category of print, such as *Les Maîtres de l'affiche*, which specialized in reduced versions of posters,[2] while others were the work of individual artists, perhaps in a particular print medium and focusing on a specific subject. Print dealers and collectors handled these albums in different ways. Albums might be sold exclusively in their entirety or as single prints; they might be kept discreetly in a connoisseur's portfolio, or framed and displayed in the home. Lively interest in the artist's print created a distinct subculture in the Paris art world and a microeconomy on the market, a point recognized in the critical literature that grew up around the medium at the fin de siècle. As André Mellerio wrote in 1898, "in the present period of fermentation the print is flourishing, is evolving, and is being produced abundantly, and the color print is playing a striking role."[3]

The reasons for the success of the artist's print in the 1890s, and with it the print album, are varied and complex. From the artist's point of view, the rapid development of the once essentially reproductive processes of color lithography and color etching into artistic media, as well as the rediscovery of time-honored techniques such as woodcut, provided a rich repertoire of challenging opportunities.[4] Because the print could be produced in substantial editions, its unit cost was generally lower than that of a painting (though a complex print could take just as long to make

OPPOSITE

**Pierre Bonnard,** Maison dans la cour, **1895/1896, color lithograph. Virginia and Ira Jackson Collection, Promised Gift to the National Gallery of Art (no. 67)**

49

as an oil). The artist thus had an excellent chance of his print being widely disseminated and attracting attention, while the collector of low or middle income could purchase original, innovative work for a fraction of the price of a canvas.

Other commercial and cultural pressures were also in play. To sell in an increasingly competitive mass market, products needed striking publicity. This was provided by the new mass medium of the color poster, which gave even young artists the opportunity to establish national reputations. And in the elite sphere of collectors and aesthetes, the burgeoning culture of art nouveau, with its emphasis on the fusion of exquisite design with the everyday, requested artists apply their skills to stylish designs for fans, screens, or decorative panels, for all of which the varied print media were well suited. Finally, the 1890s was a decade of prosperity for France, though also one of enormous anxiety. The rise of socialism fomented middle-class fears of the mob; unstable politics became polarized in the vicious divisions of the Dreyfus Affair; a declining birth rate and worries about public health indicated a weakening France in contrast to its vigorous rival Germany; and the fast pace of urban life was feared to be pitching Parisians into a state of permanent neurotic fatigue.[5] The print — its graphic range quickly adaptable to the nuances of the now; its scale, immediacy, and availability making it a close cousin to caricature — was the ideal medium for conveying the febrile modernity of fin-de-siècle France.

Pierre Bonnard's *Quelques aspects de la vie de Paris*, thirteen color lithographs published by the art dealer and print editor Ambroise Vollard in 1899, was one of the most remarkable albums of the nineties. The qualities and defining characteristics of this lively and expressive cluster of prints become evident by comparing it with the print albums made by close colleagues of Bonnard's during the same half-decade: Henri de Toulouse-Lautrec's *Elles* (1896; nos. 51–55), Félix Vallotton's *Intimités* (c. 1897), and Edouard Vuillard's *Paysages et intérieurs* (1899; nos. 68–70). Contrast and comparison serves as a means of exploring the frontiers within which Bonnard worked and which he sought to stretch. Three questions come to the fore: To what extent are these albums resolved and unified projects, or, rather, is there something improvised and ad hoc about them? How might we place these albums in the stylistic dialogue between symbolism and naturalism at this period? Last, is the imagery of the albums innovative or typical? These avenues of inquiry necessarily interweave.

A print album appears to be a homogenous work, issued as a unit. The nature of the color lithographic medium — which involves slow and methodical labor — suggests concentration on process, and so on focused, unified work. Bonnard's *Quelques aspects* (nos. 59–67) is quite unified in style, technique, and color, but not entirely so. In general the drawing is not precise; Bonnard favored witty, simplified shapes, employing edgy, approximate handling, and opted for sandy, ocher, and russet tones. This degree of uniformity is significant, because the album was put together over a period of several years. Commissioned by Vollard in 1895, it was not published until four years later.[6] Although Bonnard managed to sustain a level of consistency, the fact that the prints accrued for the album were made over an extended period of time inevitably introduced a degree of stylistic variety. *Maison dans la cour* (no. 67), for instance, seems to have been one of the earliest prints, and was derived from a pre-

liminary study of the motif — a view from Bonnard's studio — made in pastel about 1895–1896.[7] In the color print Bonnard smoothed down the gestural draftsmanship of the pastel, defining outline with a crisp tidiness reminiscent of a Japanese woodcut. However, by the time he came to produce the cover for the album (no. 60), an impression of which is dated 1898, he rendered the whole image in a nervous flurry of strokes. Such contrasts of style added variety to the album, to be sure, but also registered a shift in Bonnard's aesthetic.

Lautrec's *Elles* and Vuillard's *Paysages et intérieurs* — two very different albums — both contain prints that are very different in style from the others. Each artist may have been trying to show his range of effects, or perhaps the albums were produced piecemeal, in a casual rather than a planned compilation of images. In Lautrec's case, for example, it has been suggested that some of the motifs, if actually printed in 1896 with the *Elles* album in mind, were based on compositions drafted some years earlier.[8] It also seems as if the medium of the preparatory work affected the way in which he realized the color lithograph.[9] *Femme au tub* (no. 55) derived from a rapidly executed drawing in sanguine that fixed the outlines of the composition. The subsequent print used a brush to retain that graphic quality on the figure, so her relatively flat form looks superimposed on the compressed space of the interior. By contrast, motifs that had originated as studies in oil, such as *Femme qui se lave* (no. 54), were usually drawn onto the lithographic stone with a more conventional treatment of light and dark that accentuated the figure's sculptural mass. While Lautrec's practice did not follow hard-and-fast rules, this general pattern gives *Elles* a varied, almost uneven, quality. Whether Lautrec worked from a stock of images or from a study made expressly for an *Elles* print, however simplified or caricatural his images, he never abandoned his fundamental insistence on the seen, on the experience of the model before him. Lautrec, half a decade older than Bonnard, Vuillard, or Vallotton, had been trained and had matured with a naturalist belief in the primacy of observation. Unlike his colleagues, he was not shaped and constrained by the exigencies of style.

By the 1890s, naturalism had been the leading aesthetic in France for several decades. With its roots in the positivist philosophy of intellectual progress through rational and scientific analysis, naturalism was committed to the close study of the everyday world, its modernity centered on frank and detailed observation, whether articulated in the novels of a Zola or a Maupassant or in the paintings of a Monet or a Lhermitte. Symbolism had developed in both literature and the visual arts as a challenge to naturalism during the 1880s. Symbolists rejected the objective description of reality for a fascination with the intangible, the mood or effect that could be conjured by a conjunction of words or colors; they repudiated the representation of the candid, even the coarse, for the suggestion of emotion and ambiance. The Nabis, the avant-garde group to which Bonnard and Vuillard belonged in the early 1890s, forged a nondescriptive style from extreme simplification, flat surfaces, insistent patterning, and inventive color. By stressing artifice over observation, they were emphatically stylish. Yet by the mid-1890s, naturalism still dominated, whether gauged by the sale of Zola's novels or the paintings exhibited at the annual Salons. Symbolist writers such as Camille Mauclair continued to argue that naturalism was only "empty forms,

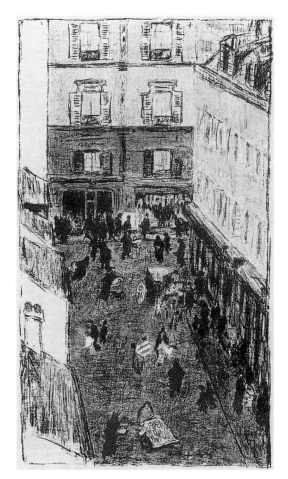

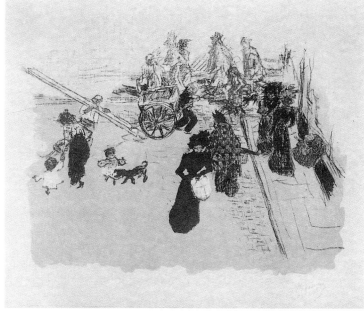

waste, the casing of ideas," but symbolism was increasingly questioned on the grounds of — as the art critic Paul Desjardins put it — "preconceived ideas about nature and neglecting to look at it. For painters that is a fatal error. Where does a painter start from if not the visible world?"[10] Increasingly throughout the second half of the 1890s, Bonnard, like Vuillard, grappled with the divergent yet still blurred aesthetics of naturalism and symbolism as, gradually, they shrugged off excess of style for a more direct response to life and looking. That aesthetic shift can be sensed in process in the accumulation of prints for *Quelques aspects* and *Paysages et intérieurs*.

It could be argued that Bonnard's images in *Quelques aspects* are symptomatic of his renegotiation of naturalism. A sense of decorative order remains in the earliest executed prints for the album, such as *Maison dans la cour*, with its pattern of windows and shutters, or the repetitive accents of the friezelike *Boulevard* (nos. 61–62). But the prints made in 1897 or 1898 are more concerned with the business of looking and depicting than with stylization. *Coin de rue vu d'en haut* (fig. 1) is one of three in the album that take a view looking down steeply from a high window onto a street below. Such angled viewpoints had been pioneered in the 1870s by painters like Edgar Degas and Gustave Caillebotte, conscious as naturalists that the range of vantages from which we look is far more varied in real life than in the head-on theatrical space of the conventional picture. *Coin de rue* (fig. 2) matches its vivid vantage with an array of likely types haphazardly grouped: the slim silhouette of the central young woman against the stooped and shawled *dame* behind her, the dog accosting the defensive child, the laborer carrying his tilted plank. *Rue, le soir, sous la pluie* or *Place*

*le soir* (nos. 65, 66) brings the figures close to the spectator, giving a fictional physical proximity of the kind that — again — had been systematically developed by the previous generation of naturalist painters. That sense of the plausible or accidental was of course contrived by the artist, but it was nonetheless closer to direct observation than had been Bonnard's Nabi practice. Vuillard's progress with *Paysages et intérieurs* was similar. Once again, the earlier prints are emphatically stylized, notably the three *Intérieurs aux tentures roses* (no. 70; fig. 3), which are close to the decorative Vaquez paintings of 1896 (Petit Palais, Paris) in their overall color harmony and use of pattern to collapse space.[11] Later prints that represent the interior of Thadée and Misia Natanson's apartment in the rue St. Florentin use the decorative background of the wallpaper much less insistently, and convey the nuances of body language in *La Partie de dames* (fig. 4) and *Les deux belles-soeurs* (no. 69) with efficient exactitude.

The subjects of these albums are all everyday rather than imagined — being scenes of street and park, boudoir and kitchen — and so register, apparently, as naturalist, derived from the observation of daily life. However, their quotidian subjects are mediated by the means of representation, for these artists, while striving to allow more veracity into their ways of seeing, had not forgotten the crucial lesson of their Nabi years: that the business of making an image has enormous impact on how it is read. As a medium the color lithograph allows a number of possibilities — both rapid, graphic drawing and the crafting of curious color harmonies — which affects the way we read the subjects. In this respect, Bonnard's *Le Marchand des quatre saisons* makes an illuminating contrast with Edgar Chahine's slightly later etching of the same subject (figs. 5, 6). Chahine's black-and-white print necessarily has a different character than Bonnard's color lithograph, but the crucial distinction is its adherence to the dour etiquette of naturalism — observation of a social type, attention to detail, an exact Paris location with the Tour St. Jacques in the rear — while Bonnard presents a generalized street, a ludicrous dog, and a street merchant with eyes like a cooked prawn leering at the *petite femme*, all harmonized by shorthand drawing on a backdrop of canary yellow. Bonnard's wit and powers of synthesis are apparent in *Boulevard* (nos. 61–62),

3 | 4

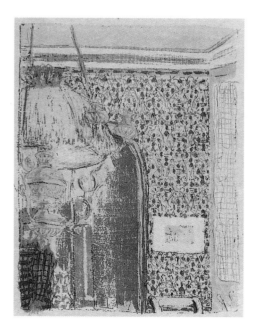 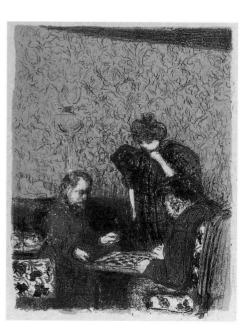

1
———
Pierre Bonnard, Coin de rue
vu d'en haut, **c. 1897, color
lithograph. Virginia and
Ira Jackson Collection,
Promised Gift to the
National Gallery of Art**

2
———
Pierre Bonnard, Coin de rue,
**c. 1897, color lithograph.
Virginia and Ira Jackson
Collection, Promised Gift to
the National Gallery of Art**

3
———
Edouard Vuillard, Intérieurs
aux tentures roses II, **c. 1896,
color lithograph. National
Gallery of Art, Washington,
Rosenwald Collection**

4
———
Edouard Vuillard, La Partie
de dames, **1897/1898,
color lithograph. National
Gallery of Art, Rosenwald
Collection**

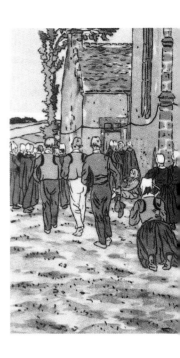

which inventories Parisian types while placing them in an elongated frieze, playfully rendering mundane the solemn spirituality of his friend Maurice Denis' *Procession under the Trees* (1892, Arthur Altschul, New York) or providing a bustling metropolitan counterpart to Henri Rivière's virtuoso woodcut, the pious panorama *The Pardon of Sainte-Anne-la-Palud* (fig. 7). Vuillard, too, used processional forms in two prints from *Paysages et intérieurs: Sur le Pont de l'Europe* and *A travers champs* (figs. 8, 9). The first might almost be a detail from Bonnard's *Boulevard*, the passage of the two girls framed by the ordered architecture of the city. The second, probably a recollection of one of Vuillard's summer visits to the Natansons at Villeneuve-sur-Yonne in 1897 and 1898, shows an almost ceremonial promenade across the sunlit meadows, with one man purposefully striding against the flow of the other dozen figures. The occasional use of processional, rather ritualistic, formats by Bonnard and Vuillard was offset by their featherlight grip on the ironies of petty events, their images fusing the artificial and the observed.

The shorthand quality of the draftsmanship in some of Bonnard's prints, evoking his partial and perceptual sensing of the city, suggests inner absorption rather than external experience of daily life. The cover of *Quelques aspects* (nos. 59–60)

5
—
6

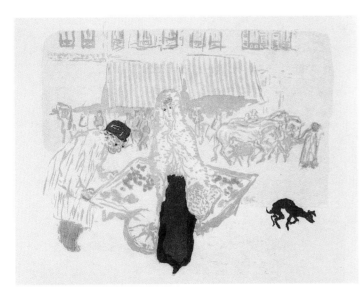

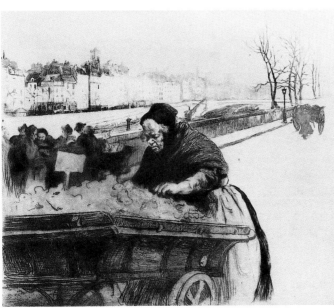

is a case in point, setting the tone as it does for the understanding of the album. The image of the Montmartre street, half hidden from us by the abrupt adjacency of a woman in extravagant bonnet, bushy coiffure, and lavish collar, is very much drawn, an agitated assemblage of marks and textures put down by Bonnard almost as if his wrist were in spasm. He presents us not so much with an account of what we might glimpse in the street — a passerby masking our view — but rather his sense of it, so the print articulates a nervous rather than an objective experience of momentary proximity to a chic woman in the transience of the city. Intriguingly, this cover provides the only eye contact in the album; with Bonnard, the artist or the peruser of the album is not expected to see the city perceived as close to, tactile, or physical, but rather as sensed "closely [to] the nervous system," to borrow the expression of Francis Bacon seventy years later.[12] This kind of gestural, instinctive *graphisme* occurs elsewhere in the later prints made for *Quelques aspects*: *Le Pont* (fig. 10), the *Arc de Triomphe* (nos. 63–64), and *Avenue du Bois*

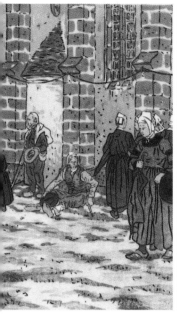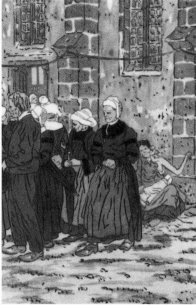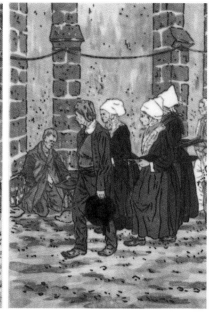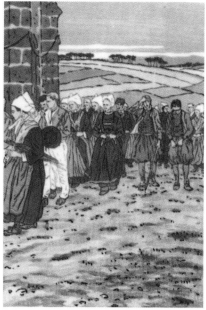

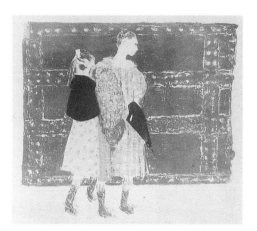

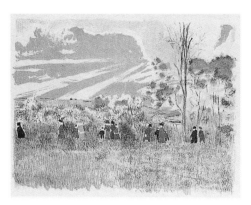

*de Boulogne* (fig. 11) all hold the agitation of the drawing in large reassuring patches of tone, line, and color working in counterplay. This is in contrast to Lautrec. The *Elles* prints chiefly deal with a single figure and the artist/spectator's relationship with her. The subjects are often emphatically tactile — sponging a neck, fixing the hair, unlacing a corset — and the drawing is geared to that, nowhere more so than in *Femme qui se peigne* (fig. 12), where the absence and presence of drawing inevitably and appropriately lures the eye to the bulging breasts. Bonnard constructed the urban experience as something distant and distilled, a set of personal perceptions given an edgy outline and seen through a softening sheen of tone. His selective experience of Paris as evoked in *Quelques aspects* is highly individual in its presentation of the city through the artistry of personal neurosis. In this respect, such images still operate as quasi-symbolist evocations of the urban world: a particularly "modern" idiom in the 1890s.

The size of the images should be linked with how each album and its subjects are to be read. In their two albums Lautrec and Vallotton were consistent in the size of their images; Vuillard and in particular Bonnard, however, were not. Consistency of size, subject, and — insistently in Vallotton's case — style meant that the album was intended to be understood as a totality, a cumulative or linked group of images. By compiling an album of prints that differed in size — and in Bonnard's case by other contrasts, such as the regularity or irregularity of the images' margins — the

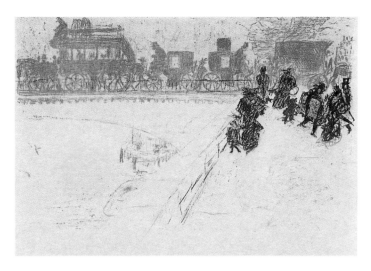

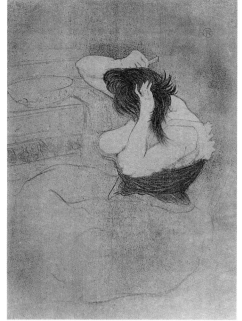

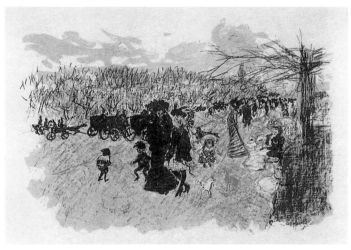

artist insisted that each print be seen as a work in its own right. It also meant that the prints were not intended to be displayed as a unit, unlike the regularity of William Nicholson's *Almanac of Twelve Sports* (1898), for example. Rather, they were intended for leisured private perusal, one by one. Vuillard's album stressed its diversity by having an internal inconsistency, for whereas most of the prints are separate images in their own right, the three *Intérieurs aux tentures roses* prints are harmonized in color, touch, size, and subject (no. 70; fig. 3). Like Vuillard's painted decorations, they offer a visual continuum and could be hung around a room, divided by windows or doors, their consistency of treatment binding them together as decor. The mural print (*L'Estampe murale*) was a possibility that many artists essayed during the 1890s, but whereas Bonnard's *Promenade des nourrices* (no. 75) was produced on the scale of a screen, Vuillard discreetly inserted his tripartite scheme into *Paysages et intérieurs.*

The subjects of these print albums were unexceptional. *Elles* had been commissioned from Lautrec by the print publisher Gustave Pellet, whose stock-in-trade was lightly erotic imagery by artists such as Charles Maurin and Louis Legrand.[13] The images represent not the world of the common prostitute working in a brothel, as they have often been interpreted, but rather the more comfortable and independent world of the kept woman. We see these pampered creatures — *elles* — as generic types, going about their intimate daily routines, the set as a whole perhaps adding up to a sequence of daily activities from waking to the end of the night's work.[14] Like *Elles*, all the scenes of *Intimités* are set indoors. Of these four albums, Vallotton's is the most consistent; published by *La Revue blanche,* each print was the same size, framed by a pasteboard mount, and in the starkly economical black-and-white style Vallotton had made his hallmark. That visual consistency added impact to its difficult subject: adul-

tery. Adultery was one of the anxieties — and entertainments — of the fin de siècle. Treated lightheartedly by some — Maurice Donnay prefaced the "modern" dialogues of his *Chères Madames* (1895) with the disclaimer, "This book is not immoral, because it's only about adultery" — to others its "deification" in popular culture was symptomatic of national decline.[15] Inevitably adultery was a stock subject in caricature for innumerable draftsmen such as Jean-Louis Forain and Théophile Alexandre Steinlen. The sheer power of Vallotton's images comes across in comparison with an already reductive print from Hermann-Paul's 1895 album *La Vie de Madame Quelconque — Et les ivresses de l'adultère* (fig. 13) — in which the couple wait passionless in a hotel room while a servant blows on the fire. Title and style work with even more economical irony in Vallotton's *Le Mensonge* (fig. 14). Here the regularity of the striped wallpaper — associative, perhaps, of moral rectitude or a middle-class cage — contrasts with the broken stripes on the woman's dress, undulating in the embrace. Vallotton's negation of detail craftily increases the ambiguities of the image: Who is the liar? Does the woman kiss, whisper, succumb, or devour? If Vallotton's *Intimités* adapted the barbed economy of his printmaking to a common subject, which he subsequently explored in a number of paintings,[16] Vuillard operated in the opposite direction, for the subjects of *Paysages et intérieurs* are the same as in his earlier paintings: streets he knew, countryside he had visited, the apartments of his mother and his friends. The album parallels the prescription for the profundity of understated privacy that the influential playwright Maurice Maeterlinck had laid down for the good painter: "he will represent a house lost in the country, an open door at the end of a corridor, a face or hands at rest, and these simple things will be able to add something to our consciousness of life."[17]

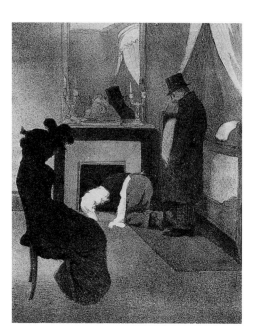

13

Once again, Bonnard's *Quelques aspects* stands apart. Its subjects may match those of his paintings and in some cases even be derived from them.[18] But unlike the many albums produced in the 1890s on the French capital — among them Auguste Lepère's *Parisiennes sensations* (1894) and Rivière's *Paysages parisiens* (1900) — it all but neglects famous sites. Those that it does depict — the Arc de Triomphe, one of the avenues leading down to the Bois de Boulogne — might even have been included to go some way toward satisfying conventional expectations. Bonnard's changes of the title for the album are important here. His initial title had been *Croquis parisiens*, but this had been used already for a booklet by Joris-Karl Huysmans, illustrated with etchings by Jean-François Raffaëlli.[19] The lettering on the title page shows that it was then to be called *Quelques aspects de Paris*, but finally Bonnard added the crucial qualifying words to make it *Quelques aspects* de la vie de Paris.[20] Thus he registered that the album was not topographical, like Lepère's or

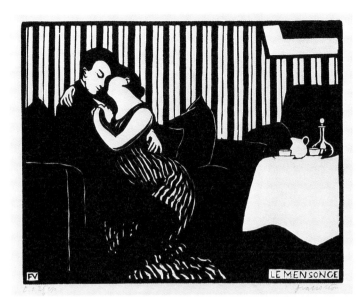

**14**

**Félix Vallotton,** Le Mensonge,
**1897, woodcut. The Art
Institute of Chicago, Gift of
the Print and Drawing Club**

Rivière's, and not even very emphatically about Paris. Instead it dealt with the *life* of the city; better still, his prints were about experiencing fragmentary perceptions of urban life, for his color lithographs summarized something of his own sense of the metropolis, his perceptions, his places and spaces. Less focused in style and subject than Lautrec's *Elles* or Vallotton's *Intimités*, more particularized than Vuillard's *Paysages et intérieurs*, *Quelques aspects* operated with fertile visual acuity and exquisite craftsmanship in the interstices between naturalist observation and symbolist evocation. Bonnard made images of Paris that are private, marginal, discursive; presenting what he had seen, but less as he had seen it than how he had perceived it. As such, the album is a triumph of scrutiny and memory, sight and neurosis: an exquisite encapsulation of fin-de-siècle modernity.

---

**1**   Patricia Eckert Boyer and
Phillip Dennis Cate, *L'Estampe ori-
ginale: Artistic Printmaking in
France, 1893–1895* [exh. cat., Jane
Voorhees Zimmerli Art Museum]
(New Brunswick and Amsterdam,
1991–1992).

**2**   Roger Marx, Alain Weill, and
Jack Rennert, *Masters of the Poster,
1896–1900: Les Maîtres de l'affiche*
(London, 1977).

**3**   André Mellerio, "La Litho-
graphie originale en couleurs"
(Paris, 1898), in Phillip Dennis
Cate and Sinclair Hamilton
Hitchings, *The Color Revolution:
Color Lithography in France, 1890–
1900* (Santa Barbara and Salt Lake
City, 1978), 79.

**4**   Phillip Dennis Cate and
Marianne Grivel, *From Pissarro to
Picasso: Color Etching in France*
(New Brunswick and Paris, 1992);
Jacquelyn Baas and Richard S.
Field, *The Artistic Revival of the
Woodcut in France, 1850–1900* [exh.
cat., University of Michigan
Museum of Art] (Ann Arbor, 1984).

**5**   Charles Rearick, *Pleasures of
the Belle Epoque: Entertainment and
Festivity in Turn-of-the-Century
France* (New Haven and London,
1985); Debora L. Silverman,
*Art Nouveau in Fin-de-siècle France:
Politics, Psychology and Style*
(Berkeley, 1989).

**6**   Colta Ives, "City Life," in
*Pierre Bonnard: The Graphic Art*
[exh. cat., Metropolitan Museum
of Art] (New York, 1989–1990),
121–124; François Fossier,
"*Quelques aspects de la vie de Paris*,"
in *Nabis, 1888–1900* [exh. cat.,
Kunsthaus Zürich] (Munich,
1993), 438–441.

**7**   Boston Museum of Fine Arts;
repr. Ives 1989–1990, 123.

**8**   I am grateful to Juliet Wilson
Bareau for this suggestion.

**9**   Richard Thomson, "*Elles*," in
*Toulouse-Lautrec* [exh. cat.,
Hayward Gallery] (New Haven
and London, 1991), 436–453;
Marie-Claire Saint-Germier, "*Elles,
les douze heures du jour, et
l'esthétique du calque*," *Revue de la
Bibliothèque Nationale* 43 (1992),
74–83.

**10**   Camille Mauclair, *Eleusis:
Causeries sur la cité intérieure*
(Paris, 1894), 91; Paul Desjardins,
"Les Salons de 1899," *Gazette des
beaux-arts* 22 (July 1999), 48.

**11**   Gloria Groom, *Edouard
Vuillard: Painter-Decorator. Patrons
and Projects, 1892–1912* (New
Haven and London, 1993), 94.

**12**   From a May 1966 interview
with the artist, quoted in David
Sylvester, *Interviews with Francis
Bacon* (London, 1975), 43.

**13** Antony Griffiths, "The Prints of Toulouse-Lautrec," in Wolfgang Wittrock, *Toulouse-Lautrec: The Complete Prints*, 2 vols. (London, 1985), 1: 45.

**14** Thomson 1991, 436–437; Saint-Germier 1992, 82–83.

**15** Yvanhoë Rambosson, "Les Livres," *Mercure de France* 26 (November 1895), 259; Baron Charles Mourre, "L'Affaiblissement de la natalité en France," *Revue bleue* 13 (January 1900), 54.

**16** Sasha M. Newman, "Stages of Sentimental Life: The Nudes and the Interiors," in *Félix Vallotton: A Retrospective* [exh. cat., Yale University Art Gallery] (New Haven, 1991–1992), 139–144.

**17** Maurice Maeterlinck, "A propos du *Solness le constructeur*," *Le Figaro*, 2 April 1894.

**18** Ives 1989–1990, 124.

**19** Loÿs Delteil, *Le Peintre-graveur illustré. 16. Raffaëlli* (Paris, 1923), 137–140.

**20** Ives 1989–1990, 121.

DO REMI FA SOL LA SI DO REMI FA SOL LA SI DO

**4º Comment représente-t-on les sons?**

En écrivant des signes appelés **notes**.

**5º Quels noms donne-t-on aux notes?**

Il n'y a que sept noms de notes :

## UT ou DO, RÉ, MI, FA, SOL, LA, SI

pour désigner tous les degrés de l'échelle musicale. Cette dernière, comme on le verra plus tard, devant se diviser en portions de sept degrés.

**6º Où place-t-on les notes?**

On place les notes sur la **portée**.

**7º Qu'est-ce que la portée?**

C'est un assemblage de cinq lignes horizontales et parallèles.

**8º Comment appelle-t-on les espaces compris entre les lignes?**

On les appelle **interlignes**.

SOL LA SI DO

*Gale B. Murray*

# **Music Illustration** in the Circle of Bonnard

FROM NATURALISM TO SYMBOLISM

For Paris artists in the 1890s, notably several of the Nabi group — Pierre Bonnard, Henri Ibels, and Maurice Denis — and their associate Henri de Toulouse-Lautrec,[1] the illustration of sheet-music title pages, music albums, and music books was a significant aspect of their graphic work.[2] The product of their interests in the decorative and utilitarian arts, in dissolving boundaries between high and low art, and in collaboration between the arts, music illustrations reflect these artists' involvement with radical developments in contemporary song, poetry, music, cabaret life, and theater.

Illustration — of music, books, theater programs, and journals — was just one facet of these avant-garde artists' interest in the decorative arts, which also led them to design posters, theater sets, furniture, folding screens, stained glass, tapestries, and ceramics. In part, practical considerations motivated these ventures. Commercial art provided a source of income and an opportunity for visibility at a time when the young artists were unknown and struggling to establish themselves. Their attraction to commercial graphics coincided with a flourishing music publication industry, which had been given new impetus by the renaissance of French song in the new bohemian cabarets of Montmartre.

Rodolphe Salis' establishment of the Chat Noir in 1881 initiated the genre of the *cabaret artistique* and provided the model for those that followed. In the cabarets the reigning spirit, decidedly counterculture, emerged in entertainments, decor, and a general ambience that employed satire, irony, and farcical humor to deride the bourgeoisie and critique contemporary society, morals, and politics.

OPPOSITE

**Pierre Bonnard,** Do Ré Mi, **in** Petit solfège illustré, **1893, Virginia and Ira Jackson Collection, Promised Gift to the National Gallery of Art (no. 106B)**

61

This irreverent and mocking attitude was called *fumisterie*. *Fumisterie* and social protest were endemic on Montmartre. As a rough and sinister area, inhabited by the poor, the social outcasts, and the purveyors of vice, as well as bohemians, progressive artists and writers, and political radicals, Montmartre served as a foil for the respectability and conventionality of bourgeois Paris.

A critical ingredient of the artistic cabaret was a new kind of song, performed by *poète-chansonniers* (serious poets who sang the poetry they themselves had written, and which composer friends had set to music). The songs, sometimes bitter and cynical, sometimes macabre, sometimes incisively witty or satirical, and often antibourgeois in tone, provided an antidote to the lighter, more mindless and sentimental romantic, militarist, and patriotic repertoire of the popular lowbrow *café-concerts*. Maurice Donnay, the writer and dramatist, spoke of a new Montmartre "school of song . . . that was particularly scoffing and irreverent in continual reaction against stupidity, injustice and knavery."[3] Many of the more socially conscious songs presented shocking pictures of the underside of Paris life — many were sung in the coarse, popular argot for authenticity's sake. Because of their similarities in content and uncompromising candor to realist and naturalist literature, they came to be called *chansons realistes* or *naturalistes*.

The emerging avant-garde artists of the later eighties and early nineties were drawn to the iconoclastic atmosphere of Montmartre, which also became highly attractive to bourgeois and aristocrats in pursuit of self-liberation. Here, as Charles Rearick has pointed out, they "could temporarily free themselves from inhibitions of everyday respectability and find normal forms of bourgeois behavior mocked or disregarded."[4] Hence, in the course of the 1880s, well-to-do Parisians and tourists made their way to artistic cabarets and other Montmartre nightspots in increasing numbers. Clever entrepreneurs, including *cabaretiers* like Salis, were quick to capitalize on this phenomenon, and the result was the rapid commercialization of the Montmartre Bohemia and its transition by the 1890s to a consumer-oriented entertainment industry.[5] Naturally, this commercial orientation created a need for publicity, and the resulting industry spawned opportunities for visual artists, who illustrated posters, postcards, journals, sheet music, and songbooks.

The popularity of cabaret song and the celebrity of its performers created a market for illustrated sheet music, which often featured an image of a particular singer and advertisements for his associated venue.[6] Publishing firms like Ondet, Enoch, Paul Dupont, Fouquet, and Pion specialized in the cabaret chanson. Words and music were printed cheaply on two pages in *petit format*, with an illustrated title page and pitches for additional song sheets on the back cover.[7] Publishers also marketed the illustrated sheets in a larger *grand format*, with piano accompaniment as well as lyrics, for home use. The sheet music was sold in music shops and *petits formats* were sold on the street by vendors and hawked at the cabarets.[8] Some songs were published in more lavish illustrated albums, which were sold to well-to-do collectors and kept in their libraries and music rooms.[9] The illustrated songs were further disseminated in the popular press — in such journals as *Le Courrier français*, and in the Sunday supplements of *L'Illustration* and *Gil Blas*, which often featured articles on the cabarets and their singers — and in the cabarets' own journals, which functioned as

their publicity organs and which contained advertisements for the sheet music of songs by their *chansonniers*. Thus, in the complex world of reciprocal commercial relations, the song sheets served the mutual interests of the publishers, the singers, and the cabarets, by further advertising and popularizing the songs and thereby bringing profit to all. The illustrated title pages, in turn, made the song sheets more attractive and therefore more salable, and also served as publicity for the artists who created them.

Artist illustrators, like Théophile Alexandre Steinlen and Adolphe Willette, who practiced accessible realist styles, received most of the commissions. Some publishers, however, most notably Ondet, also engaged the talents of more experimental avant-garde artists like Toulouse-Lautrec and the Nabis. Although the subjects of the illustrations remained naturalistic, the stylistic devices used by these artists (boldly reductive and proto-abstract flattened forms, pronounced outlines, stylization, and caricatural exaggeration and distortion) were associated with symbolism.

Steinlen, an artist with radical political sympathies, whose work focused on the plight of the poor in modern urban society, was the pioneer in the illustration of the new song. A member of the original circle of the Chat Noir, he met in the early 1880s Aristide Bruant, the naturalist singer-songwriter, who shared the artist's views. Steinlen joined forces with Bruant in 1885, when the latter established his own cabaret, *Le Mirliton*, and the journal of the same name. War between the classes was Bruant's dominant theme, and he provided nightly entertainments in which he mixed his *chansons naturalistes* with a rain of insults upon the bourgeois sophisticates in his audience. Bruant's songs, delivered in the popular argot, celebrated the urban poor and decried their position in society. His journal publicized his cabaret and his songs — each issue featured one or more illustrated songs or monologues; he also published his own sheet music and songbooks. As Bruant's preferred illustrator, Steinlen created easily comprehensible and therefore marketable visual interpretations of Bruant's songs, images that conformed closely to the lyrics in spirit, but which sometimes amplified the text with additional details about the settings, the characters, and their impoverished circumstances.[10]

Between 1884 and 1900 Steinlen designed some 184 sheet-music covers. In the 1880s these were primarily for songs by Bruant, but in the nineties he illustrated work for many other composers and poets and for a variety of publishers. Music periodicals such as *La Semaine artistique et musicale* and *L'Intransigeant illustré* also reproduced his sheet-music covers,[11] and he published numerous song illustrations in the popular journal *Gil Blas illustré*. Steinlen's title page for the music to Bruant's *Les Marcheuses* (The Streetwalkers; fig. 1), a photomechanical reproduction of a drawing of the later 1880s,[12] illustrates one of the *chansonnier*'s numerous songs about prostitution. Prostitution was a stock subject of realist and naturalist literature and song, the product of a desire for a frank and provocative vision of modern life as well as of an inclination to shock and titillate the conventionally minded. *Les Marcheuses* paints a depressing picture of Paris streetwalkers. Exhausted, penniless, past their prime, these victims of poverty wander the cold, bleak streets by night, "Their backs aching,/Their feet worn out," only to be spurned by prospective clients: "They go like that,/Hither and yon,/Soliciting the lover/Who gets away...."[13]

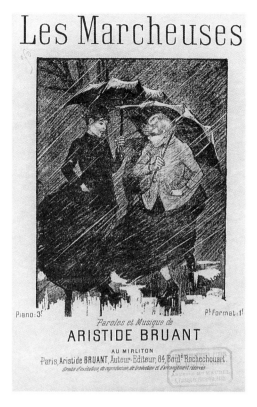

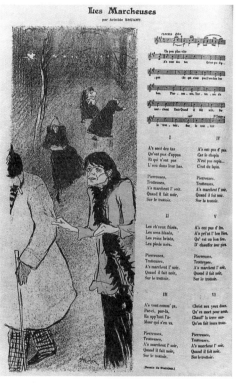

Steinlen illustrates the text with several streetwalkers braving the elements — in this case a driving rain, a detail not mentioned by Bruant. However, while he does convey Bruant's sense of the harsh environment, Steinlen bypasses other elements in the song that amplify its pathos — namely, the fading appeal of aging prostitutes and their consequent difficulty in attracting clients. Instead, Steinlen depicts more appealing, pert, younger women, perhaps to enhance the sheet music's salability. By contrast, Steinlen's later illustrations of this song, not explicitly intended for advertising purposes, capture more precisely the poignant and melancholy mood of the lyrics. His illustration in *Gil Blas illustré* in December 1893,[14] for example, depicts an aging, emaciated prostitute accosting a man who looks at her askance and turns away, while other streetwalkers shiver in the background (fig. 2).

In style, too, there is a marked contrast between Steinlen's earlier and later renditions of *Les Marcheuses*. His song-sheet version bears the typical characteristics of his earlier, more conservative, naturalistic style — employing dense hatching and cross-hatching to create a realistic sense of volume, space, light, and shadow. By contrast, in his 1890s versions he simplifies considerably, making a relatively spare image and adopting some of the more decorative devices associated with contemporary avant-garde art — a greater economy of line, larger shapes, flat unmodeled forms, and more prominent silhouettes, particularly those in the background.

Among the Nabis, it was Ibels who was the first and most prolific illustrator of songs. He successfully maintained simultaneous careers as a painter/printmaker and as an illustrator of popular journals, sheet music, theater programs, books, and posters. He employed the bold, decorative, simplified style developed by the Nabi group in the 1890s under the influence of Paul Gauguin and Japanese woodcuts. Yet he stands somewhat apart from the other Nabis in his deeper engagement with social

and political issues — much of his work deals with the harsh realities of the life of the working class. Ibels' first public success came from his 1892 poster of the popular singer Jules Mévisto, for whom he also lithographed his first sheet-music covers, published by Ondet in the early 1890s. Mévisto was one of a growing number of singers who interpreted the repertoire of the Montmartre *chansonnier-poètes* in both the cabarets and in the more lucrative *café-concerts*. Mévisto had a distinctive stage personality; he dramatized the lyrics he sang with the exaggerated gestures of pantomime and affected different "voices" for the various characters in his songs.[15] Hence, many of Ibels' cover illustrations for Mévisto focus on the image of the singer himself rather than on the lyrics. This is the case with *Les Mal Tournés* (Those who turn out badly), a monologue of social protest, written by the naturalist songwriter René Essé (no. 102). Ibels represented Mévisto, presumably singing the poignant song in which the singer "becomes" the character he sings about — a street person and petty thief who recounts his life story, explaining that he has turned out badly because of his impoverished circumstances: "My mother, when I was newborn, spent her nights in the snow." After his father died in the Franco-Prussian War, his mother took up with a bad type, and he ran away from home, living with other guttersnipes in an abandoned quarry; later he failed in the army because he couldn't submit to military discipline. In the end he had no place to go but the street: "How can one live," is his lament, "without work, without bread, without shelter?" He closes with a plea: "If you don't treat us like dogs when we're little, perhaps, when we become men, we'll turn out well!"

For *Salut, drapeau!*, Essé's song celebrating the naive patriotism of a peasant boy who joins the infantry and dies proudly, carrying his regiment's flag into battle, Ibels reprised his famous poster of Mévisto as the cover image (no. 103). The poster conveys the sense of the performer's proletarian repertoire as a whole rather than of any specific song (see Cate, fig. 12). Ibels juxtaposed the large silhouetted figure of Mévisto in the foreground with several background figures, who represent the types of whom he sings — the peasant, the day laborer, the foot soldier — set against a distant view of factories. In style, this image typifies Ibels' Nabi approach, with its reduction of three-dimensional space and volume to a flat pattern of simplified silhouettes defined by emphatic outlines, as well as his tendency to use heavyset, caricatured figures. Yet, flat pattern conflicts with spatial indications — a bird's-eye view and a recession into depth along the winding road — to establish a tension between realism and abstraction that characterizes work of many of the Nabis and of Lautrec in this period.

Ibels' cover for *Les Petites Mères* (The Little Mothers; fig. 3), of about 1893, another Mévisto song, illustrates Hector Sombre's naturalist lyrics concerning destitute orphan girls who sacrifice their own childhoods to raise younger siblings. Ibels' stencil-colored lithograph depicts a young girl holding a baby; the girl is a flat unmodeled figure in a mauve-toned dress, surrounded by a strong contour. Edouard Kleinmann, the print publisher and dealer, reproduced the same image on higher quality paper in a limited edition, without lettering, for sale to art collectors (fig. 4). This was becoming a more frequent practice, as art publishers and dealers, like Kleinmann and Edmond Sagot, realized the artistic value of these sheet-music images, further blurring the distinctions between illustrations and "original" prints.[16]

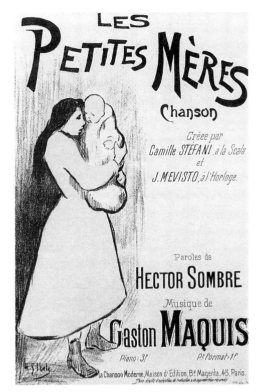
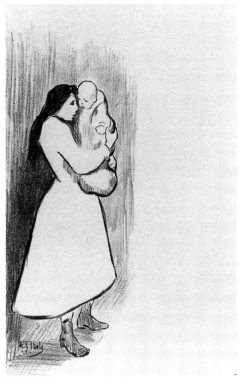

3 | 4

Such cover illustrations were clearly effective as publicity; Mévisto urged his peers to engage Ibels' talents, telling the *chansonnier* Georges Millandy: "When you have covers illustrated by Ibels, you will easily find a publisher who will be delighted to get drawings of which everyone knows the value, while getting songs which will sell."[17] Ibels, in turn, was instrumental in persuading music publishers to use fine art to illustrate sheet music. The critic Charles Saunier noted in 1896 that "we owe a bit to Ibels the rehabilitation of the frontispieces of romances and monologues, which before him were almost always grotesque or sentimental to the point of imbecility. Quite adroitly [he]...created a very new genre, which made the curious take notice, and which sometimes caused the refined observer to purchase, only for the cover design, a romance or a piece of buffoonery, that formerly would have passed unnoticed."[18] Moreover, Ibels secured commissions for sheet-music illustrations not only for himself but also for his friends. It was he who, in 1893, introduced Toulouse-Lautrec to Ondet, thereby initiating the former's career as a music illustrator.[19]

Lautrec had close connections with the artists of the Nabi group. He exhibited with them from 1891 at the gallery of Le Barc de Boutteville and at avant-garde shows in Brussels. Like the Nabis, he was part of the circle of the avant-garde artistic and literary journal *La Revue blanche*. Critics like Saunier discerned the stylistic affinities between Lautrec and the Nabis — especially Bonnard, Edouard Vuillard, and Ibels — and grouped them together, citing their common tendency to apply Japonist style to the interpretation of modern life. He particularly paired Lautrec with Ibels because of their "sharply realist spirit" in the "tradition of Degas and Daumier."[20] Lautrec shared Ibels' interest in commercial art and, in 1893, the two artists collaborated on the illustrations for Georges Montorgueil's book *Le Café-concert*, published by André Marty. There must have been some stylistic cross-pollination between them that would account for the similarities in their work at this time. It

is likely that it was Ibels, the more established of the two, who influenced Lautrec, or at least reinforced the more abstract directions in which Lautrec himself was moving.

Lautrec made illustrations for some forty sheet-music covers. His earliest song illustrations appeared in Bruant's *Mirliton* and show close affinities with those of Steinlen.[21] The cover of *Le Mirliton* of August 1887, for instance, featured Lautrec's drawing for Bruant's *A Saint-Lazare*, a song about a streetwalker confined in Saint-Lazare prison, who writes a love letter to her pimp. Ironically she worries about how he will live without her to support him. Bruant used the same image again in 1888 in volume one of his collected songs, *Dans la rue*. Here, in a unique collaboration between Lautrec and the older, more famous Steinlen, Lautrec's literal depiction of the jailed woman at her writing table accompanies an image by Steinlen, who elaborated on the song by imagining the woman's lover seated on his bed, the letter at his feet (fig. 5).[22] Though Lautrec was more economical in his use of line, like Steinlen he worked to create realistic suggestions of volume and space.

By the early nineties, however, Lautrec adopted a more decorative, abstracted style, close to that of the Nabis. His cover designs for *Carnot malade!* (Carnot is Ill!), published by Ondet in 1893, and *Le Petit Trottin* (The Little Errand Girl), published by Fouquet in 1893, are typical of his approach to style and content at this time. In each case, Kleinmann issued the same lithographs in small collectors' editions without the music (fig. 6); these were advertised on the sheet-music covers. In both song sheet and limited-edition print, some examples are stencil colored. *Carnot malade!*, a witty piece of political satire, is a monologue by the *poète-chansonnier* Eugène Lemercier, performed at the Chat Noir during the summer of 1893 when Sadi-Carnot, president of the French Republic, retired to the country with a liver ailment. The song ridicules both Carnot and his regime by comparing the president's ill health to the state of his government, which was embroiled in scandals — most notably those ensuing from the bankruptcy of the Panama Canal — and beset by social unrest. Extending his mocking metaphor, Lemercier prays for a cure: "Lord! If it's a matter of putting a mustard plaster / On parliament / That could be easily done." Lautrec parodied the traditional sickbed scene, where the patient is attended by science (a physician) and charity (a nun). His brush and spatter image, with its cartoonlike pattern of

5

3
——
**Henri-Gabriel Ibels,** Les Petites Mères, **c. 1893, stencil-colored lithograph. Jane Voorhees Zimmerli Art Museum, Rutgers, The State University of New Jersey**

4
——
**Henri-Gabriel Ibels,** Les Petites Mères, **c. 1893, lithograph on chine collé. Jane Voorhees Zimmerli Art Museum, Rutgers, The State University of New Jersey, Herbert D. and Ruth Schimmel Art Purchase Fund**

5
——
**Henri de Toulouse-Lautrec and Théophile Alexandre Steinlen,** A Saint-Lazare, in Dans la rue, **1888, photo-relief. Jane Voorhees Zimmerli Art Museum, Rutgers, The State University of New Jersey, Norma B. Bartman Research Library Fund**

simple, flat, and strongly outlined shapes and its absurdly caricatured figures, is exactly in the facetious spirit of Lemercier's lyrics.

*Le Petit Trottin*, a song by Achille Mélandri, set to music by Desiré Dihau, combines humor, titillation, and social criticism in treating another stock subject in naturalist song, poetry, and illustration — sidewalk encounters between young women and lecherous old men. The errand girls had become "erotic symbols" because many of them took up clandestine prostitution in order to supplement their meager

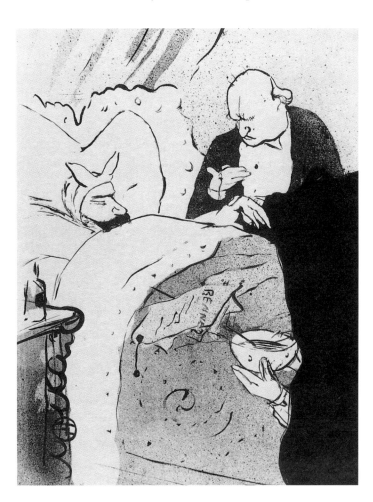

6

earnings. In the song, Mélandri recounted the tale of a young errand girl who flirts with the easy money of prostitution, but who "virtuously" turns instead to work as a laundress, laboring to exhaustion, a victim of hypocritical morality that would rather see her die young than dishonored. Lautrec illustrated the first stanza, where the *trottin* rebuffs an old man who approaches and propositions her (no. 121): "Oh! Darn / Go about your business / Says the *trottin*. Old chimpanzee. / You ought to get the flu." Lautrec, in this brush lithograph, used line alone to create figures that are radically simplified; he filled the page with the two large unmodeled figures, omitting indications of space or volume. To intensify the quality of satire and humor, he distorted and caricatured the figures. To underscore the fleeting nature of their encounter, he made the figures form two diverging diagonals and cropped the man severely at the edge of the composition. In effect, he manipulated the formal elements to convey the "sense" of the experience.

With Denis, sheet-music illustration enters a more purely symbolist realm, uniting synthetic form with dreamlike and mysterious subjects. Among the Nabis, it was Denis who associated most closely with the literary symbolists and who, in 1890, articulated a symbolist theory of painting that espoused the goal of expressing an emotional state as superior to that of reproducing nature.[23] Correspondingly, Denis asserted the principle of "subjective deformation," the artist's prerogative to transform nature in accordance with his emotions.[24] Denis believed in the potential of color and form to evoke feelings and thus advocated the use of decorative means — flat, anti-illusionistic surfaces and linear arabesques to achieve this expressiveness. At the same time, Denis set forth his theory of illustration in which he further elaborated these antinaturalistic ideals, recommending as models medieval manuscripts — "ancient missals with decorative borders" and "early woodcuts" — cautioning against "servi-

tude to the text" and declaring that illustration should be not descriptive but decorative and "expressive of the essential character of the text."[25] Denis conceived of illustration as a "musical" accompaniment to the text rather than a literal depiction. He was particularly interested in the symbolist idea of correspondences between the arts, especially painting and music, and believed that, "like music, the picture should induce 'feeling' and emotions in a realm beyond that of the intellectual comprehension of subject matter."[26] This interest emerged in Denis' style, in his paintings of musical subjects, and in a handful of sheet-music illustrations, which are explicit manifestations of his desire to make visual equivalents to music.[27]

One of these is a three-color lithograph that Denis created in 1892 as a frontispiece (no. 100) for the deluxe edition of his friend Claude Debussy's cantata of 1888 based on Dante Gabriel Rossetti's poem "La Damoiselle élue" (The Blessed Damsel). Rossetti's work was of great interest to the French symbolists, who looked to his late Pre-Raphaelite aesthetic in both painting and poetry, with its interest in the occult and the mysterious, and its subjective and archaizing tendencies, as a reinforcement for their own shift away from naturalism. Rossetti's poem about "deathless" love concerns a young woman who, tragically separated from her beloved by her death, looked down on earth from the golden gate of heaven. She longed to be reunited with her earthly lover in heaven ("only to live as once on earth / with Love, — only to be, / as then awhile, for ever now / together, I and he"). Rossetti made her wait seem eternal and her loneliness poignant as she watched other lovers rapturously reunite around her and ascend to heaven, until finally, her yearning unfulfilled, she realized she would have to enter heaven without him, and ". . . laid her face between her hands, / and wept."

Denis assembled a variety of elements from throughout Rossetti's text and attempted to transmit in visual form its magical, medievalizing, fairy-tale quality and the ethereal nature of its otherworldly heroine. Her posture and gaze convey something of the poem's yearning and nostalgia. But, for the most part, Denis achieves his pictorial interpretation of the poem's mood through his formal devices, most notably the graceful linear patterns made by his flowing contours and the attenuated form of the damsel, which create an aura of exquisite delicacy and fragility. The lack of modeling and depth results in a decorative two-dimensional surface pattern, which recalls the look of medieval manuscripts and of illustrations in children's books of fairy tales; this reductive style has the effect of dematerializing the image and lending it a spiritual purity. At the same time the linear rhythms and delicacy of the image, as well as its elusive, haunting mood, recall Debussy's music, though Denis' linear clarity opposes "the *impressionistic*, melting quality of Debussy."[28]

Bonnard was intensely interested in securing commissions for sheet-music illustrations in the early nineties. Between 1889 and 1895 he made numerous preparatory studies, mostly ink drawings and watercolors, on speculation, for cover illustrations for a variety of types of music, ranging from classical to popular. Apparently the music publishers rejected his proposals; they may have found his innovative quasi-abstract style too radical. In a letter of winter 1890, to his friend Aurélien-François Lugné-Poe, Bonnard alluded to his as yet unrealized ambitions: "Perhaps

I'll go with Vuillard to see a music publisher, but I'm not yet counting on any success in that area."[29] Gustave Coquiot acknowledged that Bonnard's production of published song sheets was negligible, but he recalled having seen "hundreds" of studies, a series of "actual compositions for covers of musical scores."[30]

One exceptional case, which did result in publication, was Bonnard's illustration for *France-Champagne: Valse de salon* of 1891 (fig. 7), a commission that resulted from the success of his *France-Champagne* poster earlier in that year (no. 5). In May, Bonnard wrote excitedly to his mother, "Everyone's asking for my poster. . . . I have also designed the cover for a book of music for the gentleman of the Champagne poster for which he has paid me 40 francs!"[31] Evidently, the waltz was further publicity for the champagne. Bonnard's illustration, a black and white photomechanical reproduction of an ink drawing, takes a subject from modern life — sophisticated figures enjoying champagne at a party or restaurant — and transforms it into a highly decorative piece of ornamentation. As in his poster, the central figure is a woman holding a champagne glass overflowing with bubbles, but now Bonnard includes three additional figures and carries the poster's play with surface pattern and decorative arabesques to a much more complex and elaborate extreme. In the music sheet he crowds pattern upon pattern with a seeming *horror vacui* — combining the black and white silhouettes of figures at different depths with that of a fan, a potted fern, the dotted champagne bubbles, and floral and paisley patterns, the curving shapes of which echo those made by the overflowing champagne foam. The result is a rich, compressed hothouse atmosphere that conveys the giddy pleasure and tipsy excitement induced by the wine. Bonnard has, in effect, put into practice Denis' symbolist precepts concerning illustration, to make it decorative and expressive through the use of simplified forms.

No doubt Japanese art was an inspiration for Bonnard's experimentation with an anti-illusionistic mode characterized by a flattened space, unmodeled figures, undulating arabesques, a profusion of patterns, and cropped and asymmetrical compositions, here enhanced by the inverted L-shaped format. The same decorative approach appears in virtually all of Bonnard's surviving preparations for unpublished sheet-music projects.[32] In *Menuet*, a watercolor of 1892 illustrating a classical piano piece by Claude Terrasse, he created a pattern of arabesques out of the repeated fluid contours of elegant ladies and gentlemen in eighteenth-century garb, dancing the minuet. In this case, after the music publisher Cranz rejected the drawing, Roger Marx purchased it and had it reproduced in the April 1892 issue of *La Revue encyclopédique* as an illustration for G. Albert-Aurier's article "Les Symbolistes" (fig. 8).[33] *Menuet* was

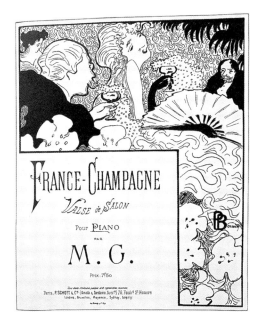

7

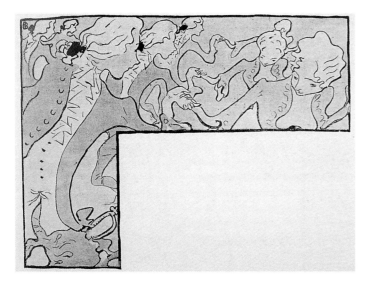

one of numerous collaborations between Bonnard and Terrasse, his brother-in-law, who in the 1890s acquired a reputation as a composer of motets, piano pieces, song settings, incidental music for theater, and scores for comic operas.[34]

In the case of his unpublished watercolor study for *La Petite qui tousse* (The Girl Who Coughs) of 1890–1891 (no. 97), Bonnard applied his highly decorative style, with its abstract patterning, sinuous line, and unusual *mise en page*, to a setting by Terrasse of a naturalist poem by Jean Richepin, whose songs of social protest, performed at the Chat Noir, were illustrated by Steinlen and Lautrec, among others. The poem, written in street argot, is from Richepin's series *La Chanson des gueux* (The Beggars' Song, 1876). *La Petite qui tousse*, one of the "Beggars of Paris" (*Gueux de Paris*), is dying of consumption and will not survive the night. She wanders the streets of Paris, with no place to go, "sobbing on the white sidewalk": "The poor child! Watch her being shaken by the gasps of her coughing, and the icy blast that bites her puts the roses of death

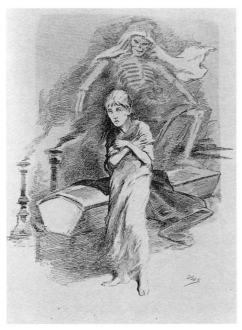

in her cheeks. Violets are less purple than the corners of her lips, than the shadowy stains left under her eyes by the blue kisses of fever."[35]

Bonnard's image of the frail young girl makes a fairly literal counterpart to Richepin's lyrics, but Bonnard also manipulated form to convey the song's mood. He employed the same curling lines as in *France-Champagne*, but here they evoke the girl's tremulous shivering rather than a sense of effervescence. The predominant violet tones also enhance the sense of morbid melancholy. Once again Bonnard used the L-format and created a highly ornamental surface pattern through the use of silhouettes — particularly in the background frieze of elegant pleasure seekers, who make an ironic contrast to the girl. Bonnard's curving lettering echoes the shapes within the image and contributes to its abstract appearance. The publisher, A. Cranz, rejected Bonnard's design and went on to publish the sheet music without an image. An illustration by the commercial artist Uzès of Richepin's song, this time set to music by Marcel Legay, and published in the latter's 1886 album, *Toute la gamme* (fig. 9), provides a dramatic measure of Bonnard's distance stylistically from the realist generation of illustrators and an indication of the kind of illustration preferred by most music publishers. Uzès employed a

7

**Pierre Bonnard, cover for**
France-Champagne: Valse de salon, **1891, zincograph.**

8

**Pierre Bonnard,** Menuet, **in** La Revue encyclopédique, **no. 32, 1 April 1892, photomechanical reproduction.**

9

**Uzès,** La Petite qui tousse, **in Marcel Legay's** Toute la gamme, **1886, photomechanical reproduction. Jane Voorhees Zimmerli Art Museum, Rutgers, The State University of New Jersey, Norma B. Bartman Research Library Fund**

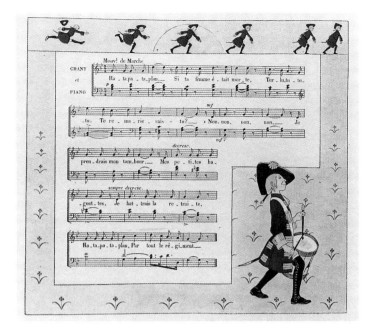

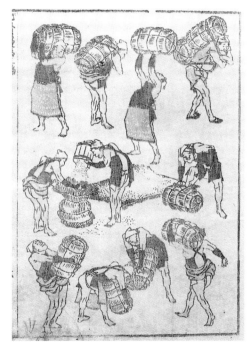

traditional tonal rendering to create volume and depth. And to make the point of Richepin's poem absolutely explicit, he juxtaposed the figure of the dying girl with her coffin and with the allegorical figure of death emerging from the shadows to claim her.

Two of Terrasse's and Bonnard's more ambitious collaborations of the early nineties did reach publication. The first of these, the *Petit solfège illustré*, published by Fromont in 1893, was not a sheet-music project, but a rather unique children's music primer (nos. 104–114). The witty and charming illustrations of this early masterpiece, for which Bonnard created numerous preparatory watercolors between 1891 and 1893, represent a continuation of the stylistic approach of his preceding sheet-music designs. They employ similar devices, but here it is the text that is printed within the inverted or sideways L or other irregularly shaped geometric area, while the illustration serves as its frame. And now Bonnard amplified the element of caricature and introduced a new, deliberate, childlike naïveté and awkwardness, completely appropriate to the subject at hand. In all likelihood, he was inspired by contemporary children's book illustrations, as well as by Japanese and medieval art. He may have looked at the work of English children's book illustrators like Walter Crane or Kate Greenaway, or that of the Frenchman Boutet de Monvel. All employ a similarly reductive approach with simplified forms and minimal modeling and space.[36] Monvel's illustrated books of children's music are particularly relevant in their use of the L-shaped format to enclose the text, and of humorous figural and decorative framing elements (fig. 10).[37] In addition, in an 1891 letter to Vuillard, Bonnard announced his intention to "think" of Japanese illustrations and medieval missal decorations in connection with this project. It is likely that he was particularly influenced by the humorous and often grotesque caricatures in Hokusai's *Manga* (fig. 11).[38] These may have been an inspiration for his turn at this time to a more quivering calligraphic line made up of shorter, separate brushstrokes, and his gradual move away from the fluid arabesques and flat areas of tone of his previous illustrations. At the same time, his recurrent placement at the

upper left of the page in the *Solfège* of a figural scene flowing into a border of highly ornamental patterns surrounding the text recalls the arrangement of historiated initials and decorative borders on medieval manuscript pages.

In terms of content, the task of creating images that would elucidate Terrasse's verbal explanations of musical theory — a situation in which literal illustration was not possible — offered Bonnard a perfect opportunity to engage in an amusing exercise in symbolist equation of form and meaning. He did so through expressive distortions of form and by finding familiar situations which, by analogy, would clarify Terrasse's meaning for the young reader. For instance, he used galloping horses to convey the sense of "prestissimo" and an overweight woman to symbolize the whole note, with progressively slimmer ones indicating, respectively, the half, quarter, and smaller note values (fig. 12). Another of his evocative images illustrates "The Accidental Signs" (fig. 13) with the caricatural figures of three weight lifters or circus strongmen at the upper left of the page. Instead of lifting the barbells beside them, one man crouches beneath the weight of a flat, which lowers a note one half-tone; another stands on tiptoe holding a sharp, which raises the note a half-tone; while a third does nothing but look at a natural, which cancels the effects of the other two signs. The signs themselves continue into the surrounding border, as a striking pattern of black against red, which becomes a symbolic and decorative extension of the narrative scene.

Bonnard's second major collaboration with Terrasse was on a music album entitled *Petites scènes familières* (Familiar Little Scenes; nos. 115–118), published in 1895 by Fromont. Bonnard worked on his illustrations in 1893 and 1894, producing a cover and nineteen black and white lithographs, based on brush and ink drawings, one to illustrate each of the piano miniatures in the album. The publisher also issued twenty sets of the lithographs without the musical scores; the Galerie Lafitte exhibited these in May and June of 1895.[39] Despite its title, the album actually contains two different and somewhat contrasting suites. The first group consists of the fifteen pieces of the *Petites scènes familières* and is private and "intimiste" in mood and subject. The second group, only four pieces, is entitled *La Fête au village: Quatre pièces humoristiques* (The Village Fair: Four Humorous

12

13

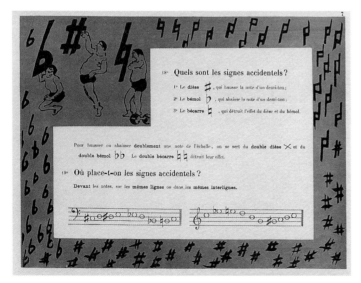

10

Maurice Boutet de Monvel, Ratapataplan, **in J. B. Wecker-lin's** Chansons de France, **c. 1885, stencil-colored photo-relief. Jane Voorhees Zimmerli Art Museum, Rutgers, The State University of New Jersey, Anonymous Donation**

11

Katsushika Hokusai, Men Lifting Bales of Rice, in Manga, **1819, color woodcut. Jane Voorhees Zimmerli Art Museum, Rutgers, The State University of New Jersey, Gift of Carolyn Tierney**

12

Pierre Bonnard, Comment indique-t-on la durée des sons?, **in** Petit solfège illustré, **1893. Virginia and Ira Jackson Collection, Promised Gift to the National Gallery of Art**

13

Pierre Bonnard, Quels sont les signes accidentels?, **in** Petit solfège illustré, 1893. **Virginia and Ira Jackson Collection, Promised Gift to the National Gallery of Art**

73

Pieces) and is more public and extroverted in nature. Terrasse was rejecting romantic high seriousness in favor of a lighter, more witty and personal music, with a focus on genre scenes and on human situations and activities.

As a whole, Bonnard's illustrations for the album, like Terrasse's music, mix quotidian subjects from real life with a symbolist interest in correspondences between forms and feelings. In style Bonnard was now moving more definitively away from the decorative approach of the earlier nineties to a more painterly one, with an appearance of greater spontaneity, characterized by broken outlines and choppy surface markings made up of short lines, strokes, and touches that seem sketchy and random. This apparent carelessness also relates to his increasing naïveté of style and tendency to deliberately distort, exaggerate, and caricature his forms. Bonnard was still practicing a quasi-abstract style, despite his realist subjects, but he approached abstraction in a relatively more subtle, less bold fashion. Likewise, he was less likely now to experiment with novel formats.

The group of *Petites scènes familières* deals with characteristic experiences of bourgeois domestic life, but probes below the surface to explore in a poignant fashion some of the states of mind elicited by those experiences — from parental tenderness to melancholy and anxiety, to reflection and humor.[40] *Rêverie*, for example, is Terrasse's piece evoking the dreamworld of thought. In his illustration, Bonnard materialized the idea of reverie in the face of a young woman, probably a portrait of his cousin, Berthe Schaedlin, who leans pensively on an elbow, resting her head on her hand (no. 116). He conveyed her dreamy, interior-oriented state not only by her pose and expression, but also through formal means. Especially in the upper half of the image, he covered the surface almost impressionistically with repeated short, choppy strokes, which continue from the figure's contours and hair into the background. The broken surfaces and contours and overall ripple pattern have the effect of merging the figure with the space around her so that she seems to dissolve and become as impalpable as the world of thoughts in which she is immersed. Bonnard thus creates a visual metaphor for the insubstantiality of the dream state. At the same time the rhythmic intricacy of the strokes recreates that of the music. Thus, while surface pattern still plays a dominant role in such work, its effect is now less decorative and more allusive.[41]

In *Promenade à âne* (The Donkey Ride), both artist and composer reverted to the more mundane and humorous side of bourgeois existence. The music is a playful tone painting about a traditional French childhood amusement — a donkey ride in the park. The music starts slowly and then speeds up as the animals begin to trot. Terrasse even evokes the "hee-haw" or braying of the donkeys and at one point incorporates an anecdote about a child who tumbles off and then gets back up on his donkey. This is the incident Bonnard depicted in his image, which also makes a visual counterpart to the music in its lighthearted and playful mood, conveyed through the comical caricatured forms of children and animals and the lively staccato markings that punctuate its surface (fig. 14). Moreover, Bonnard chose to complement the subject with a childlike style; it can be seen in his deliberately maladroit drawing, the awkward distorted and malproportioned figures, and the seemingly arbitrary surface markings. This naïveté was central to the ideals of the Nabis, who saw it as a

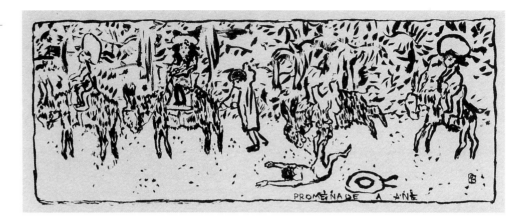

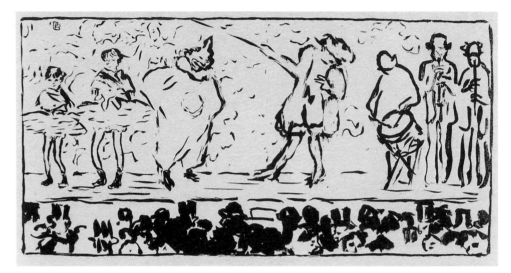

route to achieving "subjective deformation" of form, and who particularly valued primitive and unsophisticated art styles as the sincere, innocent, and unpremeditated product of natural instincts and inner feelings.[42]

Bonnard continued to employ this childlike style in his four illustrations for *La Fête au village*. Each recreates a scene from the country fair with its merchandise booths; lowbrow entertainments with clowns, mimes, and acrobats; circus acts; and public dancing. In *La Baraque* (The Booth), Bonnard illustrates the daily preview of the coming evening's circus, by the ringmaster, accompanied by the musicians, a clown, and two dancers (fig. 15). He also included, at the bottom of his image, the silhouetted heads of the spectators, who view the performers from below the stage. The cropping and the caricaturing recall Daumier, but Bonnard added a new degree of exaggeration, simplicity, and naïveté. His unrefined style effectively complements Terrasse's miniatures, which evoke the vernacular sounds of the popular fair, its raucous vendors, dances, and carnivalesque music.

Perhaps the most extreme expression of turn-of-the-century *fumisterie* was Alfred Jarry's iconoclastic play *Ubu Roi*, which premiered in December 1896 at Lugné-Poe's symbolist Théâtre de l'Oeuvre. The play featured music by Terrasse and a backdrop designed and painted by Bonnard and fellow Nabi Paul Sérusier, with assistance from Lautrec, Paul Ranson, and Vuillard. Paris audiences were shocked by the play's satire on the basest human passions — greed, brutality, cowardice, and egotism — all embodied in the grotesque and crude buffoon of a protagonist, Ubu.

**14**

**Pierre Bonnard,** Promenade à âne, **1895, lithograph. Virginia and Ira Jackson Collection, Promised Gift to the National Gallery of Art**

**15**

**Pierre Bonnard,** La Baraque, **1895, lithograph. Virginia and Ira Jackson Collection, Promised Gift to the National Gallery of Art**

The plot follows Ubu's insatiable quest for power, as he murders the king of Poland, and appropriates and then plunders the kingdom, stripping the nobility of its wealth with the aid of several instruments of torture, including a debraining machine. Eventually he is overthrown, but escapes to France. Throughout the play Ubu's greed is conveyed by metaphors of digestion and evacuation, symbolized by his enormous *gidouille* (Jarry's coined term for his belly) and his toilet-brush scepter. The play expresses a counterculture world view, continued from naturalism, that attacks "the bloated self-satisfied bourgeois . . . seeking profits for himself at the public's expense."[43]

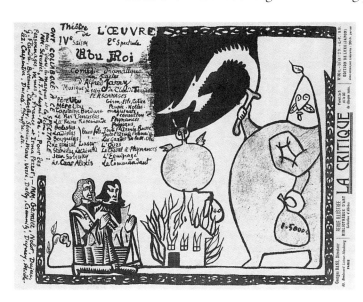

16

However, as a symbolist drama, Jarry's play rejects the realist "slice of life" and seeks instead to unmask the deeper truths of life through symbols and signs. To remove the action from the context of everyday reality, he specified that the actors wear masks, speak in artificial voices, and mimic the stiff and jerking movements of marionettes.[44]

Jarry found the Nabis to be a particularly sympathetic group of artists, and he shared their interest in primitive and naive art styles. Like them, he rejected orthodox realism and moved in the direction of abstraction through a deliberate stylization and simplification, while at the same time retaining elements of realism. These tendencies emerge not only in Jarry's writing — he wrote art criticism and edited two art journals in the 1890s, *L'Ymagier* and *Perhinderion* — but also in his own artwork of drawings, woodcuts, and lithographs. The program/poster he designed for the 1896 premiere of *Ubu* is a typical example of his primitivist mode (fig. 16). In it the figure of Ubu, with his pointed head and enormous belly, clutches a scimitar in one hand and a bag of gold in the other, as two peasants pray for mercy and one of his henchmen (*palotins*) floats above a burning house with another bag of gold; in the deluxe version, two other *palotins* pull away carts of loot (*phynances*).[45]

The Nabis also shared Jarry's enthusiasm for puppet theater; for them it was a popular art phenomenon that was naive, simplified, and therefore sincere.[46] These mutual interests led to the establishment of the Théâtre des Pantins, a brief but ambitious collaboration of late 1897 and early 1898 between the artists, Jarry, Claude Terrasse, and the writers Franc-Nohain and A. F. Hérold, which resulted in several productions with musical accompaniment and a number of illustrated music sheets. *Mercure de France* published the latter in 1898 as a collection entitled *Répertoire des pantins*. Organized by Terrasse, in the large studio of his Montmartre apartment at 6 rue Ballu, the fifty-seat theater was a *fumiste* enterprise par excellence. Hérold later recalled: "We didn't put on numerous spectacles, but we had a great time. At the *Pantins* the sets were painted and the puppets modeled by Bonnard, by Vuillard, by Ranson, by Roussel. . . . Jarry manipulated the [puppet's] strings; Terrasse

was at the piano; other comrades cheerfully sang and read the roles."[47] Coquiot recalled that Bonnard created some three hundred puppets for this enterprise.[48] In fact, in a later drawing from his series *La Vie du peintre* (The Life of the Painter; fig. 17), Bonnard pictured himself seated at a table modeling puppets as Hérold looks on and the artist's brother Charles examines a puppet; to the left the tall, bearded Terrasse confers with Jarry, who wears his habitual cycling costume, and Franc-Nohain in a bowler hat. The puppet stage is visible in the background.

The first production of the Théâtre des Pantins opened on 24 December 1897. The centerpiece of the comical Christmas eve show was a performance of Hérold's translation of *Paphnutius*, a medieval mystery play written in the late tenth century by the German nun Hrotsvitha. The play relates the story of the conversion of a harlot (Thaïs) by Paphnutius, a hermit saint. Jarry later noted that although it was a serious play, the very act of transforming it into a puppet show rendered it comical and irreverent.[49] The evening began with Franc-Nohain's welcome, delivered in rhyme, and concluded with a musical program that included *Trois chansons à la charcutière* (Three Songs to the Pork Butcher Woman) — poems by Franc-Nohain, set to music by Terrasse.

The reviewer for *La Critique* noted that Hérold's play and Franc-Nohain's songs "unleashed a storm of insane laughter" in the audience.[50] Franc-Nohain, who had begun his career at the Chat Noir, wrote *fumiste* poems that mocked the provincial bourgeoisie; he called them *poèmes amorphes*, because the verse was so free as to be almost amorphous. The sheet music for his *Trois chansons à la charcutière* had lithographed title pages by Bonnard. Each of the three centers around a zany play on words relating to the *charcutière*'s processed pork products. In a prelude Nohain explained that it is Christmas eve, the bells are ringing, and everyone is heading to church, except for the *charcutière*, who is obliged to remain at her counter: "She must sell the *cervelas* [dried sausage containing pig's brains],/the *rillettes* [minced pork pâté], and the *mortadelle* [Bologna sausage]...to prepare for the Christmas eve parties." But while she daydreams at her "saintly commerce" she hears the "sweet, exquisite, strange and tender" music of three songs sent down from heaven by the angels.[51] The first, *Du pays tourangeau* (From the Land of the Touraine), is a "love song" set in medieval Tours. The lady of the manor, a vain, cold beauty named Yette, is courted by a gentle young page, who "sings under her window" of his unrequited love for her. But "the cruel coquette" laughs at him, and "he cuts off his head." The narrator concludes, "Laugh, Yette!/Laugh, Yette of Tours!" These last words, in French (*Ris, Yette! Ris, Yette de Tours!*)[52] are pronounced exactly like the charcuterie delicacy *rillettes de Tours*, a Touraine specialty. And, coming immediately following the announcement that her suitor cut off his head, the pun makes a sly insinuation about what will become of his head.

17

16

Alfred Jarry, Théâtre de L'Oeuvre program/poster for *Ubu Roi*, **10 December 1896, photomechanical reproduction. National Gallery of Art, Gift of The Atlas Foundation**

17

Pierre Bonnard, La Vie du peintre, **c. 1910, pen and ink. France, private collection**

The second, *Malheureuse Adèle* (Unfortunate Adele), is a "song of mourning" in which the grieving narrator laments the death of a beautiful young woman and the helplessness of humans in the face of destiny: "Neither the power of monarchs, / Youth nor beauty, / Nothing is sheltered from the Fates, / All must submit to their cruelty." Each stanza ends with the mournful refrain, "She is dead, Adele!"[53] Once again the words (*Elle est morte, Adèle!*) make a witty pun — "she is mortadelle" — and the suggestion that the dead woman is merely meat for sausage abruptly deflates the elevated sentiments of the lyrics. The third poem, *Velas, ou l'officier de fortune* (Velas, or the Soldier of Fortune), is a "song of war," which recounts the tale of the brave Velas: "He laughed at death; / In his heart a voice cried: / Serve your country, / Serve Velas!" (*Sers, Velas!*). And, when he returns from war a captain, ready to marry his girlfriend, the narrator exhorts him: "Squeeze your girlfriend, / Squeeze, Velas!" (*Serre, Velas!*).[54] Both French phrases sound exactly like *cervelas*. The amusing but cynical world view expressed in these songs, their parody of the traditional sentimental poetic genres — the romantic, tragic, and heroic — is clearly heir to the iconoclastic Chat Noir mentality — now united with the symbolist spirit of the marionette theater.

These songs were probably performed with puppets. Bonnard's humorous illustrations seem to support this likelihood. Each includes the *charcutière* at her counter in the background but focuses on a single foreground figure relating to the relevant song: the serenading page for *Du pays tourangeau* (nos. 122–123), the narrator for *Malheureuse Adèle* (no. 124), and the soldier *Velas* (no. 125). Their caricatured appearances, stiff poses, and extended arms (as if attached to strings) strongly suggest that Bonnard may have based them on the very puppets he created for the performance. Using the crayon now, and appearing to set the forms down rapidly and almost carelessly, in a sketchy, improvisational, and at times roughly scribbled style, Bonnard moved further away from his decorative approach of the earlier nineties. Coquiot described these lithographs as seeming to be "drawn as if by a child," but "enhanced by a knowing drollness, by an ingenious choice of completely comical contrivances."[55]

Jarry and Bonnard each produced three sheet-music illustrations in conjunction with the Théâtre des Pantins' second production, a reprise of *Ubu Roi*. It opened on 20 January 1898 and played until 28 February. As a marionette show, it was probably the most authentic production of Jarry's play and closest in spirit to his original intentions.[56] André Fontainas, who attended a performance, described it as "a sort of primitive spectacle, almost childlike."[57] The five-act play, accompanied by the music of Terrasse and followed by three *Petits poèmes amorphes* by Franc-Nohain, set to music by Terrasse, was a success. The reviewer for *La Revue blanche* on 1 February reported that the applause was unanimous.[58]

Terrasse's burlesque musical accompaniments must have heightened the production's joviality[59] and farcical character, which was sustained in Jarry's lithographed sheet-music illustrations, done in a childlike style. The sheet-music cover for Terrasse's overture depicted a simplified caricature of the play's grotesque and absurd protagonist, Ubu (no. 129). It was one of numerous images he had made of Ubu, though perhaps his most childlike to date, and employs his own already established iconography for the character.[60] Deliberately imitating a child's style of drawing,

Jarry outlined Ubu's body and then used the crayon to fill it in with a multitude of spiral scribbles — these replace the large spiral he often superimposed on Ubu's *gidouille* to symbolize his infinite greed.[61] The three miniature figures of his *palotins* accompany Ubu here; they huddle under his belly, merging into a single black silhouette against his white form. In childish fashion, Jarry made them smaller in scale than the more important Ubu.[62] Jarry's simplistic and naive rendering of his figures without anatomy, modeling, or perspective, along with his deliberately maladroit writing — that is, his adoption of a style antithetical to conventional concepts of skill, proficiency, and good taste — was part of his more general attempt to demonstrate his liberation from traditional aesthetic values.

Jarry's most successful attempt at emulating children's art was his illustration for *La Chanson du décervelage* (The Debraining Song), sung at the conclusion of the play in the Pantins' version, much to the audiences' delight. The gleefully macabre song describes "the weekly public ritual" of debraining[63] conducted by the *palotins*, Ubu's loyal and fiendish henchmen, whose job it was to confiscate *phynance* from his subjects and brutally punish those who would not comply. Jarry's illustration pictures the *palotins*, hand in hand, in an appropriately primitive and comical style, which makes the sadistic threesome seem more impish than threatening (no. 131). He constructed each figure according to the same simplistic formula; the scribbles to their right no doubt stand for the spurting brains of their victims. Jarry's crude and schematic execution, totally lacking in conventional visual subtleties, closely approximates the elementary and simplistic conceptual sensibility of young children.

Bonnard's illustrations for the sheet music for the three *Petits poèmes amorphes* of Franc-Nohain make a striking contrast with those of Jarry. Bonnard's style is much less crude and primitive, his sensibility much less absurdist than Jarry's; his is the naïveté of a more sophisticated artist. Nohain's poems are cynically humorous attempts to debunk that which is normally idealized or held sacred and to expose the more unpleasant underlying reality.[64]

The subject deflated in the first song is death. *La Complainte de Monsieur Benoît* (Monsieur Benoît's Lament), whose name should be understood as an ironic pun, meaning "sanctimonious," reads like provincial gossip about the bourgeois M. Benoît who, "In his stylish/neat country house in Saint-Mandé, /...yesterday morning, committed suicide" and in so doing created great inconvenience and embarrassment for his family members, whose futures were now thrown in doubt — his "good" wife, his daughter who was to marry a rich industrialist, and his ambitious son. The song expresses a seemingly hypocritical pity for them, at the same time as it hints, with apparent relish, at the "disgusting" scandal that precipitated Benoît's suicide: he was a womanizer. "It didn't stop the entire family from going to the burial, /One must admit it would have been difficult for them to do otherwise." Bonnard, in fact, pictured the family members, dressed in black, at the head of the funeral procession, Benoît's "stylish country house" in the background (no. 126). The figures are simplified and awkwardly drawn; their forms are outlined and most are filled in with careless black scribbles; he used childlike formulas for the house, trees, and clouds. Despite this apparent naïveté, however, Bonnard did manage to imply spatial recession and volume

through the diminishing size and clarity of his figures as they move into the distance, through complex overlapping, and through the drapery folds of the women's black veils (on which the black scribbles function as the play of light and shadow), and even by giving the roof a mansard slope. Moreover, the figures' postures, the facial expressions of the son to the right and the mourner to the left are quite effective in conveying their mood of dejection, though not without a little comic absurdity. And the decorative play of dark silhouettes of figures and trees against a light ground remains within the aesthetically sophisticated sensibility of Bonnard's earlier work.

Franc-Nohain's second *petit poème amorphe*, *Berceuse obscène* (Obscene Lullaby), expresses irreverence for a cherished type in French society — the wet nurse, to whose maternal instincts the care of the infants of the well-to-do are entrusted. But the wet nurse in question sings a vulgar lullaby to her charge, one that suggests she carries on an illicit relationship with his father. As she "unfastens her bodice" and offers her breast, all the while prattling little endearments to the baby, she slyly suggests that "The gentleman of the house [i.e., the baby's father] would like to have some too" and that "When baby is grown up, / It will be much more interesting; / if *nounou* unfastens her bodice," especially since his father "would no longer be so ready with a hard on," implying that the son might then take his place. Bonnard complemented Nohain's prurient lyrics with a caricature of an obscenely obese wet nurse, rocking the infant in her arms (no. 127). With simple curving lines and minimal shading, he suggested the amplitude and pillowy softness of her corpulent form, which seems to literally engulf the baby, whom she eyes like a glutton contemplating her next meal. The sophisticated use of caricature here is penetrating of character and far from innocent.

The final song of Nohain's trio, *Paysage de neige* (Snowy Landscape), sets up a potentially dramatic and threatening scene and then proceeds, with a few nonchalant words, to drain the suspense from it and convey instead a sense of life's ordinariness. "Extremely white" snow covers a plain in the Ardèche, where eleven "extremely black" crows chatter on the branches of an elm tree. They seem to be waiting for an encounter between the "seven children with frozen noses and feet" who appear on a winding footpath and "a big wolf" who also inhabits this landscape. But, "After a while, the birds fly off / The children turn toward the school / The wolf dies, the snow melts: / And what can you do about it, in the end?" Bonnard recreated in visual form Nohain's vivid imagery, conveying the song's ominous undertone through the looming silhouettes of the crows; the tiny, vulnerable children; and large, hungry wolf, who is a menacing presence on the lower left of the page (no. 128). Moreover, though he simplified his forms, particularly those of the children, and though his scribble marks, scratchings, and jabbings on the surface may seem haphazard and naive, once again Bonnard displayed his refined decorative sensibility in his placement of forms across the page. His elegant patterning of black forms on a white ground and delicate calligraphic strokes to indicate the tree branches show his knowledge of Japanese art.[65]

For Bonnard and his contemporaries, music illustration was an arena for stylistic experimentation, as the artists moved from naturalist to more abstract symbolist modes. Their rejection of the strict imitation of optical reality and deliberate adoption of the stylistic simplification, naïveté, and crudeness of popular art forms

was no doubt also reinforced by their symbolist precept that the purpose of art was to convey (and evoke) feeling and their corollary belief in the superior expressive potential of abstracted and distilled forms. Yet naturalism and symbolism were not always in extreme opposition. They shared antiestablishment and *fumiste* attitudes, a mutual interest in subverting tradition, and a critique of bourgeois culture. Furthermore, the symbolist simplification and "primitivism" was an extension of the realist generation's interest in popular imagery that began with artists like Courbet and Manet and that eventually became a means to attain the symbolist generation's more universal meanings and stylistic abstraction.

---

**1** Prior to this time, music illustration was primarily the province of commercial artists. Among the French avant-garde, only Manet had previously illustrated music, lithographing in the 1860s two cover designs for sheet music, *Lola de Valence, poésie et musique de Zacharie Astruc* and *Plainte moresque*. See Jean C. Harris, *Edouard Manet: Graphic Works, a Definitive Catalogue Raisonné* (New York, 1970), 32, 29.

**2** These illustrations, however, have been largely overlooked, as collectors and critics tended to regard them as ephemera rather than original prints and few copies have been preserved, first, because the illustrations combined image and printed text and, second, because publishers generally issued them on poor quality paper in large-run editions and sold them at low prices. Often, publishers marketed the same images in more costly collectors' editions, without the accompanying lettering (i.e., the song titles, sheet music, and lyrics). It is mainly these versions that have survived; hence the images are isolated from the texts they illustrate and their meanings obscured.

**3** Maurice Donnay, *Mes débuts à Paris*, 229, 235, as quoted in Harold B. Segel, *Turn-of-the-Century Cabaret* (New York, 1987), 36, 369 n. 39.

**4** Charles Rearick, *Pleasures of the Belle Epoque* (New Haven, 1985), 62. See also Jerrold Seigel, *Bohemian Paris* (New York, 1986), 239–241.

**5** See Gale B. Murray, *Toulouse-Lautrec: The Formative Years, 1878–1891* (Oxford, 1991), 87.

**6** Mary Ellen Poole, "*Chansonnier* and *chanson* in Parisian *cabarets artistiques*, 1881–1914," Ph.D. diss., University of Illinois, 1994, 8.

**7** Poole 1994, 126. The proliferation of illustrated sheet music in the 1880s and 1890s was made possible by the spread of lithography, which facilitated the production of cheap, rapidly made, large-run and widely available mass-produced images. Between 1830 and 1850, lithographic processes gradually replaced engraving in the production of sheet music. See Michael Twyman, *Early Lithographed Music* (London, 1996), 12, 42.

**8** Richard Harding Davis, *About Paris* (New York, 1895), 69. The smaller format usually sold for one franc, while the larger cost three francs.

**9** Marie-Véronique Gauthier, *Chanson, sociabilité et grivoiserie au XIXe siècle* (Paris, 1992), 8.

**10** Howard Lay, "La Fête aux boulevards extérieurs: Art and Culture in fin-de-siècle Montmartre," Ph.D. diss., Harvard University, 1991, 97.

**11** Phillip Dennis Cate, "Steinlen and His Art: A Chronological Survey," in Phillip Dennis Cate and Susan Gill, *Théophile-Alexandre Steinlen* [exh. cat., Jane Voorhees Zimmerli Art Museum, New Brunswick] (Salt Lake City, 1982), 45.

**12** Bruant published the sheet music in 1891; however, Steinlen signed the drawing on which the sheet-music illustration was based *Jean Caillou* — the pseudonym he used only from 1885 to 1889.

**13** Aristide Bruant, *Dans la rue*, 2 vols. (Paris, 1888–1895), 2: 82. All translations by author, unless otherwise noted.

**14** See also *Le Mirliton*, 24 November 1893, and Bruant 1888–1895, 2: 82–83.

**15** Léon de Bercy, *Montmartre et ses chansons, poètes et chansonniers* (Paris, 1902), 168–169.

**16** Patricia Eckert Boyer, "The Artist as Illustrator in Fin-de-Siècle Paris," in *The Graphic Arts and French Society*, ed. Phillip Dennis Cate (New Brunswick, 1988), 115.

**17** As quoted in Boyer 1988, 152, 168 n. 71.

**18** Charles Saunier, "H-G. Ibels," *Revue encyclopédique* (1896), 236.

**19** Henri Perruchot, *Toulouse-Lautrec*, trans. Humphrey Ware (New York, 1960), 187–188.

20 Charles Saunier, "Les Peintres symbolistes," *La Revue indépendante*, December 1892, quoted in George L. Mauner, *The Nabis: Their History and Their Art, 1888–1896* (New York, 1978), 102.

21 He also made several early paintings illustrating Bruant songs. See, e.g., Murray 1991, 106–107, 114–119, 138–139.

22 Bruant 1888–1895, 1: 61. See Murray 1991, 114–118; Lautrec's drawing appeared again in 1888, when Bruant had it reproduced in lithographic form by a printer on the sheet-music cover for the song. This was Lautrec's only sheet-music illustration for Bruant.

23 Maurice Denis, "Définition du néo-traditionnisme," *Art et critique*, 23 and 29 August 1890. Reprinted in Maurice Denis, *Théories: 1890–1910* (Paris, 1912).

24 Helen E. Giambruni, "Early Bonnard, 1885–1900," Ph.D. diss., University of California, Berkeley, 1983, 40, 291 n. 12.

25 Quoted by Antoine Terrasse, "Graphic Arts," in Claire Frèches-Thory and Antoine Terrasse, *The Nabis*, trans. Mary Pardoc (New York, 1991), 214.

26 Gerard Vaughan, "Maurice Denis and the Sense of Music," *The Oxford Art Journal* 7, 1 (1984), 39. Vaughan notes that fellow Nabi Paul Ranson nicknamed Denis "le Nabi polichrophilharmonique" (the polychro[matic]-philharmonic Nabi) in acknowledgment of Denis' interest in establishing a "musical" art (p. 41).

27 See Vaughan 1984 for paintings with musical themes. In the early 1890s Denis also made a number of watercolor designs for lampshades with illustrations of musical subjects, e.g., "Erlkönig," a poem by Goethe set to music by Schubert, and "Au pont du nord," an old French ballad. See *The Nabis and the Parisian Avant-Garde*, ed. Patricia Eckert Boyer [exh. cat., Jane Voorhees Zimmerli Art Museum, New Brunswick] (New Brunswick, 1988), nos. 52, 53.

28 Vaughan 1984, 44.

29 Aurélien-François Lugné-Poe, *La Parade: Le Sot du Tremplin* (Paris, 1930), 243.

30 Gustave Coquiot, *Bonnard* (Paris, 1922), 12.

31 Quoted in Giambruni 1983, 85.

32 See, e.g., *Danse macabre* and *Marche héroique* (music by Camille Saint-Saëns); *Mandoline* and *Espièglerie* (music by Francis Thomé); *Sonatine* and *Suite pour piano* (music by Claude Terrasse); *Le Cid* (music by Jules Massenet); *J'ai tout donné pour rien* (poem by Théophile Gautier, music by Terrasse). Listed in Colta Ives, Helen Giambruni, and Sasha Newman, *Pierre Bonnard: The Graphic Art* [exh. cat., The Metropolitan Museum of Art] (New York, 1989), 236–237. See also *Pas redoublé*, Jackson Collection.

33 Antoine Terrasse, *Pierre Bonnard Illustrator* (New York, 1989), no. 4, 18; the drawing was reproduced a second time in the journal *La Croisade* in April 1893.

34 See A.-Ferdinand Hérold, "Claude Terrasse," *Mercure de France*, 1 August 1923, 695–696.

35 As translated in exh. cat. New Brunswick 1988; see also 77 n. 20.

36 On the influence of children's book illustrations, see Giambruni, "Domestic Scenes," in exh. cat. New York 1989, 53–57.

37 See, e.g., Charles M. Widor, *Vieilles chansons et rondes pour les petits enfants* (Paris, 1884), and J.-B. Weckerlin, *Chansons de France pour les petits français* (Paris, 1884).

38 Letter quoted by Giambruni in exh. cat. New York 1989, 56; on Japanese influence see Ursula Perucchi-Petri, *Die Nabis und Japan* (Munich, 1976), 79–80.

39 Giambruni in exh. cat. New York 1989, 198 n. 53.

40 Giambruni in exh. cat. New York 1989, 64.

41 Giambruni in exh. cat. New York 1989, 91.

42 Giambruni 1983, 186–189.

43 Patricia Leighten, "'La Propagande par le rire': Satire and Subversion in Apollinaire, Jarry and Picasso's Collages," *Gazette des beaux-arts* 112 (October 1988), 165.

44 See Arthur Symons, *Studies in Seven Arts* (New York, 1925), 240–241, and S. Beynon John, "Actor as Puppet: Variations on a Nineteenth-Century Theatrical Idea," in *Bernhardt and the Theater of Her Time*, ed. Eric Salmon (Westport, 1984), 251–252.

45 Stephen H. Goddard, "Ubu's Almanac: Alfred Jarry and the Graphic Arts," in S. H. Goddard, *Ubu's Almanac: Alfred Jarry and the Graphic Arts* [exh. cat., Spencer Museum] (Lawrence, Kans., 1998), 15.

46 The premiere of Maeterlinck's *Les Sept princesses* took place in 1891 at a puppet theater organized by the Nabis, who created the sets, puppets, costumes, and program announcement. In 1894, Ranson organized a second puppet theater and began to write and produce a series of irreverent, antiestablishment plays in which the central character was a cleric, the Abbé Prout.

47 Hérold 1923, 694.

48 Coquiot 1922, 27.

49 Alfred Jarry, "Les Marionnettes," excerpt from "Conférence sur les Pantins," presented at La Libre Esthétique, Brussels, 22 March 1902, reprinted in Alfred Jarry, *Oeuvres complètes*, ed. Henri Bordillon (Paris, 1987), 2: 636.

50 G. B., "Théâtre des Pantins," *La Critique* 69 (January 1898), 10.

51 Franc-Nohain, *Poèmes amorphes* ([Paris,] 1969), prelude, 115–116; prelude and all three poems originally published in the collection *Flutes*, 1898.

52 Franc-Nohain 1969, 116–117; slight changes in wording in *Mercure de France* song edition.

53 Franc-Nohain 1969, 117–118.

**54** Franc-Nohain 1969, 118–119; probably a cruder meaning is implied by "Serre ton amie," i.e., "do it to your girlfriend."

**55** Coquiot 1922, 28.

**56** Judith Cooper, *Ubi Roi: An Analytical Study* (New Orleans, 1974), 31–32.

**57** André Fontainas, *Mes Souvenirs du symbolisme* (Paris, 1928), 168.

**58** F, "La Quinzaine dramatique," post scriptum, *La Revue blanche*, 1 February 1898, quoted in Noël Arnaud, *Alfred Jarry: d'Ubu Roi au Docteur Faustroll* (Paris, 1974), 395–396. See also Thadée Natanson, "Petite gazette d'art," *La Revue blanche*, 1 February 1898, 213, who praised the decorations and Bonnard's puppets.

**59** Keith Beaumont, *Alfred Jarry: A Critical and Biographical Study* (New York, 1984), 143.

**60** For Jarry's images of Ubu, see Michel Arrivé, *Peintures, gravures et dessins d'Alfred Jarry* (Paris, 1968), and Christine van Schoonbeek, *Les Portraits d'Ubu* (Paris, 1997), 43–51.

**61** See, e.g., Arrivé 1968, pl. 53.

**62** They, too, follow a standard Jarry iconography; in fact, in this case he borrowed their forms and configuration from one of his earlier renderings. See Arrivé 1968, pl. 47.

**63** Cooper 1974, 63.

**64** Originally published in Franc-Nohain, *Les Inattentions et sollicitudes* (Paris, 1894).

**65** He may have been directly influenced by Ogata Korin's woodcut of crows; see Perucchi-Petri 1976, 87–88. It was reproduced in Samuel Bing, *Le Japon artistique* 4, 23 (March 1890).

# Catalogue

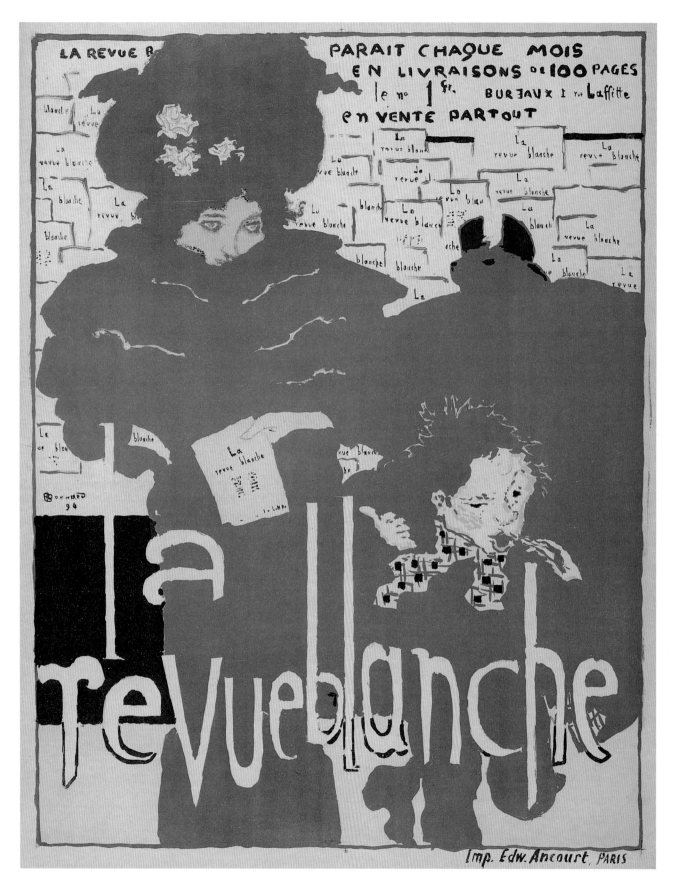

**NO. 1**
**PIERRE BONNARD**

Poster for *La Revue blanche*, 1894. Virginia and Ira Jackson Collection, Promised Gift to the National Gallery of Art

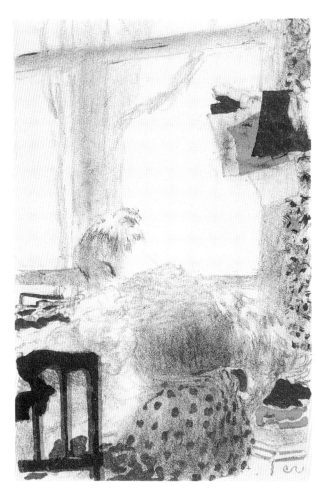

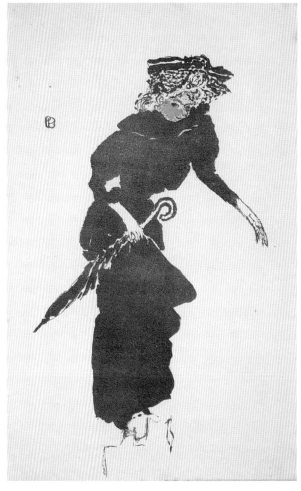

**NO. 2**
**EDOUARD VUILLARD**

*La Couturière*
(The Dressmaker),
1894. Virginia
and Ira Jackson
Collection, Prom-
ised Gift to the
National Gallery
of Art

**NO. 3**
**PIERRE BONNARD**

*Femme au parapluie*
(Woman with
an Umbrella),
1894. Virginia
and Ira Jackson
Collection, Prom-
ised Gift to the
National Gallery
of Art

**NO. 6A–B**
**PIERRE BONNARD**

Studies for *France-Champagne,* c. 1889.
Virginia and Ira Jackson Collection,
Promised Gift
to the National
Gallery of Art

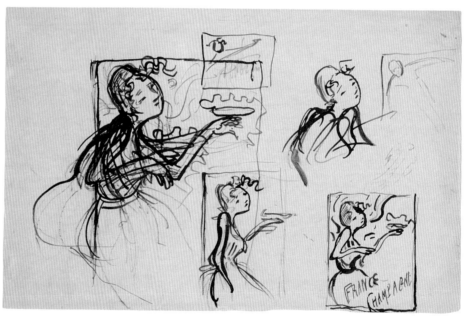

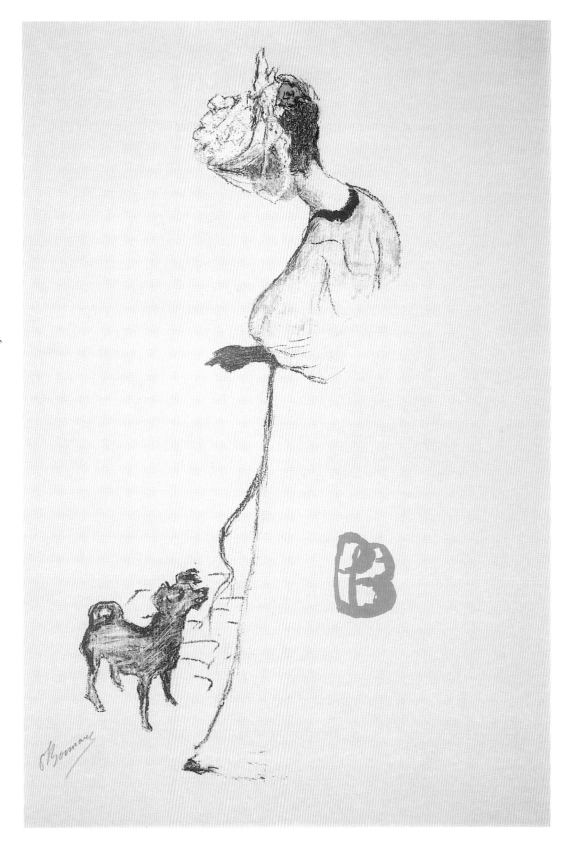

**NO. 7**
**PIERRE BONNARD**

Poster for *Salon des cent* (proof), 1896. National Gallery of Art, Virginia and Ira Jackson Collection, Partial and Promised Gift

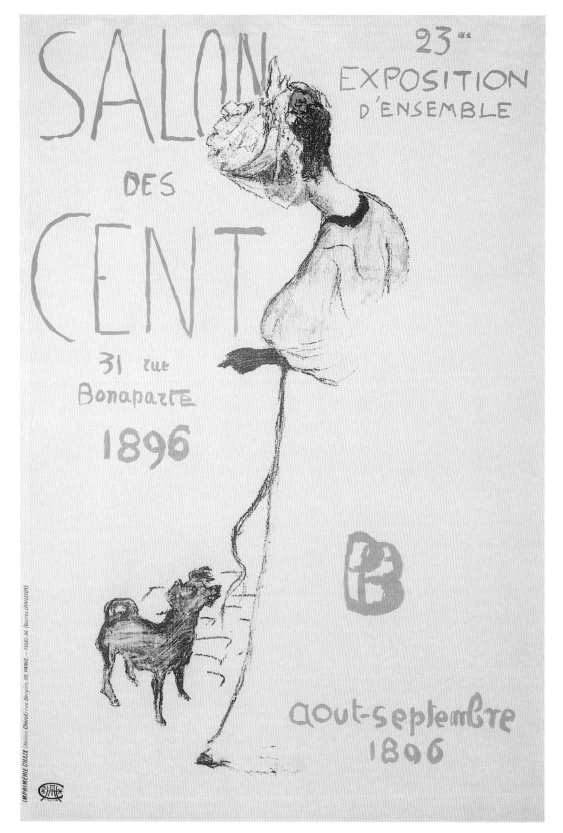

**NO. 8**
**PIERRE BONNARD**

Poster for *Salon des cent*, 1896. National Gallery of Art, Virginia and Ira Jackson Collection, Partial and Promised Gift

NO. 9
HERMANN-PAUL

Cover for *L'Escar-
mouche,* 24 Decem-
ber 1893. Virginia
and Ira Jackson
Collection

## L'ESCARMOUCHE NO. 9 – NO. 12

NO. 10
PIERRE BONNARD

*Les Chiens* (Dogs),
1893. Virginia
and Ira Jackson
Collection, Prom-
ised Gift to the
National Gallery
of Art

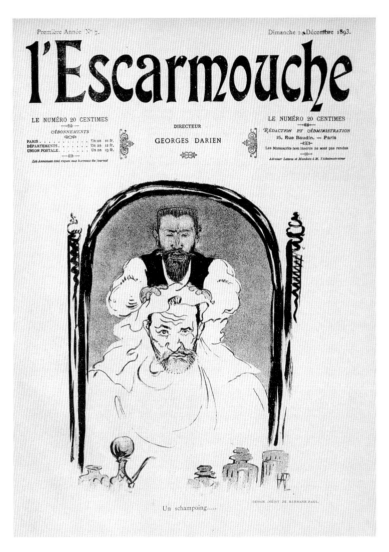

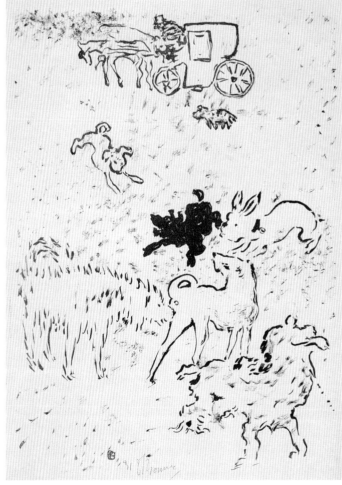

**NO. 11**
**PIERRE BONNARD**

*Conversation*, 1893.
Virginia and Ira
Jackson Collection,
Promised Gift
to the National
Gallery of Art

**NO. 12**
**PIERRE BONNARD**

Study for
*Conversation*, 1893.
Virginia and Ira
Jackson Collection

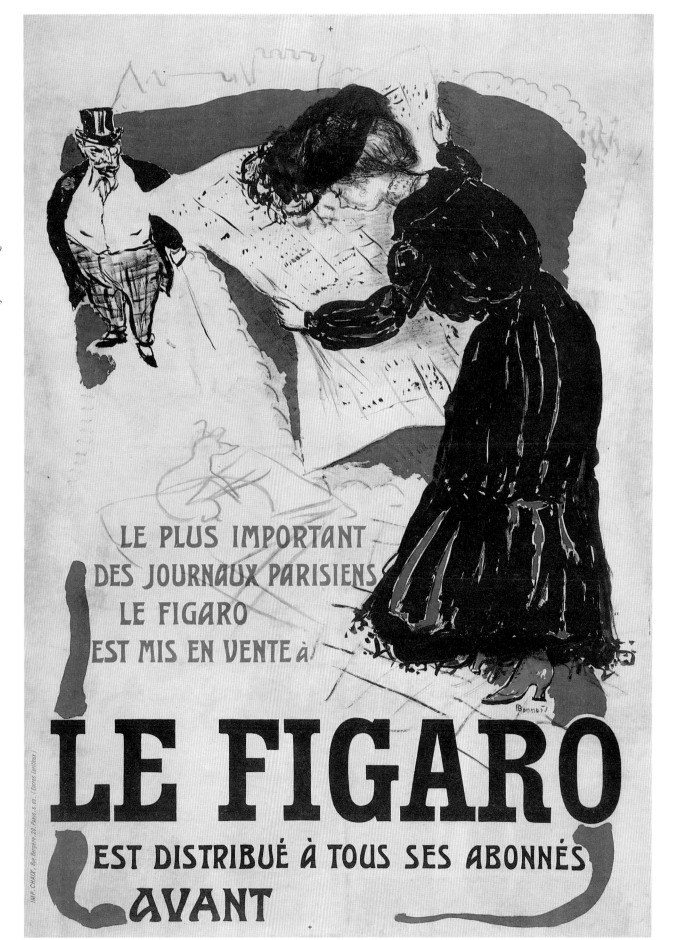

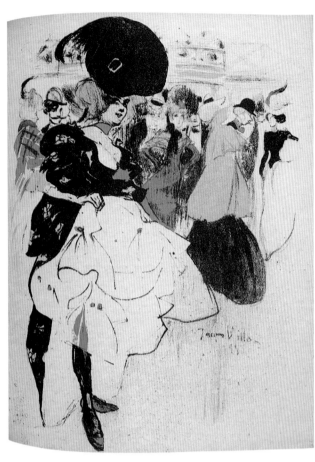

**NO. 14**
**JACQUES VILLON**

*La Danseuse au Moulin Rouge* (Dancer at the Moulin Rouge), in *L'Estampe et l'affiche*, 1899. Virginia and Ira Jackson Collection

**NO. 15**
**PIERRE BONNARD**

*Les Boulevards,* in *Album-Pan*, 1900. Virginia and Ira Jackson Collection, Promised Gift to the National Gallery of Art

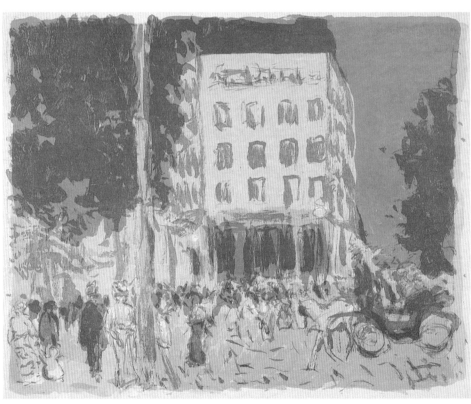

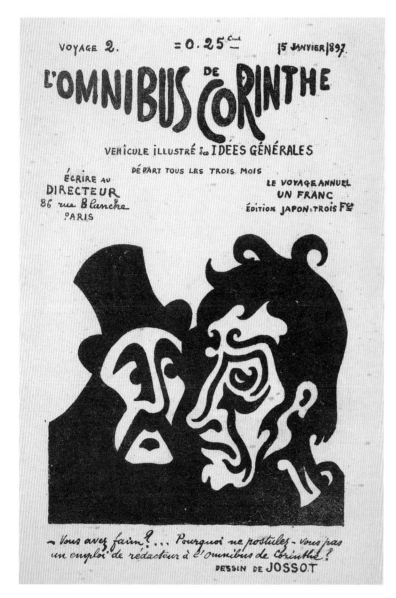

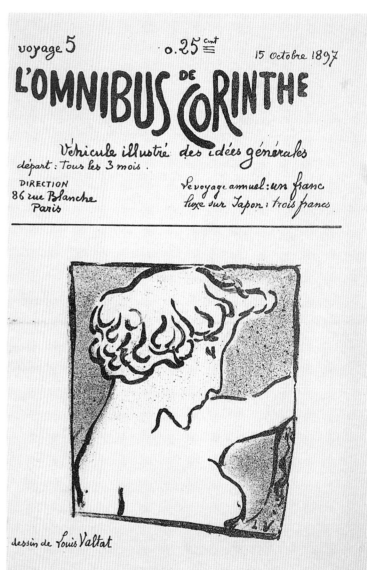

NO. 16A
**HENRI-GUSTAVE
JOSSOT**

Cover for
*L'Omnibus de
Corinthe,* 15 January
1897. Virginia
and Ira Jackson
Collection,
Promised Gift
to the National
Gallery of Art

NO. 16B
**LOUIS VALTAT**

Cover for *L'Omni-
bus de Corinthe,*
15 October 1897.
Virginia and Ira
Jackson Collection,
Promised Gift
to the National
Gallery of Art

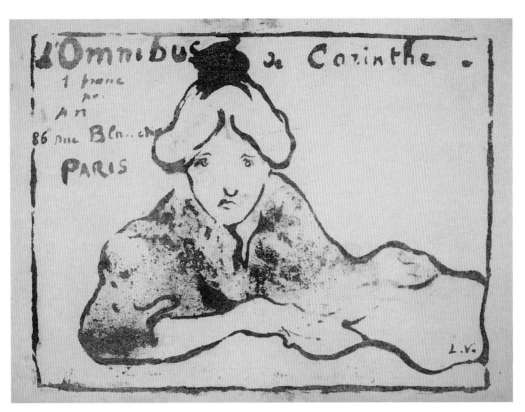

**NO. 17**
**LOUIS VALTAT**

Supplement to
*L'Omnibus de
Corinthe,* 1896.
Virginia and Ira
Jackson Collection,
Promised Gift
to the National
Gallery of Art

**NO. 18**
**PIERRE BONNARD**

Supplement to
*L'Omnibus de
Corinthe,* 1897.
Virginia and Ira
Jackson Collection,
Promised Gift
to the National
Gallery of Art

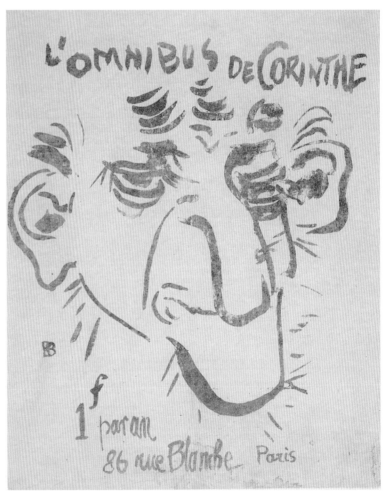

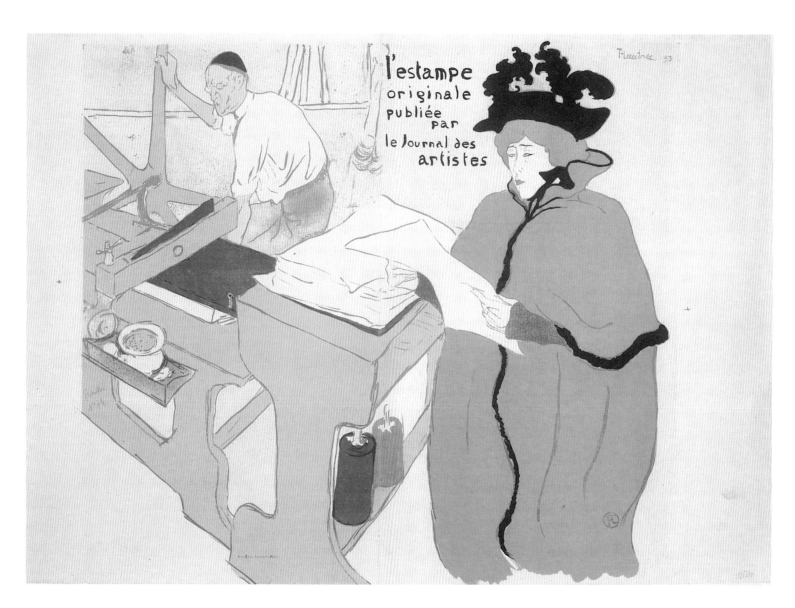

**NO. 19**
**HENRI DE**
**TOULOUSE-LAUTREC**

Cover for
*L'Estampe originale,*
1893. National
Gallery of Art,
Rosenwald Col-
lection

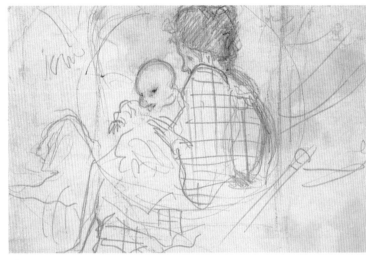

**NO. 20**
**PIERRE BONNARD**

*Scène de famille*
(Family Scene),
1893. National
Gallery of Art,
Virginia and Ira
Jackson Collec-
tion, Partial and
Promised Gift

**NO. 21**
**PIERRE BONNARD**

Study for *Scène
de famille,* 1892.
Virginia and Ira
Jackson Collection,
Promised Gift
to the National
Gallery of Art

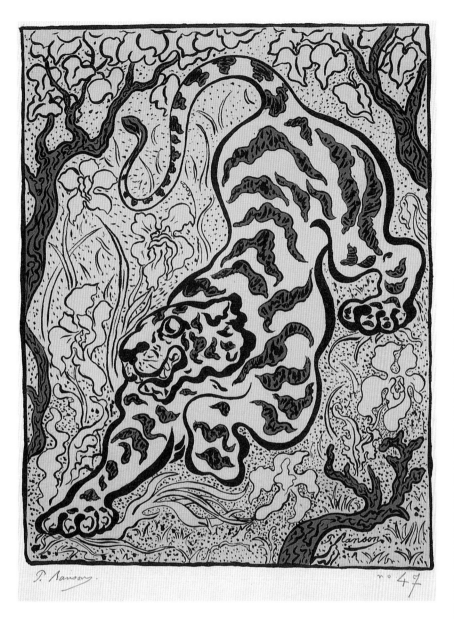

NO. 22
PAUL RANSON

*Tigre dans les jungles* (Tiger in the Jungle), 1893. Virginia and Ira Jackson Collection, Promised Gift to the National Gallery of Art

NO. 23
KER XAVIER ROUSSEL

*Dans la neige* (In the Snow), 1893. Virginia and Ira Jackson Collection, Promised Gift to the National Gallery of Art

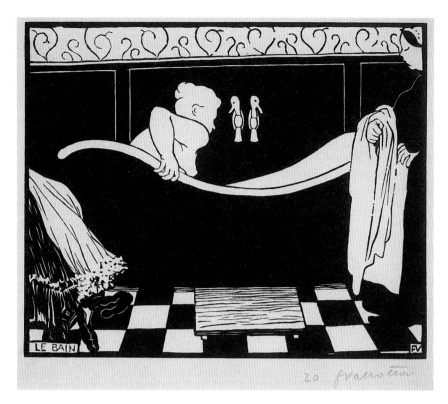

NO. 24
FÉLIX VALLOTTON

*Le Bain* (The Bath),
1894. Virginia
and Ira Jackson
Collection,
Promised Gift
to the National
Gallery of Art

NO. 25
PAUL SIGNAC

*Saint-Tropez*, 1894.
National Gallery
of Art, Virginia
and Ira Jackson
Collection, Partial
and Promised Gift

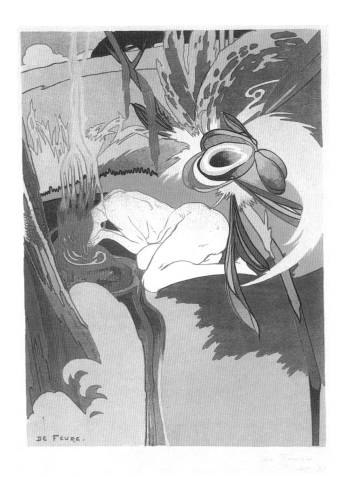

NO. 26
**GEORGES DE FEURE**

*La Source du mal*
(The Source of
Evil), 1894.
Virginia and Ira
Jackson Collection,
Promised Gift
to the National
Gallery of Art

NO. 27
**HENRI-GUSTAVE
JOSSOT**

*La Vague* (The
Wave), 1894.
Virginia and Ira
Jackson Collection,
Promised Gift
to the National
Gallery of Art

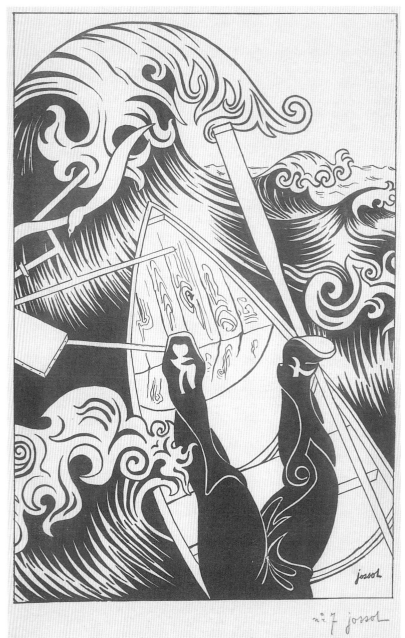

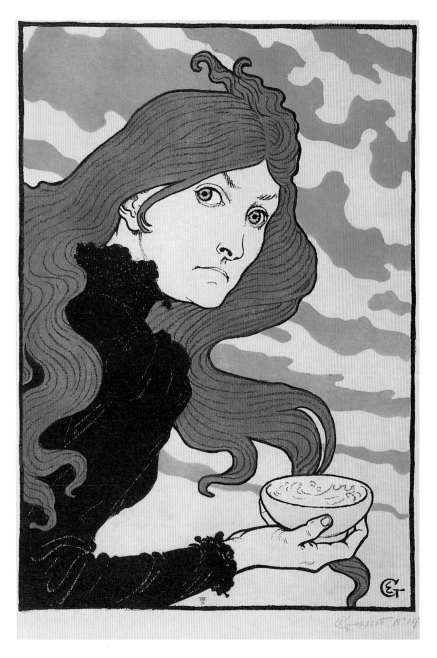

**NO. 28**
**EUGÈNE GRASSET**

*La Vitrioleuse* (The
Acid Thrower),
1894. Virginia
and Ira Jackson
Collection

**NO. 29**
**PAUL GAUGUIN**

*Manao Tupapau*
(She is Haunted
by a Spirit), 1894.
National Gallery
of Art, Rosenwald
Collection

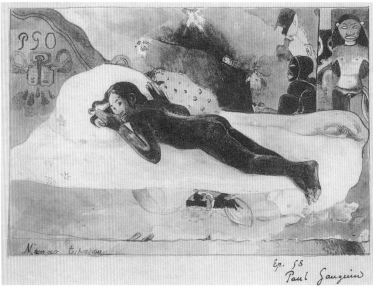

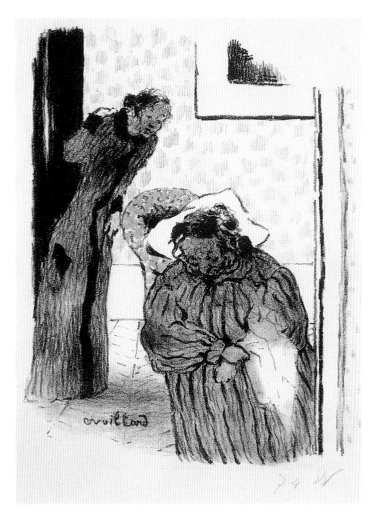

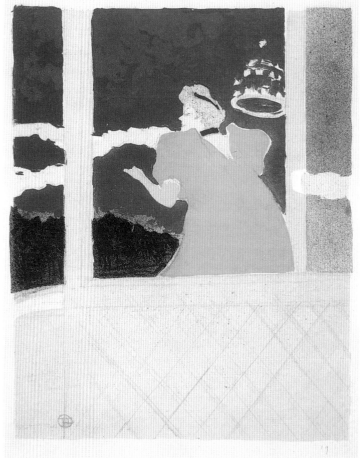

**NO. 30**
**EDOUARD VUILLARD**

*Intérieur* (Interior),
1893. Virginia
and Ira Jackson
Collection, Prom-
ised Gift to the
National Gallery
of Art
*(left)*

**NO. 31**
**HENRI DE**
**TOULOUSE-LAUTREC**

*Aux Ambassadeurs*
(At the Ambas-
sadeurs), 1894.
National Gallery
of Art, Collection
of Mr. and
Mrs. Paul Mellon
*(right)*

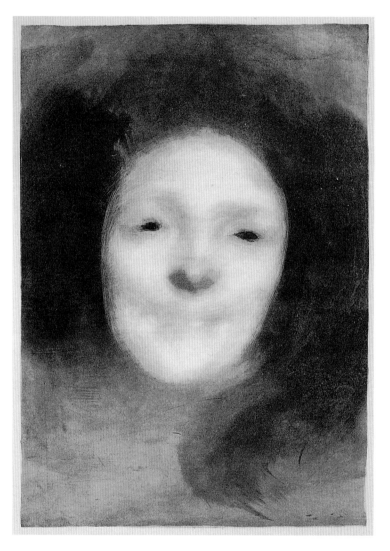

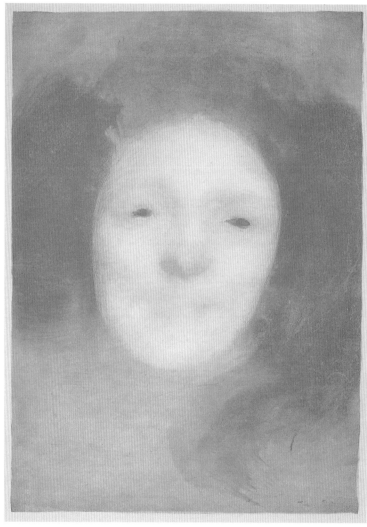

**NO. 32A**
**EUGÈNE CARRIÈRE**

*Etude de femme*
(Study of a Woman),
1894. National
Gallery of Art,
Virginia and Ira
Jackson Collec-
tion, Partial and
Promised Gift

**NO. 32B**
**EUGÈNE CARRIÈRE**

*Etude de femme*
(Study of a Woman),
1894. National
Gallery of Art,
Virginia and Ira
Jackson Collec-
tion, Partial and
Promised Gift

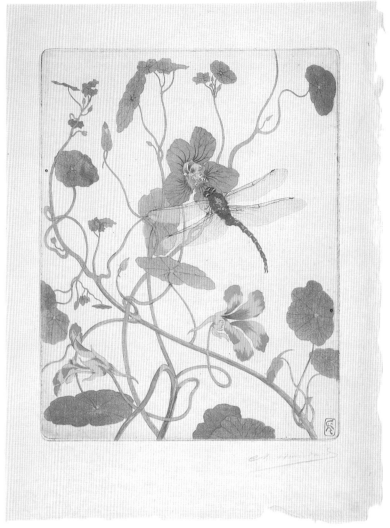

**NO. 32C**
**PAUL SÉRUSIER**

*Paysage* (Landscape), 1895.
National Gallery of Art, Virginia and Ira Jackson Collection, Partial and Promised Gift
*(left)*

**NO. 32D**
**CHARLES-LOUIS-M. HOUDARD**

*Fleurs* (Flowers), 1895. National Gallery of Art, Virginia and Ira Jackson Collection, Partial and Promised Gift
*(right)*

**NO. 32E**
**ARISTIDE MAILLOL**

*Eté* (Summer),
1895. National
Gallery of Art,
Virginia and Ira
Jackson Collec-
tion, Partial and
Promised Gift

**NO. 32F**
**ARISTIDE MAILLOL**

*Eté* (Summer),
1895. National
Gallery of Art,
Virginia and Ira
Jackson Collec-
tion, Partial and
Promised Gift

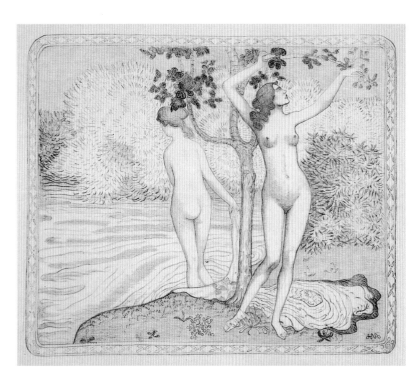

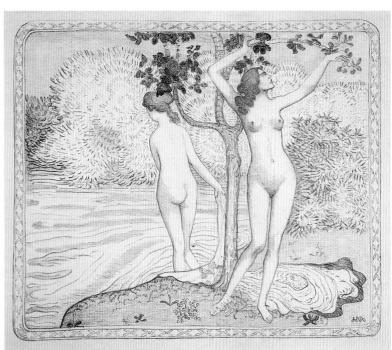

**NO. 32G**
**EDOUARD VUILLARD**

*Les Tuileries* (The Tuileries), 1895. National Gallery of Art, Virginia and Ira Jackson Collection, Partial and Promised Gift

**NO. 33**
**PIERRE BONNARD**

*L'Arrière-grand-mère* (Great Grandmother) (proof), 1895. Virginia and Ira Jackson Collection, Promised Gift to the National Gallery of Art

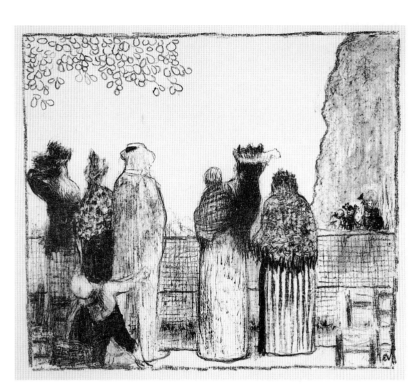

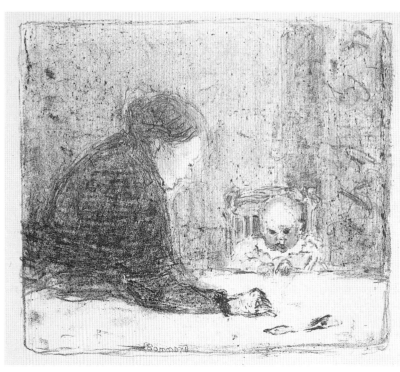

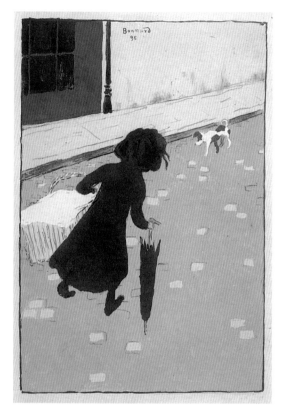

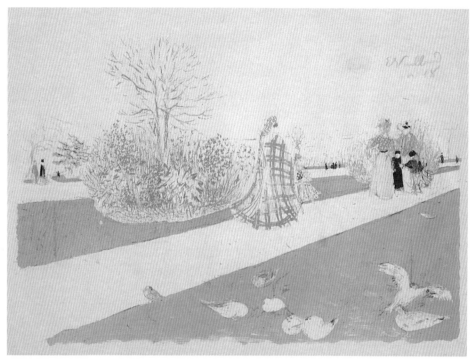

**NO. 34**
**PIERRE BONNARD**

*La Petite Blanchis-seuse* (The Little Laundry Maid), 1896. National Gallery of Art, Virginia and Ira Jackson Collection, Partial and Promised Gift

**NO. 35**
**EDOUARD VUILLARD**

*Le Jardin des Tuileries* (The Tuileries Garden), 1896. National Gallery of Art, Rosenwald Collection

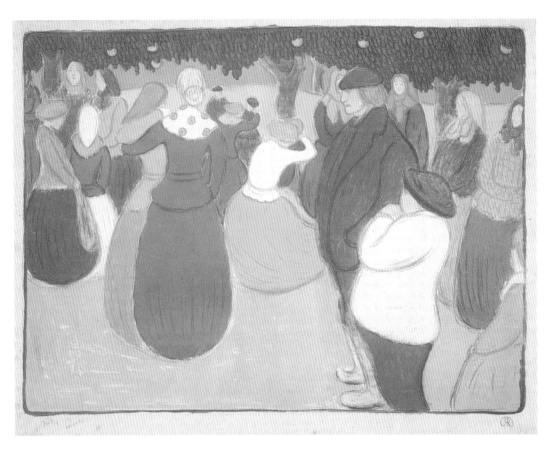

**NO. 36**
**JÓZSEF RIPPL-RÓNAI**

*La Fête de village*
(Village Festival),
1896. National
Gallery of Art,
Virginia and Ira
Jackson Collec-
tion, Partial and
Promised Gift

**NO. 37**
**EDVARD MUNCH**

*Anxiété* (Anxiety),
1896. The Epstein
Family Collection

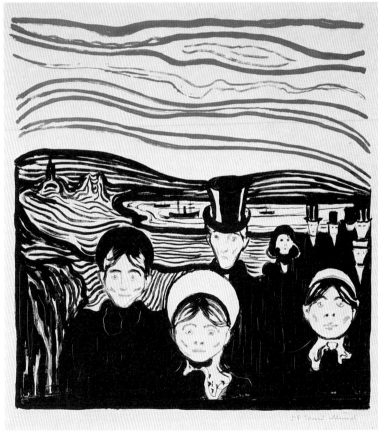

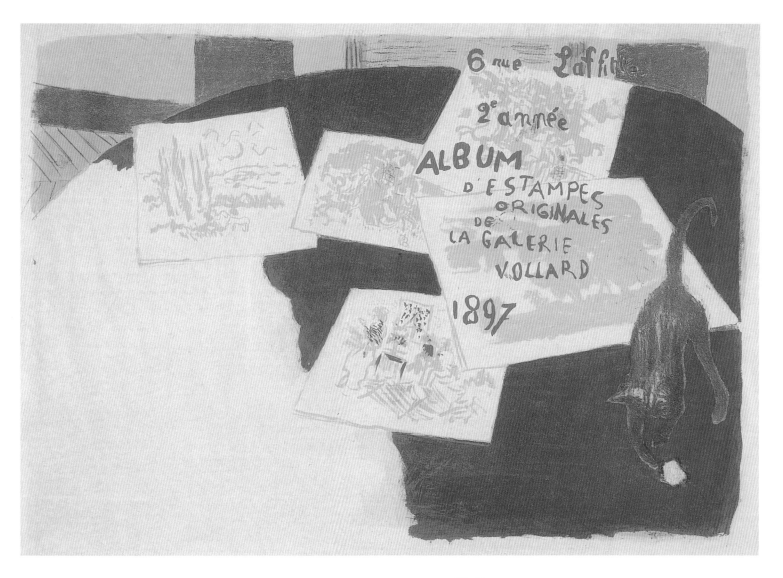

**NO. 38**
**PIERRE BONNARD**

Cover for *Album
d'estampes origi-
nales de la Galerie
Vollard*, 1897.
Virginia and Ira
Jackson Collection,
Promised Gift
to the National
Gallery of Art

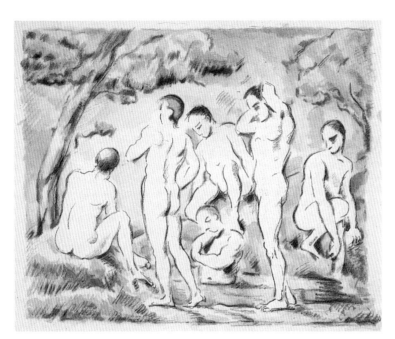

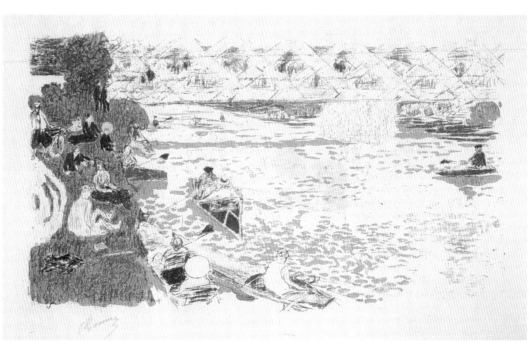

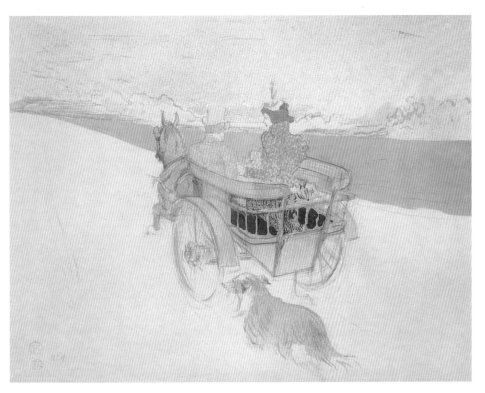

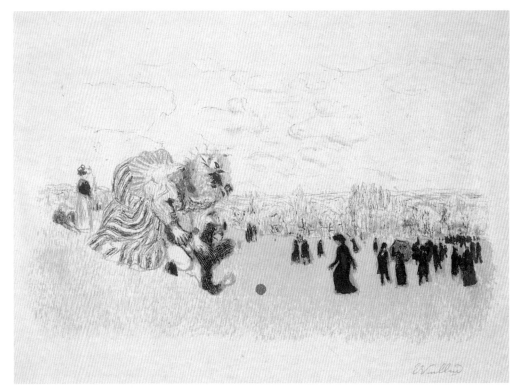

NO. 41
HENRI DE
TOULOUSE-LAUTREC

*Partie de campagne*
(Country Outing),
1897. National
Gallery of Art,
Collection
of Mr. and Mrs.
Paul Mellon

NO. 42
EDOUARD VUILLARD

*Jeux d'enfants*
(Children's Play),
1897. National
Gallery of Art,
Rosenwald Col-
lection

**NO. 43**
**ODILON REDON**

*Béatrice,* 1897.
National Gallery
of Art, Rosen-
wald Collection

**NO. 44**
**PIERRE BONNARD**

*L'Enfant à la lampe*
(Child with
Lamp), c. 1897.
National Gallery
of Art, Virginia
and Ira Jackson
Collection, Partial
and Promised Gift

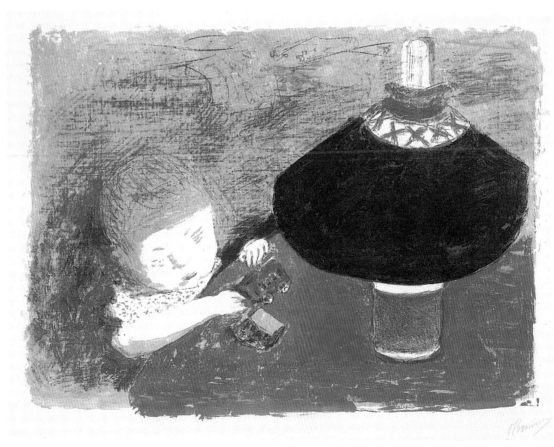

## DIX ZINCOGRAPHIES NO. 45 – NO. 47

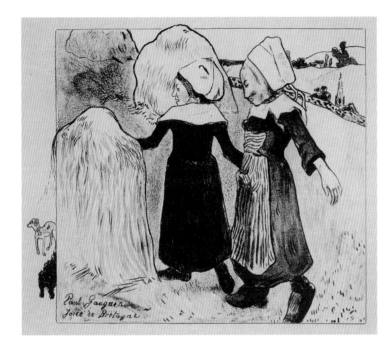

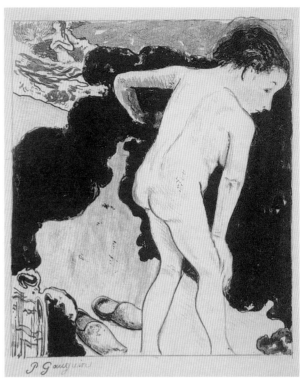

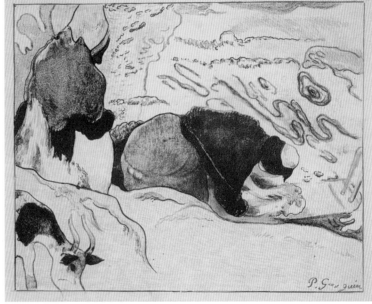

**NO. 45**
**PAUL GAUGUIN**

*Joies de Bretagne*
(Pleasures of
Brittany), 1889.
National Gallery
of Art, Andrew
W. Mellon Fund

**NO. 46**
**PAUL GAUGUIN**

*Baigneuses bretonnes*
(Breton Bathers),
1889. Virginia
and Ira Jackson
Collection,
Promised Gift
to the National
Gallery of Art

**NO. 47**
**PAUL GAUGUIN**

*Les Laveuses*
(Washerwomen),
1889. National
Gallery of Art,
Print Purchase
Fund (Rosenwald
Collection)

# PARIS INTENSE  NO. 48 – NO. 50

**NO. 48**
**FÉLIX VALLOTTON**

Frontispiece for
*Paris intense,* 1894.
National Gallery
of Art, Rosen-
wald Collection

**NO. 49**
**FÉLIX VALLOTTON**

*Deuxieme bureau*
(Box Office), 1894.
National Gallery
of Art, Rosen-
wald Collection

**NO. 50**
**FÉLIX VALLOTTON**

*L'Averse* (The
Shower), 1894.
National Gallery
of Art, Rosen-
wald Collection

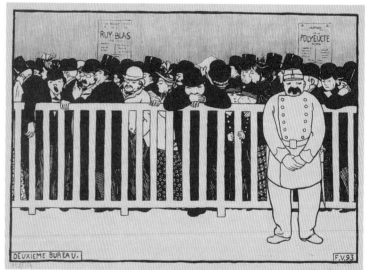

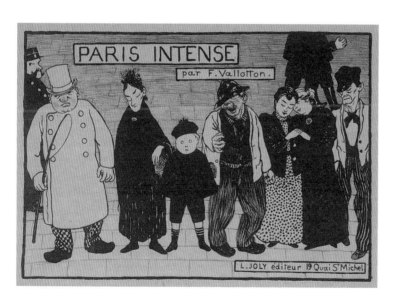

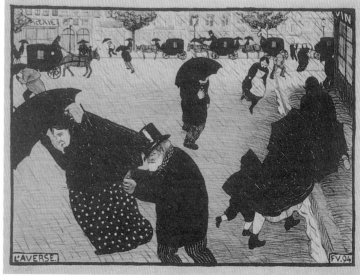

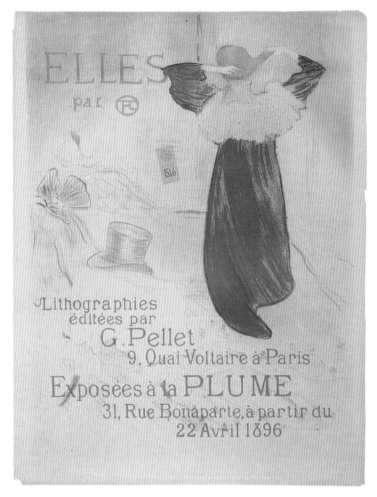

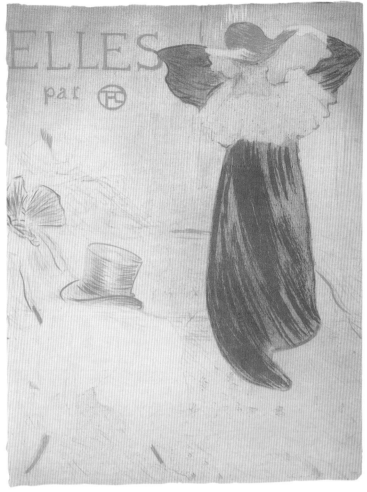

**HENRI DE
TOULOUSE-LAUTREC**

Poster for *Elles*,
1896. National
Gallery of Art,
Rosenwald Col-
lection
*(not in exhibition)*

**NO. 51
HENRI DE
TOULOUSE-LAUTREC**

Frontispiece for
*Elles*, 1896. National
Gallery of Art,
Rosenwald Col-
lection

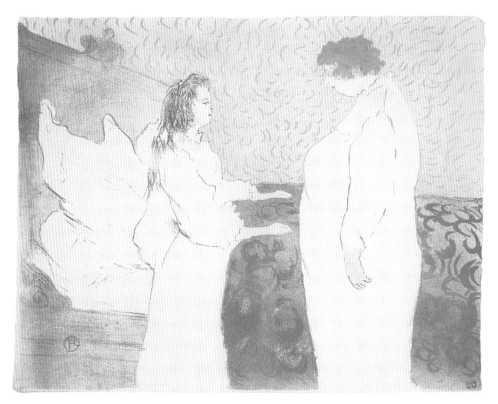

**NO. 52**
**HENRI DE**
**TOULOUSE-LAUTREC**

*Femme au lit, profil*
(Woman in Bed,
Profile), 1896.
National Gallery
of Art, Rosen-
wald Collection

**NO. 53**
**HENRI DE**
**TOULOUSE-LAUTREC**

*La Clownesse assise*
(Seated Clown),
1896. National
Gallery of Art,
Gift of Mr. and
Mrs. Robert L.
Rosenwald, in
Honor of the 50th
Anniversary of the
National Gallery
of Art

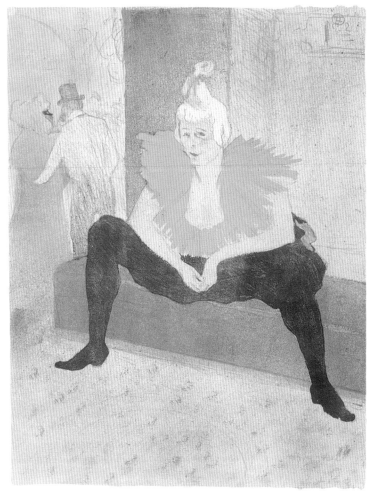

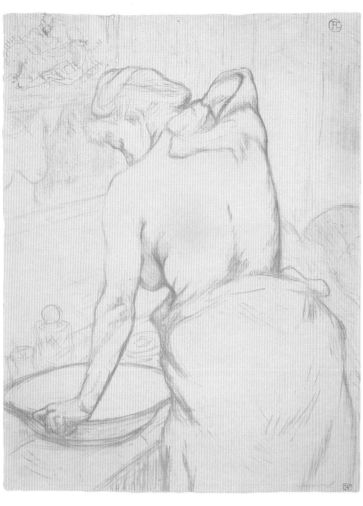

**NO. 54**
**HENRI DE**
**TOULOUSE-LAUTREC**

*Femme qui se lave*
(Woman Washing
Herself), 1896.
National Gallery
of Art, Rosen-
wald Collection

**NO. 55**
**HENRI DE**
**TOULOUSE-LAUTREC**

*Femme au tub*
(Woman at the
Tub), 1896.
National Gallery
of Art, Rosen-
wald Collection

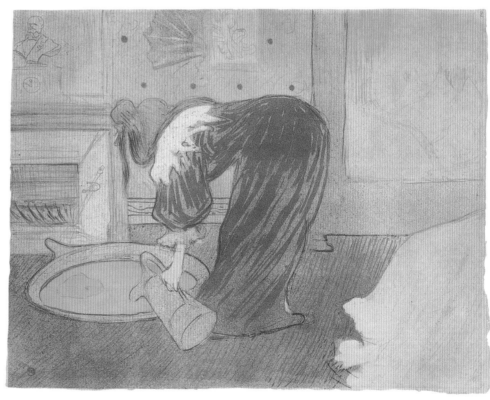

## APOCALYPSE DE SAINT-JEAN NO. 56 – NO. 58

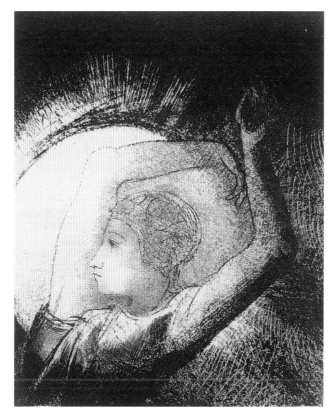

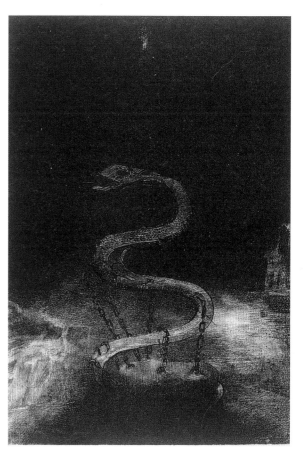

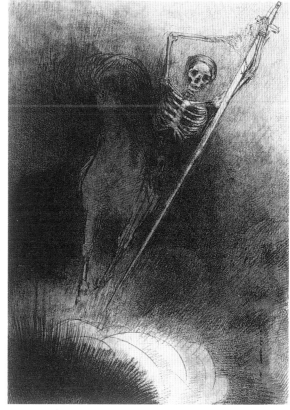

**NO. 56**
**ODILON REDON**

*Une femme revêtue du soleil* (A Woman Clothed with the Sun), 1899. National Gallery of Art, Rosenwald Collection

**NO. 57**
**ODILON REDON**

*Et le lia pour mille ans* (And Bound Him for a Thousand Years), 1899. National Gallery of Art, Rosenwald Collection

**NO. 58**
**ODILON REDON**

*Et celui qui était monté dessus se nommait la mort* (And His Name that Sat on Him was Death), 1899. National Gallery of Art, Rosenwald Collection

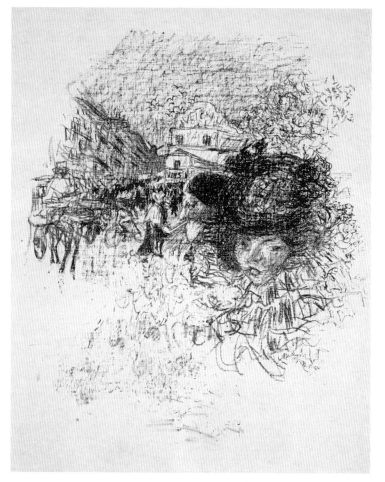

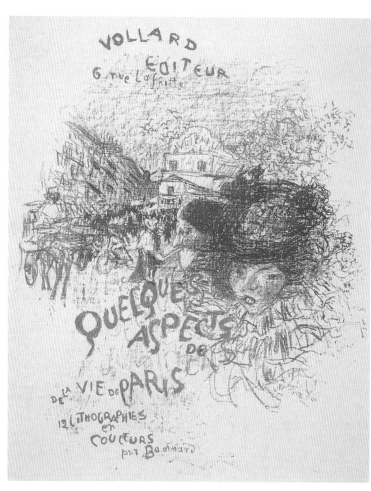

**NO. 59**
**PIERRE BONNARD**

Cover for *Quelques aspects de la vie de Paris* (proof), 1898. Virginia and Ira Jackson Collection

**NO. 60**
**PIERRE BONNARD**

Cover for *Quelques aspects de la vie de Paris*, 1898. Virginia and Ira Jackson Collection, Promised Gift to the National Gallery of Art

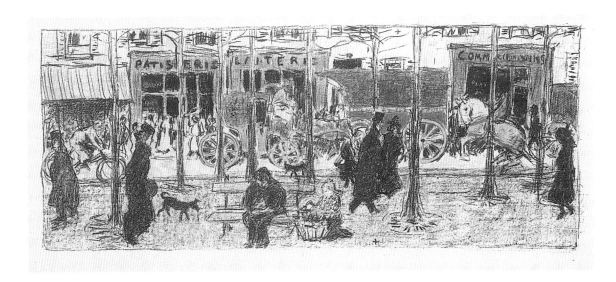

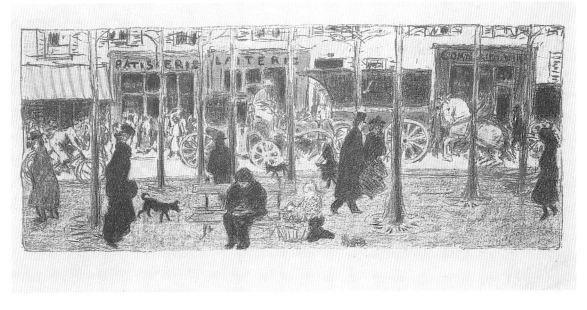

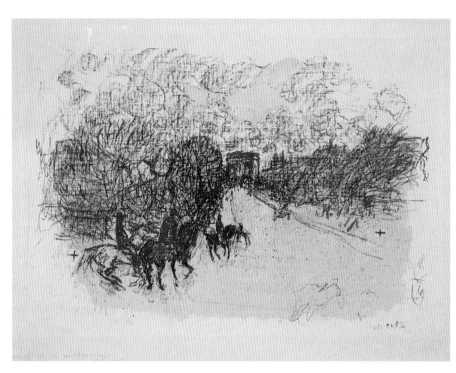

**NO. 63**
**PIERRE BONNARD**

*L'Arc de Triomphe*
(proof), c. 1898.
Virginia and Ira
Jackson Collection,
Promised Gift
to the National
Gallery of Art

**NO. 64**
**PIERRE BONNARD**

*L'Arc de Triomphe*,
c. 1898. Virginia
and Ira Jackson
Collection, Prom-
ised Gift to the
National Gallery
of Art

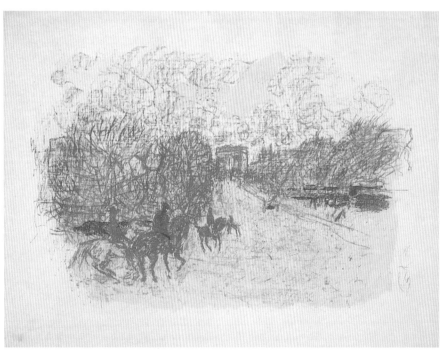

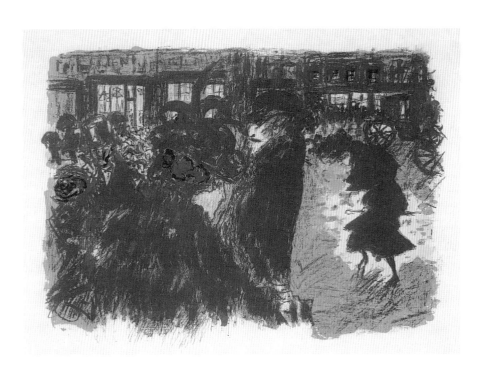

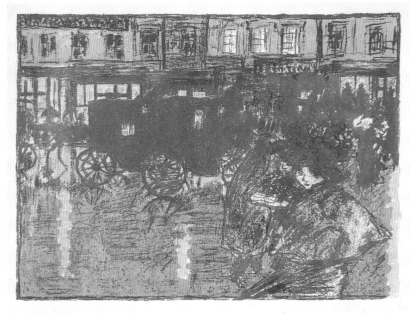

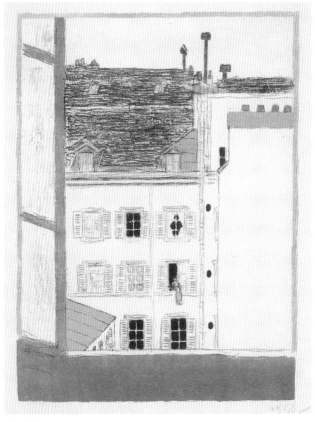

NO. 65
PIERRE BONNARD

*Rue, le soir, sous la pluie* (The Street at Night in the Rain) (proof), c. 1897. Virginia and Ira Jackson Collection, Promised Gift to the National Gallery of Art
*(left)*

NO. 66
PIERRE BONNARD

*Place le soir* (The Square at Night), c. 1897. Virginia and Ira Jackson Collection, Promised Gift to the National Gallery of Art
*(top)*

NO. 67
PIERRE BONNARD

*Maison dans la cour* (House in the Courtyard), 1895/1896. Virginia and Ira Jackson Collection, Promised Gift to the National Gallery of Art
*(right)*

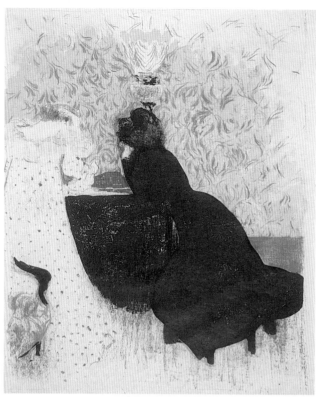

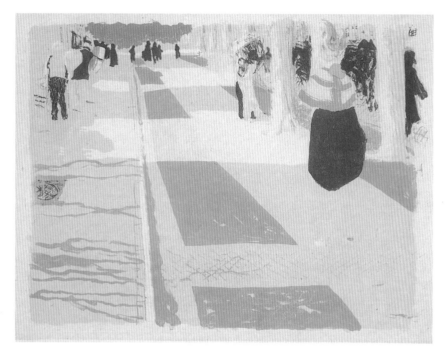

**NO. 68**
**EDOUARD**
**VUILLARD**

*L'Avenue,* 1899.
National Gallery
of Art, Rosen-
wald Collection

**NO. 69**
**EDOUARD**
**VUILLARD**

*Les deux belles-
soeurs* (Two Sisters-
in-Law), 1899.
National Gallery
of Art, Rosen-
wald Collection

**NO. 70**
**EDOUARD VUILLARD**

*Intérieur aux ten-
tures roses I*
(Interior with Pink
Wallpaper I), 1899.
National Gallery
of Art, Rosen-
wald Collection

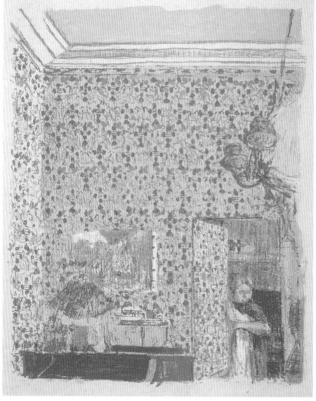

# ALBUM DE PAYSAGES NO. 71 – NO. 74

**NO. 73**
**KER XAVIER**
**ROUSSEL**

*Femme en robe à rayures* (Woman in a Striped Dress), 1899. National Gallery of Art, Rosenwald Collection

**NO. 74**
**KER XAVIER**
**ROUSSEL**

Study for *Femme en robe à rayures*, c. 1898. National Gallery of Art, Ailsa Mellon Bruce Fund

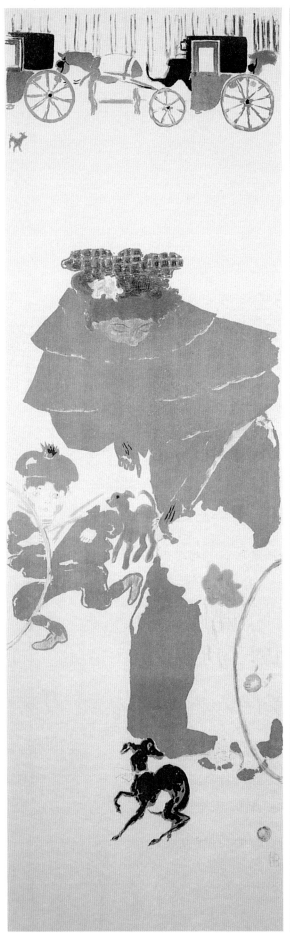
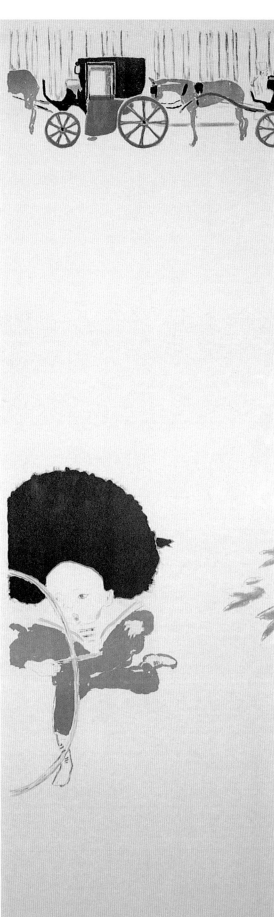

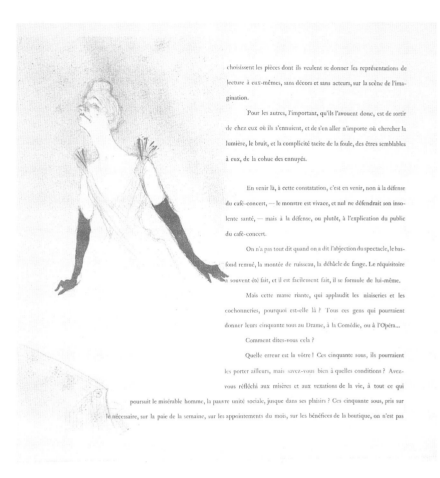

choisissent les pièces dont ils veulent se donner les représentations de lecture à eux-mêmes, sans décors et sans acteurs, sur la scène de l'imagination.

Pour les autres, l'important, qu'ils l'avouent donc, est de sortir de chez eux où ils s'ennuient, et de s'en aller n'importe où chercher la lumière, le bruit, et la complicité tacite de la foule, des êtres semblables à eux, de la cohue des ennuyés.

En venir là, à cette constatation, c'est en venir, non à la défense du café-concert, — le monstre est vivace, et nul ne défendrait son insolente santé, — mais à la défense, ou plutôt, à l'explication du public du café-concert.

On n'a pas tout dit quand on a dit l'abjection du spectacle, le basfond remué, la montée de ruisseau, la débâcle de fange. Le réquisitoire a souvent été fait, et il est facilement fait, il se formule de lui-même.

Mais cette masse riante, qui applaudit les niaiseries et les cochonneries, pourquoi est-elle là ? Tous ces gens qui pourraient donner leurs cinquante sous au Drame, à la Comédie, ou à l'Opéra...

Comment dites-vous cela ?

Quelle erreur est la vôtre ! Ces cinquante sous, ils pourraient les porter ailleurs, mais savez-vous bien à quelles conditions ? Avezvous réfléchi aux misères et aux vexations de la vie, à tout ce qui poursuit le misérable homme, la pauvre unité sociale, jusque dans ses plaisirs ? Ces cinquante sous, pris sur le nécessaire, sur la paie de la semaine, sur les appointements du mois, sur les bénéfices de la boutique, on n'est pas

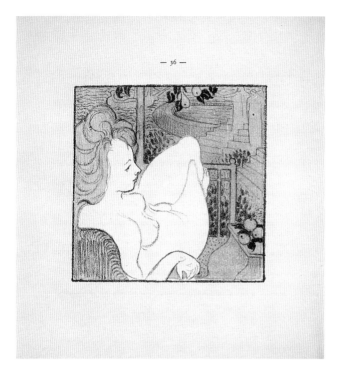

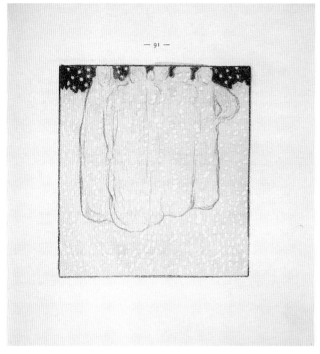

**NO. 76**
**HENRI DE**
**TOULOUSE-LAUTREC**

in Gustave Geffroy's *Yvette Guilbert*, 1894. National Gallery of Art, New Century Fund, Gift of Edwin L. Cox—Ed Cox Foundation *(left)*

**NO. 77A–B**
**MAURICE DENIS**

in André Gide's *Le Voyage d'Urien*, 1893. Virginia and Ira Jackson Collection, Promised Gift to the National Gallery of Art

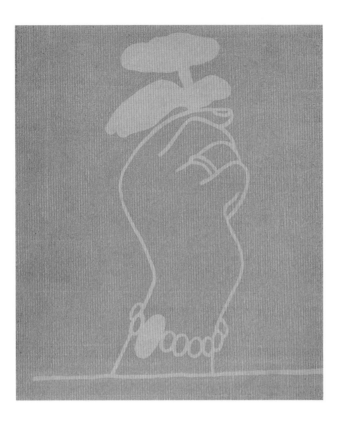

**NO. 78**
**JAMES PITCAIRN-KNOWLES**

Cover for Georges Rodenbach's *Les Tombeaux*, 1895. Virginia and Ira Jackson Collection, Promised Gift to the National Gallery of Art

**NO. 79**
**JÓZSEF RIPPL-RÓNAI**

in Georges Rodenbach's *Les Vierges*, 1895. Virginia and Ira Jackson Collection, Promised Gift to the National Gallery of Art

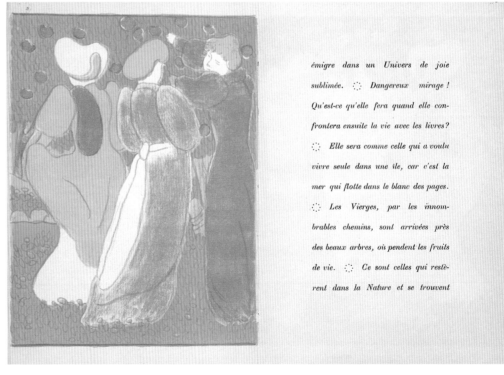

émigre dans un Univers de joie sublimée. Dangereux mirage! Qu'est-ce qu'elle fera quand elle confrontera ensuite la vie avec les livres? Elle sera comme celle qui a voulu vivre seule dans une ile, car c'est la mer qui flotte dans le blanc des pages. Les Vierges, par les innombrables chemins, sont arrivées près des beaux arbres, où pendent les fruits de vie. Ce sont celles qui restèrent dans la Nature et se trouvent

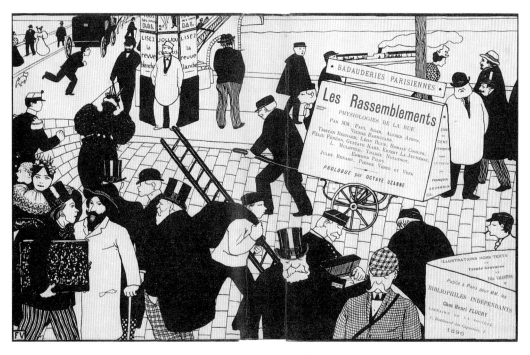

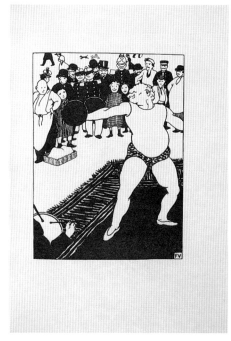

NO. 80
FÉLIX VALLOTTON

Book jacket for
*Badauderies
parisiennes — Les
Rassemblements,
physiologies de la
rue,* 1896. Virginia
and Ira Jackson
Collection,
Promised Gift
to the National
Gallery of Art

NO. 81
FÉLIX VALLOTTON

*L'Hercule du car-
refour* (Hercules
of the Crossroads),
in *Badauderies
parisiennes — Les
Rassemblements,
physiologies de la
rue,* 1896. Virginia
and Ira Jackson
Collection,
Promised Gift
to the National
Gallery of Art

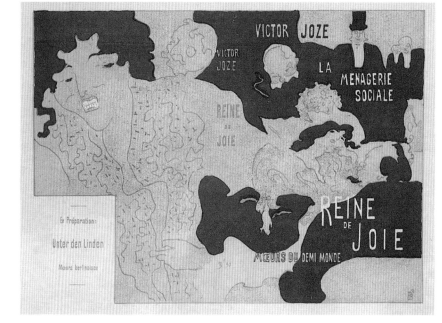

NO. 82
PIERRE BONNARD

Cover for Victor
Joze's *Reine de joie*
(proof), 1892.
Virginia and Ira
Jackson Collection,
Promised Gift to
the National
Gallery of Art

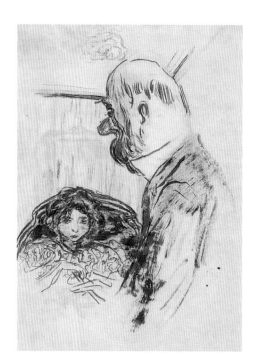

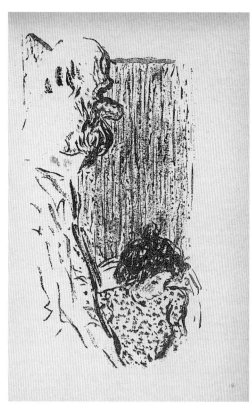

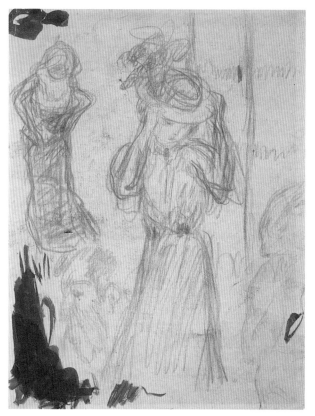

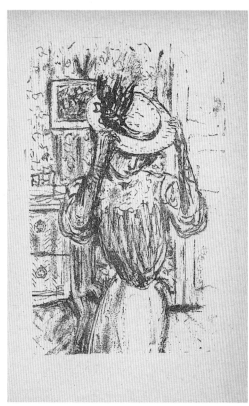

ALMANACH
du
Père Ubu
*illustré*
(Janvier-Février-Mars 1899)

✕✕ En vente partout ✕✕
Prix 50 centimes.
Abonnement d'un an (4 numéros) : 1 fr. 50.
*Vente en gros, 3, rue Corneille, Paris.*

**NO. 86**
**PIERRE BONNARD**

Title page for
Alfred Jarry's
*Almanach du Père
Ubu illustré*, 1899.
Virginia and Ira
Jackson Collection,
Promised Gift
to the National
Gallery of Art

**NO. 87**
**PIERRE BONNARD**

in Alfred Jarry's
*Almanach illustré
du Père Ubu
(XXe siècle)*, 1901.
Virginia and Ira
Jackson Collection,
Promised Gift
to the National
Gallery of Art

**NO. 88**
**PIERRE BONNARD**

in Alfred Jarry's
*Almanach illustré
du Père Ubu
(XXe siècle)*, 1901.
Virginia and Ira
Jackson Collection,
Promised Gift
to the National
Gallery of Art

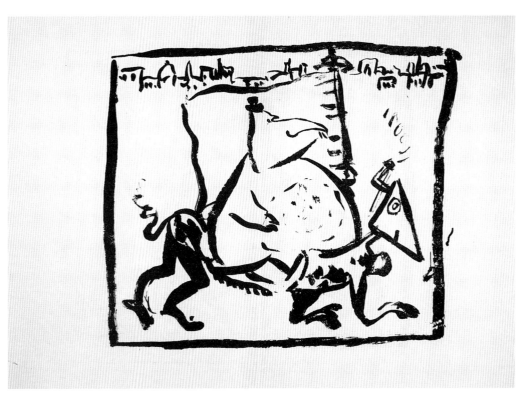

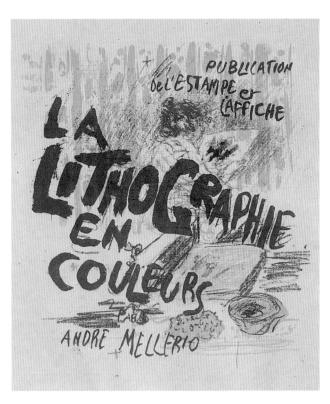

**NO. 89**
**PIERRE BONNARD**

Cover for André Mellerio's *La Lithographie en couleurs* (proof), 1898. Virginia and Ira Jackson Collection, Promised Gift to the National Gallery of Art

**NO. 90**
**HENRI DE TOULOUSE-LAUTREC**

Cover for Georges Clémenceau's *Au pied du Sinaï*, 1898. National Gallery of Art, Gift of Robert M. Walker

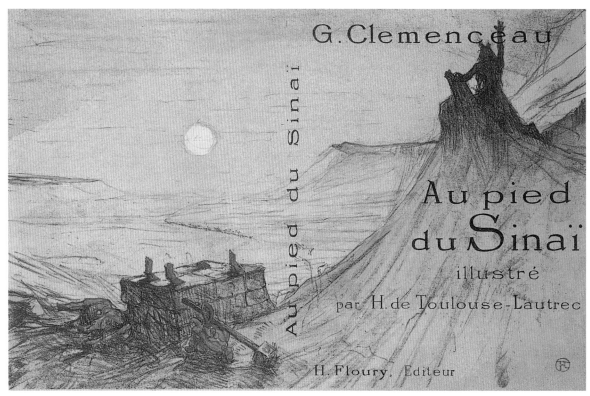

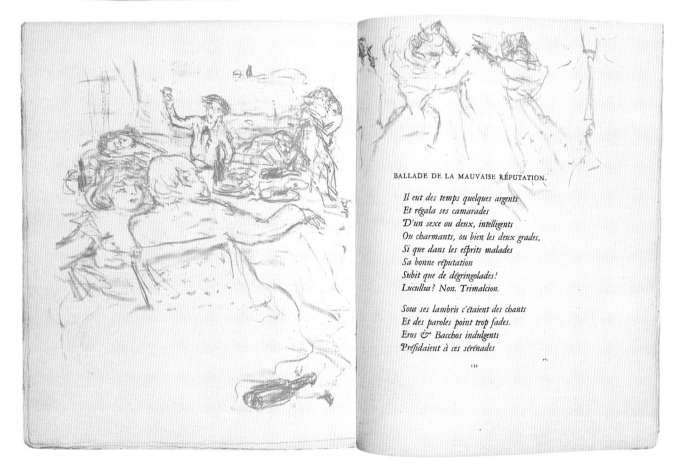

A MADAME ✳✳✳

*Vos narines qui vont en l'air,*
*Non loin de deux beaux yeux quelconques,*
*Sont mignonnes comme ces conques*
*Du bord de mer de bains de mer;*

*Un sourire moins franc qu'aimable*
*Découvre de petites dents,*
*Diminutifs outrecuidants*
*De celles d'un loup de la fable;*

*Bien en chair, lente avec du chien,*
*On remarque votre personne,*
*Et votre voix fine résonne*
*Non sans des agréments très bien.*

43

BALLADE DE LA MAUVAISE RÉPUTATION.

*Il eut des temps quelques argents*
*Et régala ses camarades*
*D'un sexe ou deux, intelligents*
*Ou charmants, ou bien les deux grades,*
*Si que dans les esprits malades*
*Sa bonne réputation*
*Subit que de dégringolades!*
*Lucullus? Non. Trimalcion.*

*Sous ses lambris c'étaient des chants*
*Et des paroles point trop fades.*
*Eros & Bacchos indulgents*
*Présidaient à ces sérénades*

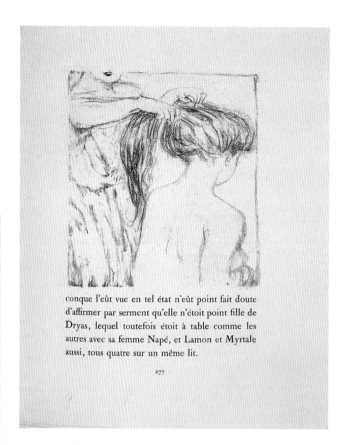

conque l'eût vue en tel état n'eût point fait doute
d'affirmer par serment qu'elle n'étoit point fille de
Dryas, lequel toutefois étoit à table comme les
autres avec sa femme Napé, et Lamon et Myrtale
aussi, tous quatre sur un même lit.

277

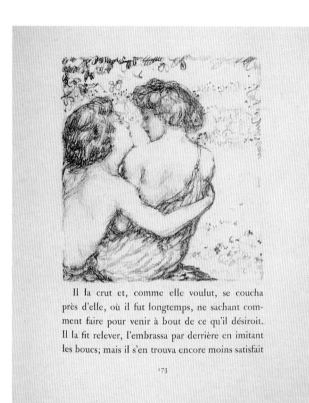

Il la crut et, comme elle voulut, se coucha
près d'elle, où il fut longtemps, ne sachant com-
ment faire pour venir à bout de ce qu'il désiroit.
Il la fit relever, l'embrassa par derrière en imitant
les boucs; mais il s'en trouva encore moins satisfait

173

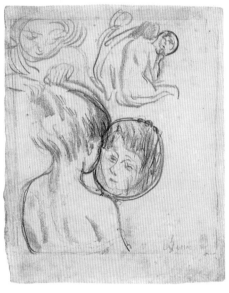

**NO. 92A–B**
**PIERRE BONNARD**

in Longus' *Daphnis
et Chloé*, 1902.
Virginia and Ira
Jackson Collection,
Promised Gift
to the National
Gallery of Art

**NO. 93**
**PIERRE BONNARD**

*Fille avec miroir*
(Girl with
Mirror), c. 1902.
Virginia and Ira
Jackson Collection,
Promised Gift
to the National
Gallery of Art
*(bottom right)*

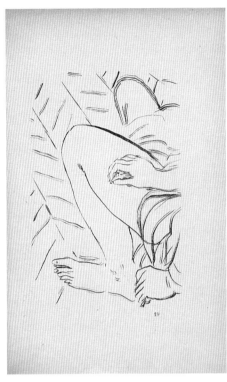

**NO. 94A**
**PIERRE BONNARD**

*La Puce* (Flea),
in Jules Renard's
*Histoires naturelles,*
1904. Virginia
and Ira Jackson
Collection, Prom-
ised Gift to the
National Gallery
of Art

**NO. 94B**
**PIERRE BONNARD**

*Le Cygne* (Swan),
in Jules Renard's
*Histoires naturelles,*
1904. Virginia
and Ira Jackson
Collection, Prom-
ised Gift to the
National Gallery
of Art

**NO. 95**
**PIERRE BONNARD**

Study for *Le Cygne*,
c. 1904. Virginia
and Ira Jackson
Collection, Prom-
ised Gift to the
National Gallery
of Art
*(bottom right)*

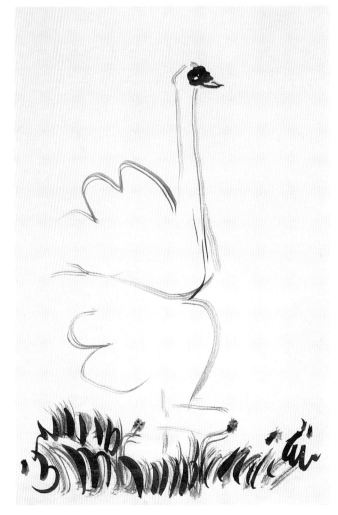

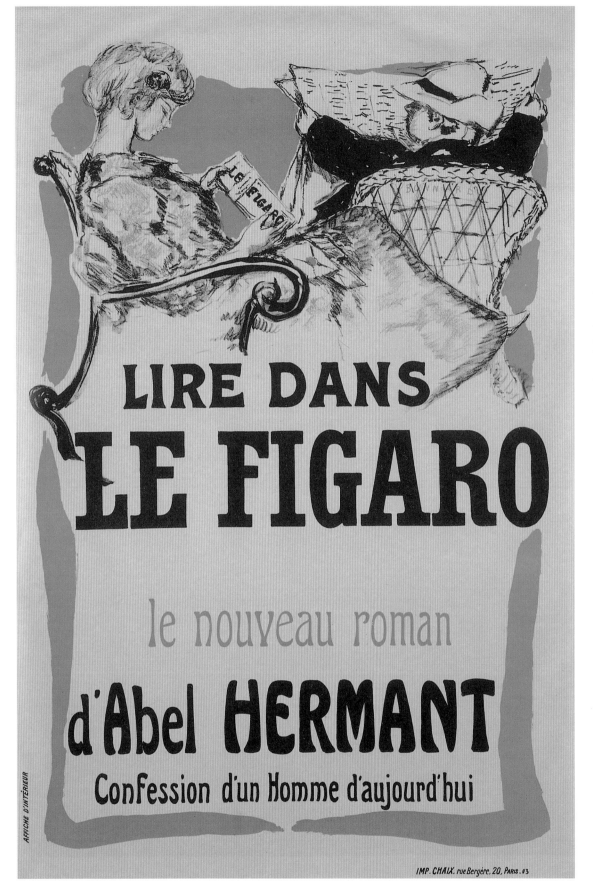

LIRE DANS
LE FIGARO
le nouveau roman
d'Abel **HERMANT**
Confession d'un Homme d'aujourd'hui

AFFICHE D'INTÉRIEUR

IMP. CHAIX. rue Bergère, 20, PARIS. 03

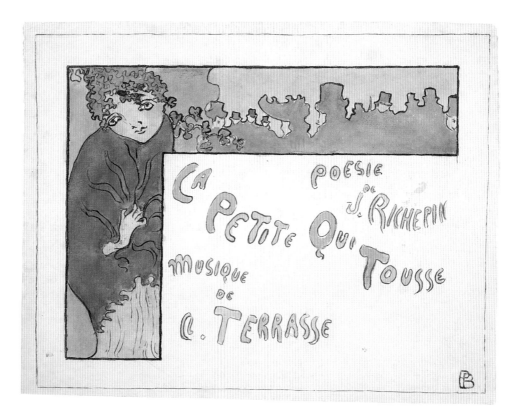

**NO. 97**
**PIERRE BONNARD**

*La Petite qui tousse* (The Girl Who Coughs), 1890/ 1891. Virginia and Ira Jackson Collection, Promised Gift to the National Gallery of Art

**NO. 98**
**PIERRE BONNARD**

*Young Girl (Berthe Schaedlin)*, c. 1890. Virginia and Ira Jackson Collection, Promised Gift to the National Gallery of Art

**NO. 99**
**PIERRE BONNARD**

*Pas redoublé,* 1891. Virginia and Ira Jackson Collection, Promised Gift to the National Gallery of Art

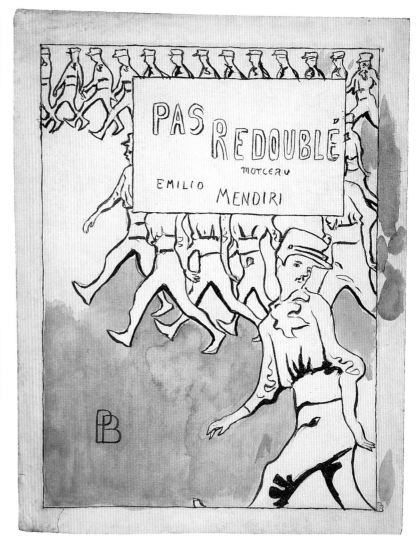

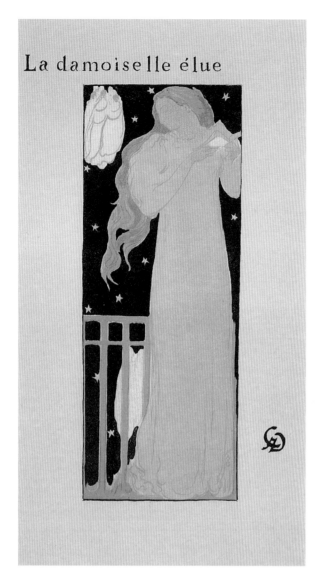

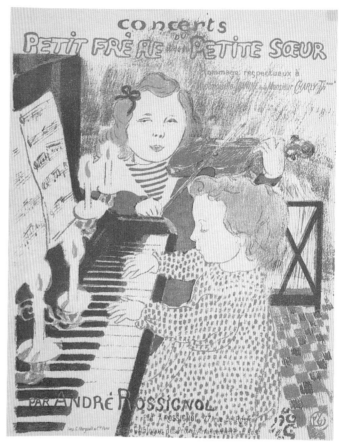

**NO. 100**
**MAURICE DENIS**

Frontispiece for
*La Damoiselle élue*
(The Blessed
Damsel), 1892.
Virginia and Ira
Jackson Collection

**NO. 101**
**MAURICE DENIS**

Cover for *Concerts
du petit frère et de
la petite soeur*, 1903.
Virginia and Ira
Jackson Collection

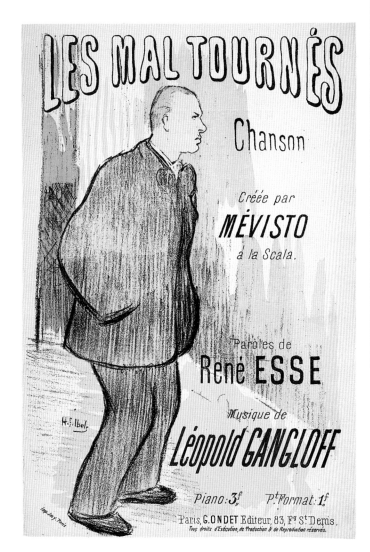

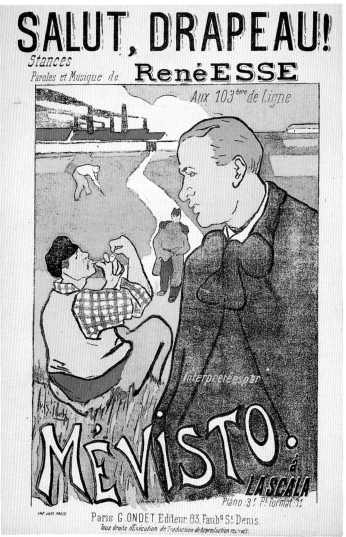

NO. 102
HENRI-GABRIEL
IBELS

Cover for *Les Mal Tournés*, early 1890s. Virginia and Ira Jackson Collection, Promised Gift to the National Gallery of Art

NO. 103
HENRI-GABRIEL
IBELS

Cover for *Salut, drapeau!*, early 1890s. Virginia and Ira Jackson Collection, Promised Gift to the National Gallery of Art

PETIT SOLFÈGE ILLUSTRÉ   NO. 104 – NO. 114

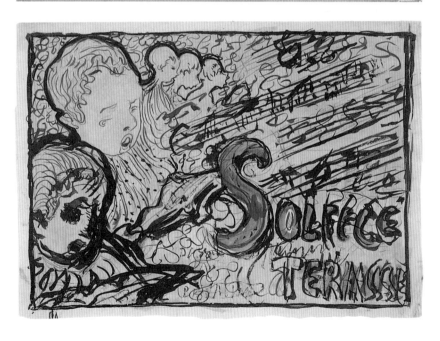

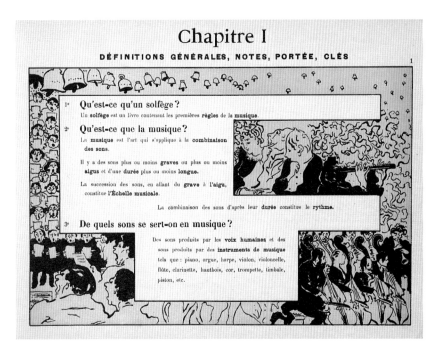

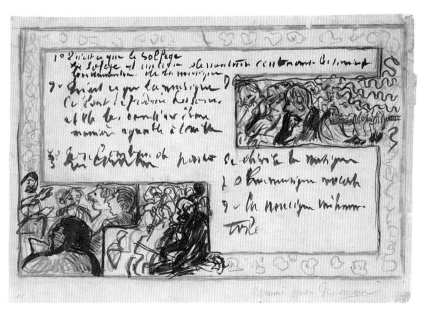

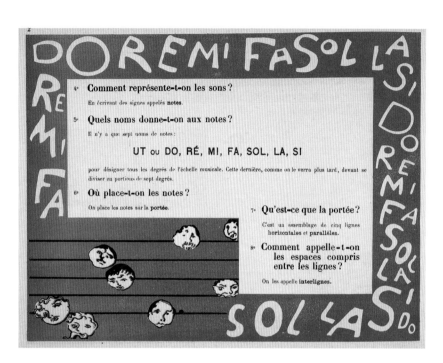

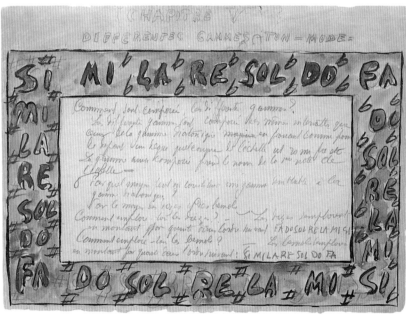

NO. 106B
**PIERRE BONNARD**

*Do Ré Mi*, 1893.
Virginia and Ira
Jackson Collection,
Promised Gift
to the National
Gallery of Art

NO. 108
**PIERRE BONNARD**

Study for *Do Ré
Mi*, 1891/1893.
Virginia and Ira
Jackson Collection,
Promised Gift
to the National
Gallery of Art

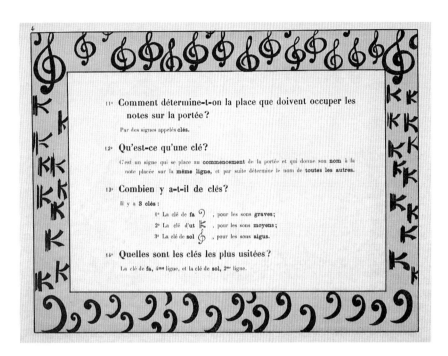

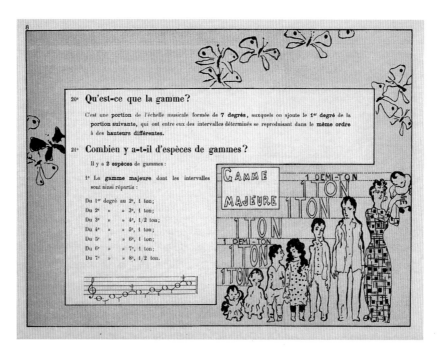

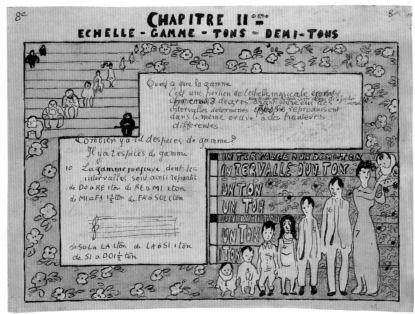

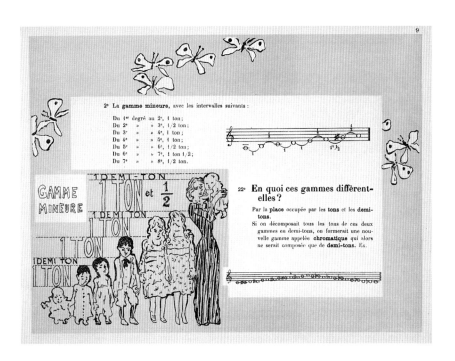

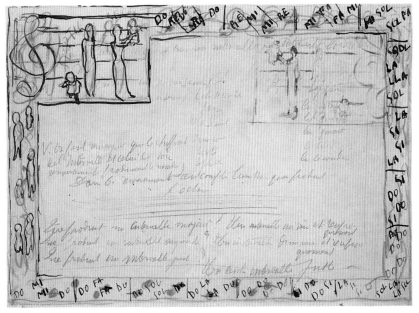

**NO. 106E**
**PIERRE BONNARD**

*Gamme mineure,*
1893. Virginia
and Ira Jackson
Collection, Prom-
ised Gift to the
National Gallery
of Art

**NO. 111**
**PIERRE BONNARD**

Study for *Gamme
mineure* and
*Gamme majeure,*
1891/1893. Virginia
and Ira Jackson
Collection, Prom-
ised Gift to the
National Gallery
of Art

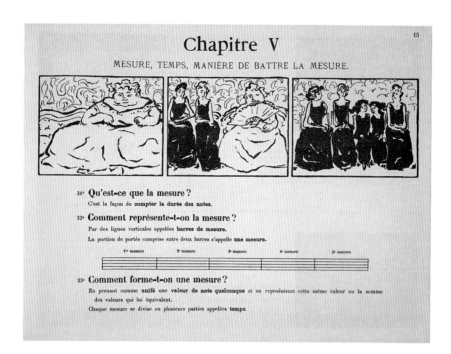

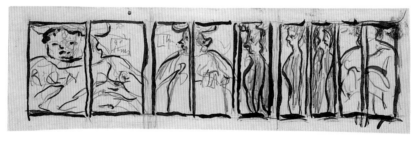

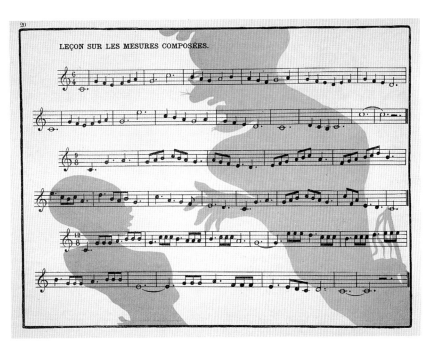

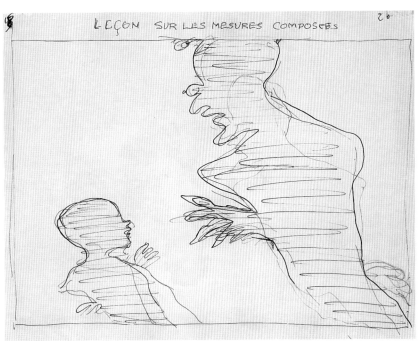

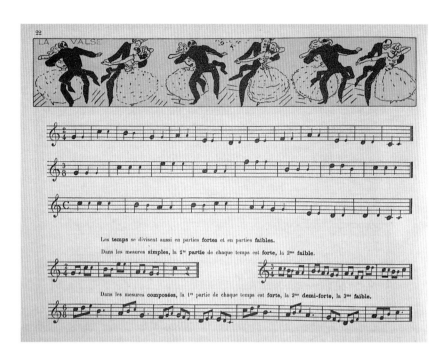

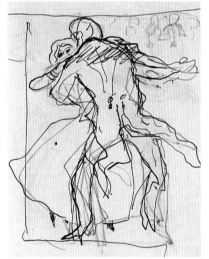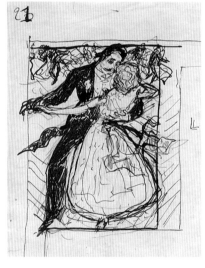

**NO. 106H**
**PIERRE BONNARD**

*La Valse,* 1893.
Virginia and Ira
Jackson Collection,
Promised Gift
to the National
Gallery of Art

**NO. 114A–B**
**PIERRE BONNARD**

Studies for
*La Valse,* 1891/1893.
Virginia and Ira
Jackson Collection,
Promised Gift
to the National
Gallery of Art

## PETITES SCÈNES FAMILIÈRES NO. 115 – NO. 118

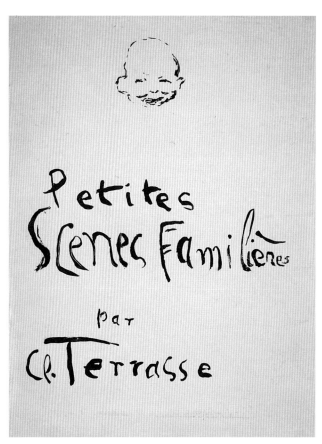

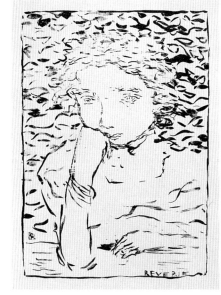

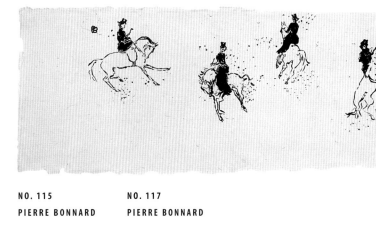

**NO. 115**
**PIERRE BONNARD**

*Quadrille* (proof),
1895. Virginia
and Ira Jackson
Collection, Prom-
ised Gift to the
National Gallery
of Art

**NO. 116**
**PIERRE BONNARD**

*Réverie* (proof),
1895. Virginia
and Ira Jackson
Collection, Prom-
ised Gift to the
National Gallery
of Art

**NO. 117**
**PIERRE BONNARD**

Cover for Claude
Terrasse's *Petites
scènes familières,
pour piano,* 1895.
Virginia and Ira
Jackson Collection,
Promised Gift
to the National
Gallery of Art

**NO. 118**
**PIERRE BONNARD**

*Au cirque* (proof),
1895. Virginia
and Ira Jackson
Collection, Prom-
ised Gift to the
National Gallery
of Art

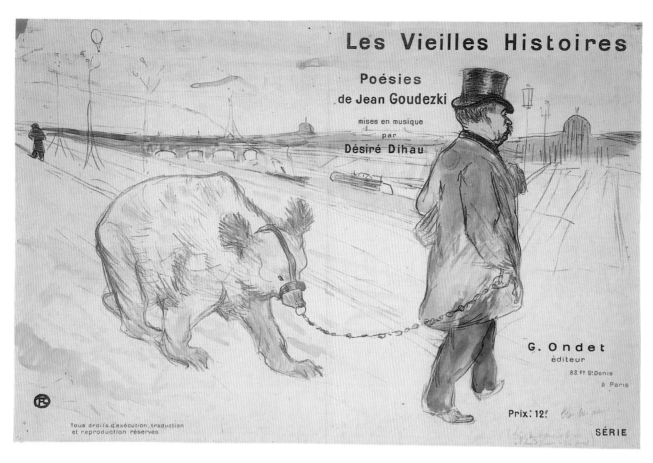

NO. 119
**HENRI DE
TOULOUSE-LAUTREC**

Cover for *Les
Vieilles Histoires*
(proof), 1893.
National Gallery
of Art, Rosenwald
Collection

NO. 120
**HENRI DE
TOULOUSE-LAUTREC**

*Pour toi!* (For
You!), 1893.
National Gallery
of Art, Rosenwald
Collection

NO. 121
**HENRI DE
TOULOUSE-LAUTREC**

*Le Petit Trottin*
(The Little Errand
Girl), 1893.
National Gallery
of Art, Rosen-
wald Collection

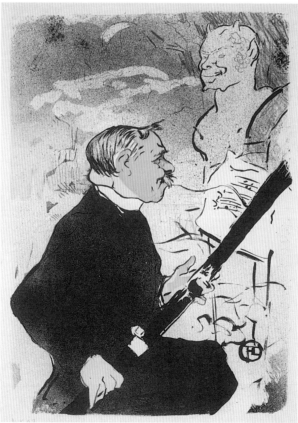

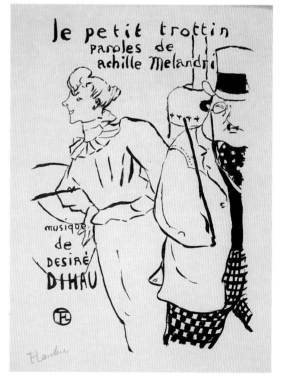

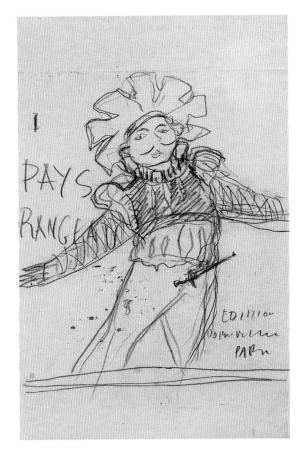

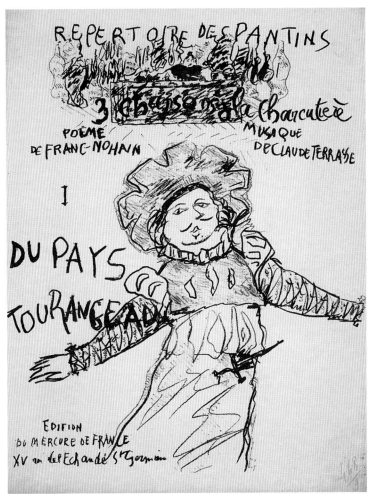

**NO. 122**
**PIERRE BONNARD**

Study for *Du pays tourangeau*, 1898. Virginia and Ira Jackson Collection, Promised Gift to the National Gallery of Art

**NO. 123**
**PIERRE BONNARD**

Cover for *Du pays tourangeau* (From the Land of Touraine), 1898. Virginia and Ira Jackson Collection, Promised Gift to the National Gallery of Art

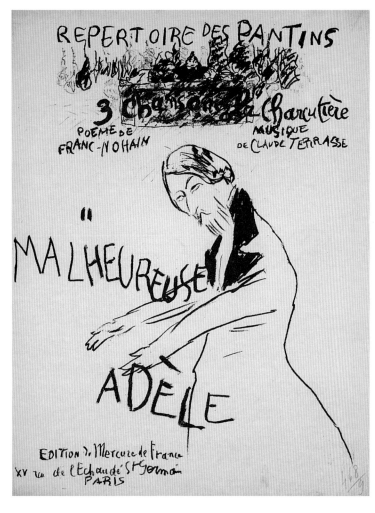

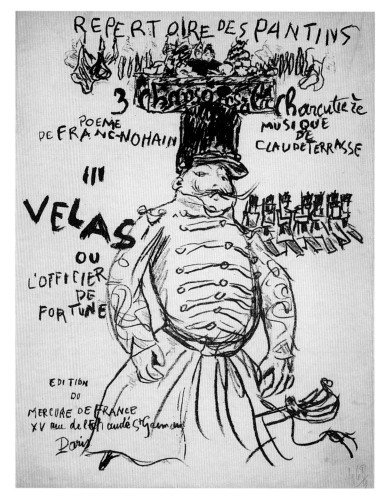

NO. 124
PIERRE BONNARD

Cover for *Mal-heureuse Adèle* (Unfortunate Adele), 1898. Virginia and Ira Jackson Collection, Promised Gift to the National Gallery of Art

NO. 125
PIERRE BONNARD

Cover for *Velas ou l'officier de fortune* (Velas, or the Soldier of Fortune), 1898. Virginia and Ira Jackson Collection, Promised Gift to the National Gallery of Art

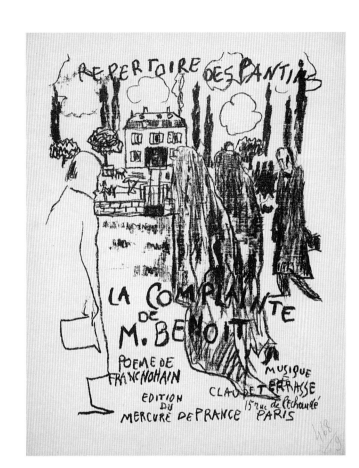

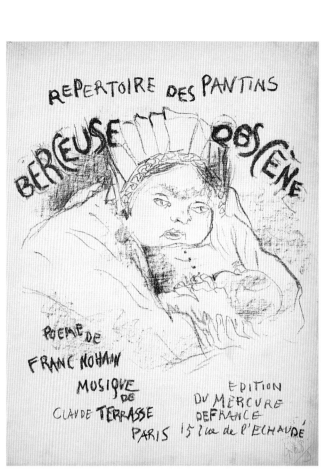

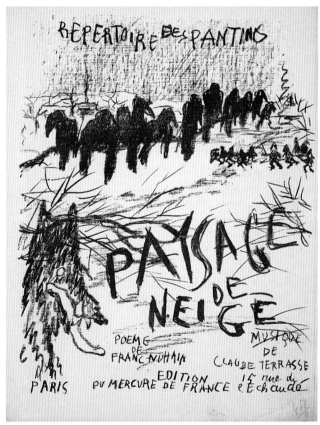

**NO. 126**
**PIERRE BONNARD**

Cover for *La Complainte de Monsieur Benoît* (Monsieur Benoît's Lament), 1898. Virginia and Ira Jackson Collection, Promised Gift to the National Gallery of Art

**NO. 127**
**PIERRE BONNARD**

Cover for *Berceuse obscène* (Obscene Lullaby), 1898. Virginia and Ira Jackson Collection, Promised Gift to the National Gallery of Art

**NO. 128**
**PIERRE BONNARD**

Cover for *Paysage de neige* (Snowy Landscape), 1898. Virginia and Ira Jackson Collection, Promised Gift to the National Gallery of Art

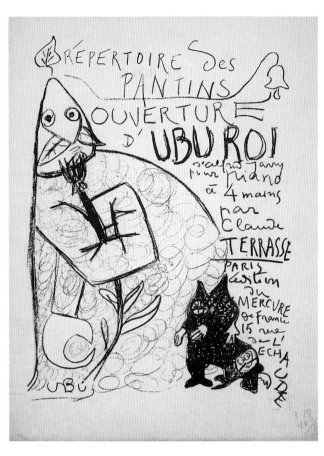

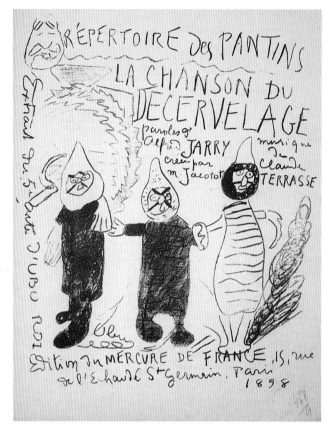

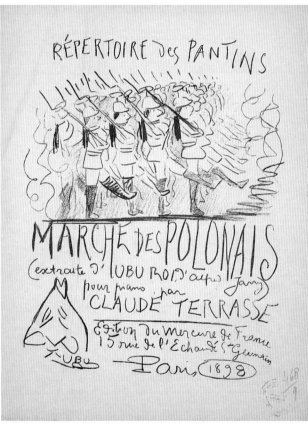

**NO. 129**
**ALFRED JARRY**

Cover for
*Ouverture d'Ubu
Roi* (Overture to
*Ubu Roi*), 1898.
Virginia and Ira
Jackson Collection,
Promised Gift
to the National
Gallery of Art

**NO. 130**
**ALFRED JARRY**

Cover for *Marche
des polonais* (Polish
March), 1898.
Virginia and Ira
Jackson Collection,
Promised Gift
to the National
Gallery of Art

**NO. 131**
**ALFRED JARRY**

Cover for *La
Chanson du
décervelage* (The
Debraining Song),
1898. Virginia
and Ira Jackson
Collection,
Promised Gift
to the National
Gallery of Art

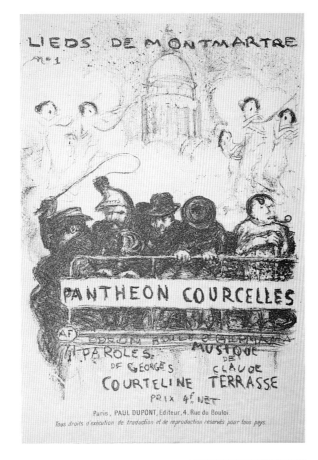

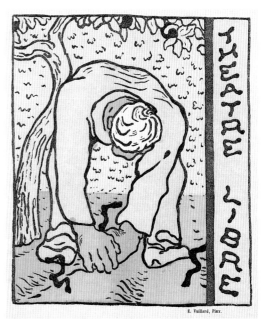

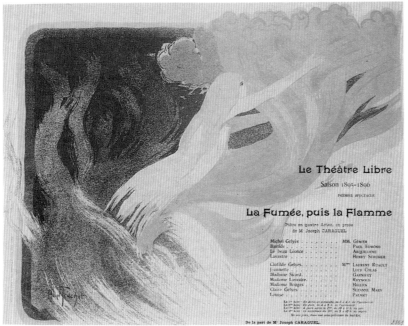

NO. 132
**PIERRE BONNARD**

Title page for *Panthéon-Courcelles*, 1899. Virginia and Ira Jackson Collection, Promised Gift to the National Gallery of Art

NO. 133
**ABEL-TRUCHET**

Theater program for *La Fumée, puis la flamme*, 1895. Virginia and Ira Jackson Collection

NO. 134
**EDOUARD VUILLARD**

Theater program for *Monsieur Bute; L'Amant de sa femme; La Belle Operation*, 1890. Virginia and Ira Jackson Collection

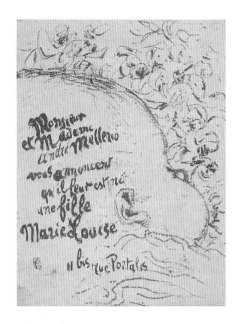

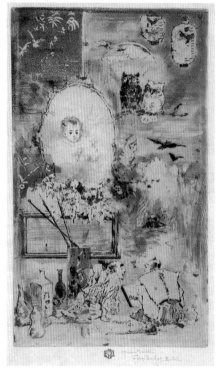

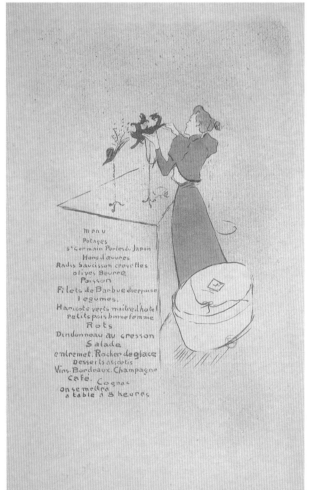

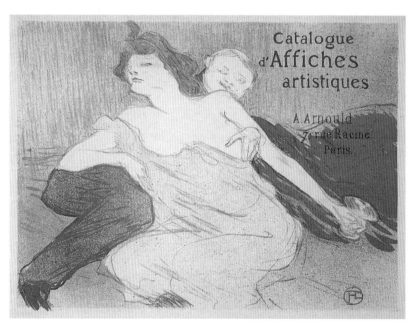

# References

CHECKLIST, BIBLIOGRAPHY, SELECT CHRONOLOGY OF ARTISTS' PRINTS IN FRANCE, INDEX

# Checklist

_____

*Dimensions are in centimeters, height preceding width, with inches in parentheses. Unless otherwise noted, dimensions refer to sheet size. Abbreviated references are cited in full in the bibliography.*

**NO. 1**

Pierre Bonnard
(French, 1867–1947)
Poster for *La Revue blanche*, 1894
color lithograph
Bouvet 30
80.1 x 61.6 (31 9/16 x 24 1/4)
Virginia and Ira Jackson
Collection, Promised Gift to
the National Gallery of Art

**NO. 2**

Edouard Vuillard
(French, 1868–1940)
*La Couturière* (The Dressmaker)
color lithograph (deluxe edition)
Roger-Marx 13, iii/iv
frontispiece in *La Revue blanche*,
no. 27, January 1894
(Natanson Brothers, Paris)
25 x 16.3 (9 13/16 x 6 7/16)
Virginia and Ira Jackson
Collection, Promised Gift to
the National Gallery of Art

**NO. 3**

Pierre Bonnard
(French, 1867–1947)
*Femme au parapluie*
(Woman with an Umbrella)
color lithograph
Bouvet 33
frontispiece in *La Revue blanche*,
no. 35, September 1894
(Natanson Brothers, Paris)
25 x 16.3 (9 13/16 x 6 7/16)
Virginia and Ira Jackson
Collection, Promised Gift to
the National Gallery of Art

**NO. 4**

Maurice Denis
(French, 1870–1943)
Poster for *La Dépêche de
Toulouse*, 1892
color lithograph
Cailler 33
133.7 x 89.2 (52 5/8 x 35 1/8)
Virginia and Ira Jackson
Collection, Promised Gift to
the National Gallery of Art

**NO. 5**

Pierre Bonnard
(French, 1867–1947)
Poster for *France-Champagne*, 1891
color lithograph
Bouvet 1
79.8 x 60.3 (31 7/16 x 23 3/4)
Virginia and Ira Jackson
Collection, Promised Gift to
the National Gallery of Art

**NO. 6A – B**

Pierre Bonnard
(French, 1867–1947)
Studies for *France-Champagne*
(recto/verso), c. 1889
pen and black ink
30.9 x 19.9 (12 3/16 x 7 13/16)
Virginia and Ira Jackson
Collection, Promised Gift to
the National Gallery of Art

**NO. 7**

Pierre Bonnard
(French, 1867–1947)
Poster for *Salon des cent*, 1896
color lithograph on japan paper
(proof before letters)
Bouvet 39
63.8 x 47 (25 1/8 x 18 1/2)
National Gallery of Art, Virginia
and Ira Jackson Collection,
Partial and Promised Gift,
1999.138.6

**NO. 8**

Pierre Bonnard
(French, 1867–1947)
Poster for *Salon des cent*, 1896
color lithograph
Bouvet 39
63.6 x 44.5 (25 1/16 x 17 1/2)
National Gallery of Art, Virginia
and Ira Jackson Collection,
Partial and Promised Gift,
1999.138.5

**NO. 9**

Henri de Toulouse-Lautrec
(French, 1864–1901); Henri-
Gabriel Ibels (French, 1867–
1936); Hermann-Paul (French,
1864–1940); Pierre Bonnard
(French, 1867–1947); Félix
Vallotton (Swiss, 1865–1925);
Adolphe Léon Willette (French,
1857–1926); and Louis Anquetin
(French, 1861–1932)
*L'Escarmouche*, 12 November
1893–14 January 1894
(Georges Darien, Paris)
ten issues of weekly journal with
photo-relief illustrations
page size: 40.3 x 30 (15 7/8 x 11 13/16)
Virginia and Ira Jackson
Collection

NO. 10

Pierre Bonnard
(French, 1867–1947)
*Les Chiens* (Dogs), 1893
lithograph in black
Bouvet 25
37.9 x 28.2 (14 15/16 x 11 1/8)
*note:* reissued as a photo-relief
in *L'Escarmouche*, no. 5,
10 December 1893
Virginia and Ira Jackson
Collection, Promised Gift to
the National Gallery of Art

NO. 11

Pierre Bonnard
(French, 1867–1947)
*Conversation*, 1893
lithograph in brown black
Bouvet 28
38.5 x 28.2 (15 3/16 x 11 1/8)
*note:* intended but never realized
as a photo-relief in *L'Escarmouche*
Virginia and Ira Jackson
Collection, Promised Gift to
the National Gallery of Art

NO. 12

Pierre Bonnard
(French, 1867–1947)
Study for *Conversation* (recto), 1893
graphite with pen and black ink
15.4 x 20.2 (6 1/16 x 7 15/16)
Virginia and Ira Jackson
Collection

NO. 13

Pierre Bonnard
(French, 1867–1947)
Poster for *Le Figaro*, 1903
color lithograph reworked with
charcoal and ink (proof)
Bouvet 77
123 x 87 (48 7/16 x 34 1/4)
Virginia and Ira Jackson
Collection, Promised Gift to
the National Gallery of Art

NO. 14

Jacques Villon
(French, 1875–1963)
*La Danseuse au Moulin Rouge*
(Dancer at the Moulin Rouge)
color lithograph
Ginestet and Pouillon 31
illustration in *L'Estampe et
l'affiche*, no. 3
(Clement-Janin and André
Mellerio, Paris, 1899)
page size: 28 x 22 (11 x 8 11/16)
Virginia and Ira Jackson
Collection

NO. 15

Pierre Bonnard
(French, 1867–1947)
*Les Boulevards*
color lithograph with
tissue cover-sheet
Bouvet 72
one of ten prints in *Album-Pan*,
no. 2, with introductory text by
Gustave Geffroy
(Editions de la "Maison
moderne," Paris, 1900)
27.7 x 35.5 (10 7/8 x 14)
Virginia and Ira Jackson
Collection, Promised Gift to
the National Gallery of Art

NO. 16

Henri-Gustave Jossot (French,
1866–1951); Louis Valtat
(French, 1869–1952); and others
*L'Omnibus de Corinthe*, nos. 1–5,
15 October 1896–15 October 1897
(Marc Mouclier, Paris)
five issues of quarterly journal
with lithographic illustrations
and script
25.2 x 16 (9 15/16 x 6 5/16)
Virginia and Ira Jackson
Collection, Promised Gift to
the National Gallery of Art

NO. 17

Louis Valtat
(French, 1869–1952)
Supplement to *L'Omnibus de
Corinthe*, 1896
zincograph in black
28.1 x 37.9 (11 1/16 x 14 15/16)
Virginia and Ira Jackson
Collection, Promised Gift to
the National Gallery of Art

NO. 18

Pierre Bonnard
(French, 1867–1947)
Supplement to *L'Omnibus de
Corinthe*, 1897
lithograph in black
Bouvet 45
31.2 x 24.8 (12 5/16 x 9 3/4)
Virginia and Ira Jackson
Collection, Promised Gift to
the National Gallery of Art

NO. 19

Henri de Toulouse-Lautrec
(French, 1864–1901)
Cover for *L'Estampe originale*
(Journal des artistes, André
Marty, Paris, 1893)
color lithograph
Delteil 17; Wittrock 3
image: 56.3 x 64.2 (22 3/16 x 25 1/4)
National Gallery of Art,
Rosenwald Collection, 1952.8.321

NO. 20

Pierre Bonnard
(French, 1867–1947)
*Scène de famille* (Family Scene),
from *L'Estampe originale* (album 1)
(Journal des artistes, André
Marty, Paris, 1893)
color lithograph
Bouvet 4
image: 31.2 x 17.7 (12 5/16 x 6 15/16)
National Gallery of Art, Virginia
and Ira Jackson Collection,
Partial and Promised Gift,
1999.138.2

NO. 21

Pierre Bonnard
(French, 1867–1947)
Study for *Scène de famille*
(recto), 1892
graphite
14.5 x 21.3 (5 11/16 x 8 3/8)
Virginia and Ira Jackson
Collection, Promised Gift to
the National Gallery of Art

NO. 22

Paul Ranson
(French, 1862–1909)
*Tigre dans les jungles* (Tiger
in the Jungle), from *L'Estampe
originale* (album 1)
(Journal des artistes, André
Marty, Paris, 1893)
color lithograph
image: 36.5 x 28.3 (14 3/8 x 11 1/8)
Virginia and Ira Jackson
Collection, Promised Gift to
the National Gallery of Art

NO. 23

Ker Xavier Roussel
(French, 1867–1944)
*Dans la neige* (In the Snow),
from *L'Estampe originale*
(album 1) (Journal des artistes,
André Marty, Paris, 1893)
color lithograph
Salomon 10
image: 32.9 x 19.2 (12 15/16 x 7 9/16)
Virginia and Ira Jackson
Collection, Promised Gift to
the National Gallery of Art

**NO. 24**

Félix Vallotton
(Swiss, 1865–1925)
*Le Bain* (The Bath), from
*L'Estampe originale* (album 8)
(Journal des artistes, André
Marty, Paris, 1894)
woodcut in black on yellow
paper support
Vallotton and Goerg 148
image: 18.1 x 22.5 (7 1/8 x 8 7/8)
Virginia and Ira Jackson
Collection, Promised Gift to
the National Gallery of Art

**NO. 25**

Paul Signac
(French, 1863–1935)
*Saint-Tropez*, from *L'Estampe
originale* (album 7)
(Journal des artistes, André
Marty, Paris, 1894)
color lithograph
Kornfeld and Wick 6
image: 27.6 x 36.8 (10 7/8 x 14 1/2)
National Gallery of Art, Virginia
and Ira Jackson Collection,
Partial and Promised Gift,
1999.138.10

**NO. 26**

Georges de Feure
(French, 1868–1943)
*La source du mal* (The Source of
Evil), from *L'Estampe originale*
(album 6)
(Journal des artistes, André Marty,
Paris, 1894)
color lithograph
image: 34.3 x 25.1 (13 1/2 x 9 7/8)
Virginia and Ira Jackson
Collection, Promised Gift to
the National Gallery of Art

**NO. 27**

Henri-Gustave Jossot
(French, 1866–1951)
*La Vague* (The Wave), from
*L'Estampe originale* (album 6)
(Journal des artistes,
André Marty, Paris, 1894)
lithograph in olive green
image: 53 x 35.2 (20 7/8 x 13 7/8)
Virginia and Ira Jackson
Collection, Promised Gift to
the National Gallery of Art

**NO. 28**

Eugène Grasset
(French, 1841–1917)
*La Vitrioleuse* (The Acid
Thrower), from *L'Estampe
originale* (album 6)
(Journal des artistes,
André Marty, Paris, 1894)
photo-relief with watercolor
stenciling
image: 39.9 x 27.6 (15 11/16 x 10 7/8)
Virginia and Ira Jackson
Collection

**NO. 29**

Paul Gauguin
(French, 1848–1903)
*Manao Tupapau* (She is Haunted
by a Spirit), from *L'Estampe
originale* (album 6)
(Journal des artistes,
André Marty, Paris, 1894)
lithograph in black
Guérin 50
image: 18.1 x 27.3 (7 1/8 x 10 3/4)
National Gallery of Art,
Rosenwald Collection, 1947.7.59

**NO. 30**

Edouard Vuillard
(French, 1868–1940)
*Intérieur* (Interior), from
*L'Estampe originale* (album 1)
(Journal des artistes, André
Marty, Paris, 1893)
lithograph in black and
gray green
Roger-Marx 2, ii/ii
image: 29.5 x 22.9 (11 5/8 x 9)
Virginia and Ira Jackson
Collection, Promised Gift to
the National Gallery of Art

**NO. 31**

Henri de Toulouse-Lautrec
(French, 1864–1901)
*Aux Ambassadeurs* (At the
Ambassadeurs), from *L'Estampe
originale* (album 6)
(Journal des artistes,
André Marty, Paris, 1894)
color lithograph
Delteil 68; Wittrock 58
image: 30.3 x 24.1 (11 15/16 x 9 1/2)
National Gallery of Art,
Collection of Mr. and Mrs. Paul
Mellon, 1985.64.176

**NO. 32A**

Eugène Carrière
(French, 1849–1906)
*Etude de femme* (Study of a
Woman), from *L'Epreuve*
(album 1, deluxe edition)
(Maurice Dumont, Paris,
December 1894)
lithograph in black on
china paper
Delteil 19
image: 33.2 x 23.5 (13 1/16 x 9 1/4)
National Gallery of Art, Virginia
and Ira Jackson Collection,
Partial and Promised Gift,
1996.151.2

**NO. 32B**

Eugène Carrière
(French, 1849–1906)
*Etude de femme* (Study of a
Woman), from *L'Epreuve*
(album 1, deluxe edition)
(Maurice Dumont, Paris,
December 1894)
lithograph in red on china paper
Delteil 19
image: 33.2 x 23.5 (13 1/16 x 9 1/4)
National Gallery of Art, Virginia
and Ira Jackson Collection,
Partial and Promised Gift,
1996.151.1

**NO. 32C**

Paul Sérusier
(French, 1863–1927)
*Paysage* (Landscape),
from *L'Epreuve* (album 4,
deluxe edition)
(Maurice Dumont, Paris,
March 1895)
lithograph in black on japan paper
image: 23.2 x 21.7 (9 1/8 x 8 9/16)
National Gallery of Art, Virginia
and Ira Jackson Collection,
Partial and Promised Gift,
1996.151.72

**NO. 32D**

Charles-Louis-M. Houdard
(French, active 19th century)
*Fleurs* (Flowers), from *L'Epreuve*
(album 2, deluxe edition)
(Maurice Dumont, Paris,
January 1895)
color etching and aquatint
plate: 28.1 x 22.1 (11 1/16 x 8 11/16)
sheet: 37 x 27.8 (14 9/16 x 10 15/16)
National Gallery of Art, Virginia
and Ira Jackson Collection,
Partial and Promised Gift,
1996.151.43

**NO. 32E**

Aristide Maillol
(French, 1861–1944)
*Eté* (Summer), from *L'Epreuve*
(album 9–10, deluxe edition)
(Maurice Dumont, Paris,
August–September 1895)
zincograph in black on japan
paper
Guérin 263
image: 25.6 x 30.6 (10 1/16 x 12 1/16)
National Gallery of Art, Virginia
and Ira Jackson Collection,
Partial and Promised Gift,
1996.151.191

Aristide Maillol
(French, 1861–1944)
*Eté* (Summer), from *L'Epreuve*
(album 9–10, deluxe edition)
(Maurice Dumont, Paris,
August–September 1895)
zincograph in green on japan paper
Guérin 263
image: 25.6 x 30.6 (10 1/16 x 12 1/16)
National Gallery of Art, Virginia
and Ira Jackson Collection,
Partial and Promised Gift,
1996.151.192

NO. 32G

Edouard Vuillard
(French, 1868–1940)
*Les Tuileries* (The Tuileries),
from *L'Epreuve* (album 6,
deluxe edition)
(Maurice Dumont, Paris,
May 1895)
lithograph in black on japan paper
Roger-Marx 27
image: 24.2 x 27.8 (9 1/2 x 10 15/16)
National Gallery of Art, Virginia
and Ira Jackson Collection,
Partial and Promised Gift,
1996.151.117

NO. 33

Pierre Bonnard
(French, 1867–1947)
*L'Arrière-grandmère* (Great
Grandmother), from
*L'Epreuve* (album 11–12)
(Maurice Dumont, Paris,
December 1895)
lithograph in brown reworked
with colored pencil on china
paper (proof)
Bouvet 36
image: 20.1 x 23.1 (7 15/16 x 9 1/8)
Virginia and Ira Jackson
Collection, Promised Gift to
the National Gallery of Art

NO. 34

Pierre Bonnard
(French, 1867–1947)
*La Petite Blanchisseuse* (The Little
Laundry Maid), from *Album des
peintres-graveurs*
(Ambroise Vollard, Paris, 1896)
color lithograph on china paper
Bouvet 40
image: 29.5 x 19.7 (11 5/8 x 7 3/4)
National Gallery of Art, Virginia
and Ira Jackson Collection,
Partial and Promised Gift,
1999.138.4

NO. 35

Edouard Vuillard
(French, 1868–1940)
*Le Jardin des Tuileries*
(The Tuileries Garden), from
*Album des peintres-graveurs*
(Ambroise Vollard, Paris, 1896)
color lithograph on china paper
Roger-Marx 28, ii/ii
42.8 x 57.3 (16 7/8 x 22 9/16)
National Gallery of Art,
Rosenwald Collection,
1943.3.9061

NO. 36

József Rippl-Rónai
(Hungarian, 1861–1927)
*La Fête de village* (Village
Festival), from *Album des
peintres-graveurs*
(Ambroise Vollard, Paris, 1896)
color lithograph on japan paper
image: 39.5 x 53.3 (15 9/16 x 21)
National Gallery of Art, Virginia
and Ira Jackson Collection,
Partial and Promised Gift,
1999.138.9

NO. 37

Edvard Munch
(Norwegian, 1863–1944)
*Anxiété* (Anxiety), from *Album
des peintres-graveurs*
(Ambroise Vollard, Paris, 1896)
color lithograph
Schiefler 61, 11/b
image: 43.5 x 38.7 (17 1/8 x 15 1/4)
The Epstein Family Collection

NO. 38

Pierre Bonnard
(French, 1867–1947)
Cover for the second *Album
d'estampes originales de la Galerie
Vollard*
(Ambroise Vollard, Paris, 1897)
color lithograph on china paper
Bouvet 41
70.6 x 92.8 (27 13/16 x 36 9/16)
Virginia and Ira Jackson
Collection, Promised Gift to
the National Gallery of Art

NO. 39

Paul Cézanne
(French, 1839–1906)
*Les Baigneurs* (The Bathers),
from *Album d'estampes originales
de la Galerie Vollard*
(Ambroise Vollard, Paris, 1897)
color lithograph on china paper
image: 23.6 x 29.1 (9 5/16 x 11 7/16)
National Gallery of Art,
Rosenwald Collection,
1950.16.16

NO. 40

Pierre Bonnard
(French, 1867–1947)
*Le Canotage* (Boating), from
*Album d'estampes originales de la
Galerie Vollard*
(Ambroise Vollard, Paris, 1897)
color lithograph on china paper
Bouvet 42
image: 26.2 x 47 (10 5/16 x 18 1/2)
Virginia and Ira Jackson
Collection, Promised Gift to
the National Gallery of Art

NO. 41

Henri de Toulouse-Lautrec
(French, 1864–1901)
*Partie de campagne* (Country
Outing), from *Album d'estampes
originales de la Galerie Vollard*
(Ambroise Vollard, Paris, 1897)
color lithograph
Delteil 219; Wittrock 228
39.9 x 51.7 (15 11/16 x 20 3/8)
National Gallery of Art,
Collection of Mr. and Mrs.
Paul Mellon, 1994.59.31

NO. 42

Edouard Vuillard
(French, 1868–1940)
*Jeux d'enfants* (Children's Play),
from *Album d'estampes originales
de la Galerie Vollard*
(Ambroise Vollard, Paris, 1897)
color lithograph on china paper
Roger-Marx 29, iii/iii
42.8 x 57.3 (16 7/8 x 22 9/16)
National Gallery of Art,
Rosenwald Collection,
1944.2.74

NO. 43

Odilon Redon
(French, 1840–1916)
*Béatrice*, from *Album d'estampes
originales de la Galerie Vollard*
(Ambroise Vollard, Paris, 1897)
color lithograph on chine collé
Mellerio 168
33.6 x 29.7 (13 1/4 x 11 11/16)
National Gallery of Art,
Rosenwald Collection,
1950.16.205

NO. 44

Pierre Bonnard
(French, 1867–1947)
*L'Enfant à la lampe* (Child with
Lamp), from *Album d'estampes
originales de la Galerie Vollard*
(unpublished), c. 1897
color lithograph on china paper
Bouvet 43
image: 33 x 45.7 (13 x 18)
National Gallery of Art, Virginia
and Ira Jackson Collection,
Partial and Promised Gift,
1999.138.1

NO. 45

Paul Gauguin
(French, 1848–1903)
*Joies de Bretagne* (Pleasures of
Brittany), from *Dix zincographies*
(Edouard Ancourt, Paris, 1889)
zincograph in black on
yellow paper
Guérin 2 (1st edition)
image: 20.4 x 23.9 (8 1/16 x 9 7/16)
National Gallery of Art, Andrew
W. Mellon Fund, 1978.54.1

NO. 46

Paul Gauguin
(French, 1848–1903)
*Baigneuses bretonnes* (Breton
Bathers), from *Dix zincographies*
(Edouard Ancourt, Paris, 1889)
zincograph in black on
yellow paper
Guérin 3 (1st edition)
image: 23.7 x 20 (9 5/16 x 7 7/8)
Virginia and Ira Jackson
Collection, Promised Gift to
the National Gallery of Art

NO. 47

Paul Gauguin
(French, 1848–1903)
*Les Laveuses* (Washerwomen),
from *Dix zincographies*
(Edouard Ancourt, Paris, 1889)
zincograph in black on
yellow paper
Guérin 6 (1st edition)
image: 21 x 26 (8 1/4 x 10 1/4)
National Gallery of Art, Print
Purchase Fund (Rosenwald
Collection), 1985.7.1

NO. 48

Félix Vallotton
(Swiss, 1865–1925)
Frontispiece for *Paris intense*
(L. Joly, Paris, 1894)
zincograph on green paper
Vallotton and Goerg 45e
image: 21.9 x 31.5 (8 5/8 x 12 3/8)
National Gallery of Art,
Rosenwald Collection,
1952.8.479

NO. 49

Félix Vallotton
(Swiss, 1865–1925)
*Deuxieme bureau* (Box Office),
from *Paris intense*
(L. Joly, Paris, 1894)
zincograph on yellow paper
Vallotton and Goerg 48b
image: 21.9 x 31.3 (8 5/8 x 12 5/16)
National Gallery of Art,
Rosenwald Collection,
1952.8.482

NO. 50

Félix Vallotton
(Swiss, 1865–1925)
*L'Averse* (The Shower), from
*Paris intense*
(L. Joly, Paris, 1894)
zincograph on yellow paper
Vallotton and Goerg 51b
image: 22.8 x 31.3 (9 x 12 5/16)
National Gallery of Art,
Rosenwald Collection,
1952.8.484

NO. 51

Henri de Toulouse-Lautrec
(French, 1864–1901)
Frontispiece for *Elles*
(Gustave Pellet, Paris, 1896)
color lithograph
Delteil 179; Wittrock 155
52.8 x 40.2 (20 13/16 x 15 13/16)
National Gallery of Art,
Rosenwald Collection,
1952.8.434

NO. 52

Henri de Toulouse-Lautrec
(French, 1864–1901)
*Femme au lit, profil* (Woman in
Bed, Profile), from *Elles*
(Gustave Pellet, Paris, 1896)
color lithograph
Delteil 187; Wittrock 163
40.5 x 52.5 (15 15/16 x 20 11/16)
National Gallery of Art,
Rosenwald Collection,
1964.8.1893

NO. 53

Henri de Toulouse-Lautrec
(French, 1864–1901)
*La Clownesse assise* (Seated
Clown), from *Elles*
(Gustave Pellet, Paris, 1896)
color lithograph (*bon à tirer* proof)
Delteil 180; Wittrock 156
51.8 x 40 (20 7/16 x 15 3/4)
National Gallery of Art, Gift
of Mr. and Mrs. Robert L.
Rosenwald, in Honor of the
50th Anniversary of the National
Gallery of Art, 1991.30.1

NO. 54

Henri de Toulouse-Lautrec
(French, 1864–1901)
*Femme qui se lave* (Woman
Washing Herself), from *Elles*
(Gustave Pellet, Paris, 1896)
color lithograph
Delteil 184; Wittrock 160
52 x 40.1 (20 1/2 x 15 13/16)
National Gallery of Art,
Rosenwald Collection,
1964.8.1891

NO. 55

Henri de Toulouse-Lautrec
(French, 1864–1901)
*Femme au tub* (Woman at the
Tub), from *Elles*
(Gustave Pellet, Paris, 1896)
color lithograph
Delteil 183; Wittrock 159
40.3 x 53.1 (15 7/8 x 20 7/8)
National Gallery of Art,
Rosenwald Collection,
1964.8.1904

NO. 56

Odilon Redon
(French, 1840–1916)
*Une femme revêtue du soleil* (A
Woman Clothed with the Sun),
from *Apocalypse de Saint-Jean*
(Ambroise Vollard, Paris, 1899)
lithograph in black on chine collé
Mellerio 179
28.9 x 23 (11 3/8 x 9 1/16)
National Gallery of Art,
Rosenwald Collection,
1943.3.7369

NO. 57

Odilon Redon
(French, 1840–1916)
*Et le lia pour mille ans* (And
Bound Him for a Thousand
Years), from *Apocalypse de
Saint-Jean*
(Ambroise Vollard, Paris, 1899)
lithograph in black on chine collé
Mellerio 182
30 x 21 (11 13/16 x 8 1/4)
National Gallery of Art,
Rosenwald Collection,
1943.3.7375

NO. 58

Odilon Redon
(French, 1840–1916)
*Et celui qui était monté dessus se
nommait la mort* (And His Name
that Sat on Him was Death),
from *Apocalypse de Saint-Jean*
(Ambroise Vollard, Paris, 1899)
lithograph in black on chine collé
Mellerio 176
31 x 22.4 (12 3/16 x 8 13/16)
National Gallery of Art,
Rosenwald Collection,
1943.3.7376

**NO. 59**

Pierre Bonnard
(French, 1867–1947)
Cover for *Quelques aspects de la vie de Paris*, 1898
(Ambroise Vollard, Paris, 1899)
lithograph in black on china paper (proof before letters)
Bouvet 58
44 x 35.7 (17⁵/₁₆ x 14¹/₁₆)
Virginia and Ira Jackson Collection

**NO. 60**

Pierre Bonnard
(French, 1867–1947)
Cover for *Quelques aspects de la vie de Paris*, 1898
(Ambroise Vollard, Paris, 1899)
color lithograph on china paper
Bouvet 58
52 x 39.4 (20¹/₂ x 15¹/₂)
Virginia and Ira Jackson Collection, Promised Gift to the National Gallery of Art

**NO. 61**

Pierre Bonnard
(French, 1867–1947)
*Boulevard*, from *Quelques aspects de la vie de Paris*, c. 1896
(Ambroise Vollard, Paris, 1899)
color lithograph (proof)
Bouvet 63
image: 17.6 x 43.8 (6¹⁵/₁₆ x 17¹/₄)
Virginia and Ira Jackson Collection, Promised Gift to the National Gallery of Art

**NO. 62**

Pierre Bonnard
(French, 1867–1947)
*Boulevard*, from *Quelques aspects de la vie de Paris*, c. 1896
(Ambroise Vollard, Paris, 1899)
color lithograph
Bouvet 63
image: 17.6 x 43.8 (6¹⁵/₁₆ x 17¹/₄)
Virginia and Ira Jackson Collection, Promised Gift to the National Gallery of Art

**NO. 63**

Pierre Bonnard
(French, 1867–1947)
*L'Arc de Triomphe*, from *Quelques aspects de la vie de Paris*, c. 1898
(Ambroise Vollard, Paris, 1899)
color lithograph (proof)
Bouvet 69
image: 31 x 46.5 (12³/₁₆ x 18⁵/₁₆)
Virginia and Ira Jackson Collection, Promised Gift to the National Gallery of Art

**NO. 64**

Pierre Bonnard
(French, 1867–1947)
*L'Arc de Triomphe*, from *Quelques aspects de la vie de Paris*, c. 1898
(Ambroise Vollard, Paris, 1899)
color lithograph
Bouvet 69
image: 31 x 46.5 (12³/₁₆ x 18⁵/₁₆)
Virginia and Ira Jackson Collection, Promised Gift to the National Gallery of Art

**NO. 65**

Pierre Bonnard
(French, 1867–1947)
*Rue, le soir, sous la pluie* (The Street at Night in the Rain), from *Quelques aspects de la vie de Paris*, c. 1897
(Ambroise Vollard, Paris, 1899)
color lithograph (proof)
Bouvet 68
image: 25.6 x 35.2 (10¹/₁₆ x 13⁷/₈)
Virginia and Ira Jackson Collection, Promised Gift to the National Gallery of Art

**NO. 66**

Pierre Bonnard
(French, 1867–1947)
*Place le soir* (The Square at Night), from *Quelques aspects de la vie de Paris*, c. 1897
(Ambroise Vollard, Paris, 1899)
color lithograph
Bouvet 64
image: 26.5 x 38.7 (10⁷/₁₆ x 15¹/₄)
Virginia and Ira Jackson Collection, Promised Gift to the National Gallery of Art

**NO. 67**

Pierre Bonnard
(French, 1867–1947)
*Maison dans la cour* (House in the Courtyard), from *Quelques aspects de la vie de Paris*, 1895/1896
(Ambroise Vollard, Paris, 1899)
color lithograph
Bouvet 61
image: 34.7 x 25.7 (13¹¹/₁₆ x 10¹/₈)
Virginia and Ira Jackson Collection, Promised Gift to the National Gallery of Art

**NO. 68**

Edouard Vuillard
(French, 1868–1940)
*L'Avenue*, from *Paysages et intérieurs*
(Ambroise Vollard, Paris, 1899)
color lithograph on china paper
Roger-Marx 33, ii/ii
33.4 x 45 (13¹/₈ x 17¹¹/₁₆)
National Gallery of Art, Rosenwald Collection, 1950.16.267

**NO. 69**

Edouard Vuillard
(French, 1868–1940)
*Les deux belles-soeurs* (Two Sisters-in-Law), from *Paysages et intérieurs*
(Ambroise Vollard, Paris, 1899)
color lithograph on china paper
Roger-Marx 43, iii/iii
36.9 x 30.1 (14¹/₂ x 11⁷/₈)
National Gallery of Art, Rosenwald Collection, 1950.16.268

**NO. 70**

Edouard Vuillard
(French, 1868–1940)
*Intérieur aux tentures roses I* (Interior with Pink Wallpaper I), from *Paysages et intérieurs*
(Ambroise Vollard, Paris, 1899)
color lithograph on china paper
Roger-Marx 36, iv/iv
39.2 x 30.7 (15⁷/₁₆ x 12¹/₁₆)
National Gallery of Art, Rosenwald Collection, 1950.16.271

**NO. 71**

Ker Xavier Roussel
(French, 1867–1944)
*Femme en rouge dans un paysage* (Woman in Red in a Landscape), from *Album de paysage*
(Ambroise Vollard, Paris, 1899)
color lithograph on china paper
Salomon 15
image: 23.4 x 35.6 (9³/₁₆ x 14)
National Gallery of Art, Rosenwald Collection, 1950.16.224

**NO. 72**

Ker Xavier Roussel
(French, 1867–1944)
*Femmes dans la campagne* (Women in the Country), from *Album de paysage*
(Ambroise Vollard, Paris, 1899)
color lithograph on china paper
Salomon 19
image: 23.5 x 32.5 (9¹/₄ x 12¹³/₁₆)
National Gallery of Art, Rosenwald Collection, 1950.16.227

NO. 73

Ker Xavier Roussel
(French, 1867–1944)
*Femme en robe à rayures*
(Woman in a Striped Dress),
from *Album de paysage*
(Ambroise Vollard, Paris, 1899)
color lithograph on china paper
Salomon 16
image: 21.5 x 32.4 (8 7/16 x 12 3/4)
National Gallery of Art,
Rosenwald Collection,
1950.16.225

NO. 74

Ker Xavier Roussel
(French, 1867–1944)
Study for *Femme en robe à rayures*
(Woman in a Striped Dress),
c. 1898
pastel
28.2 x 36.5 (11 1/16 x 14 3/8)
National Gallery of Art, Ailsa
Mellon Bruce Fund, 1988.13.1

NO. 75

Pierre Bonnard
(French, 1867–1947)
*Promenade des nourrices, frise
des fiacres* (Nursemaids'
Promenade, Frieze of Carriages)
(Molines, Paris, 1895)
four-panel color-lithographic
screen
Bouvet 55
150 x 200 (59 1/16 x 78 3/4)
National Gallery of Art, Virginia
and Ira Jackson Collection,
Partial and Promised Gift,
1999.138.8

NO. 76

Henri de Toulouse-Lautrec
(French, 1864–1901)
Gustave Geffroy's *Yvette Guilbert*
(L'Estampe originale, Paris, 1894)
album with sixteen lithographs
in olive green printed on eight
sheets (recto/verso) with
lithographic cover in black
Delteil 81–95; Wittrock 71–85
folded: 38 x 38 (14 15/16 x 14 15/16)
National Gallery of Art,
New Century Fund, Gift
of Edwin L. Cox — Ed Cox
Foundation, 2000.1.1

NO. 77A – B

Maurice Denis
(French, 1870–1943)
André Gide's *Le Voyage d'Urien*
(Librarie de l'art indépendant,
Paris, 1893)
volume with thirty color
lithographs and one woodcut
in black on cover; inscribed by
Gide and Denis on title page
Cailler 37–67
page size: 20.1 x 19.1 (7 15/16 x 7 1/2)
Virginia and Ira Jackson
Collection, Promised Gift to
the National Gallery of Art

NO. 78

James Pitcairn-Knowles
(Scottish, 1864–1914)
Georges Rodenbach's
*Les Tombeaux* (issued with
*Les Vierges*)
(Editions de l'Art Nouveau,
Siegfried Bing, Paris, 1895)
volume with three woodcuts in
black and one woodcut in yellow
green on wrapper
page size: 25.1 x 17.2 (9 7/8 x 6 3/4)
Virginia and Ira Jackson
Collection, Promised Gift to
the National Gallery of Art

NO. 79

József Rippl-Rónai
(Hungarian, 1861–1927)
Georges Rodenbach's *Les Vierges*
(issued with *Les Tombeaux*)
(Editions de l'Art Nouveau,
Siegfried Bing, Paris, 1895)
volume with four color
lithographs and one woodcut
by James Pitcairn-Knowles on
wrapper in gray green
page size: 25.1 x 17.2 (9 7/8 x 6 3/4)
Virginia and Ira Jackson
Collection, Promised Gift to
the National Gallery of Art

NO. 80

Félix Vallotton
(Swiss, 1865–1925)
Book jacket for *Badauderies
parisiennes — Les Rassemblements,
physiologies de la rue*, 1896
photo-relief
image: 24.1 x 37.5 (9 1/2 x 14 3/4)
Virginia and Ira Jackson
Collection, Promised Gift to
the National Gallery of Art

NO. 81

Félix Vallotton
(Swiss, 1865–1925)
Octave Uzanne's *Badauderies
parisiennes — Les Rassemblements,
physiologies de la rue*
(Bibliophiles indépendants,
Paris, 1896)
volume with thirty photo-relief
illustrations
page size: 23.4 x 17.3 (9 3/16 x 6 13/16)
Virginia and Ira Jackson
Collection, Promised Gift to
the National Gallery of Art

NO. 82

Pierre Bonnard
(French, 1867–1947)
Cover for Victor Joze's *Reine de
joie, moeurs du demi-monde*, 1892
color lithograph (proof)
Bouvet 3
21.5 x 28.4 (8 7/16 x 11 3/16)
Virginia and Ira Jackson
Collection, Promised Gift to
the National Gallery of Art

NO. 83A – B

Pierre Bonnard
(French, 1867–1947)
Peter Nansen's *Marie*
(Editions de la Revue blanche,
Paris, 1898)
volume with eighteen
photo-relief illustrations
page size: 18.7 x 11.9 (7 3/8 x 4 11/16)
Virginia and Ira Jackson
Collection, Promised Gift to
the National Gallery of Art

NO. 84

Pierre Bonnard
(French, 1867–1947)
Study for *Marie and Her
Protector* (recto), 1897
brush and black ink
21.3 x 15.7 (8 3/8 x 6 3/16)
Virginia and Ira Jackson
Collection, Promised Gift to
the National Gallery of Art

NO. 85

Pierre Bonnard
(French, 1867–1947)
Study for *Marie Putting on
Her Hat* (recto), 1897
charcoal and black ink
32.5 x 25 (12 13/16 x 9 13/16)
Virginia and Ira Jackson
Collection, Promised Gift to
the National Gallery of Art

NO. 86

Pierre Bonnard
(French, 1867–1947)
Alfred Jarry's *Almanach du Père
Ubu illustré*
(Thuillier-Chauvin, Paris, 1899)
*petit* volume with twenty
photo-relief illustrations
page size: 11 x 9.4 (4 5/16 x 3 11/16)
Virginia and Ira Jackson
Collection, Promised Gift to
the National Gallery of Art

NO. 87

Pierre Bonnard
(French, 1867–1947)
Alfred Jarry's *Almanach illustré du
Père Ubu (XXe siècle)*
(Ambroise Vollard, Paris, 1901)
volume with seventy-nine
lithographic or zinc relief-prints
in red, blue, and black (before
numbered edition, uncut)
page size: 28.7 x 20.3 (11 5/16 x 8)
Virginia and Ira Jackson
Collection, Promised Gift to
the National Gallery of Art

NO. 88

Pierre Bonnard
(French, 1867–1947)
Alfred Jarry's *Almanach illustré
du Père Ubu (XXe siècle)*
(Ambroise Vollard, Paris, 1901)
volume with seventy-nine
lithographic or zinc relief-prints
in black (uncut and without text)
page size: 28.7 x 20.3 (11 5/16 x 8)
Virginia and Ira Jackson
Collection, Promised Gift to
the National Gallery of Art

NO. 89

Pierre Bonnard
(French, 1867–1947)
André Mellerio's *La Lithographie
en couleurs*, 1898
(L'Estampe et l'affiche, Paris, 1898)
volume with color-lithographic
cover and color-lithographic
frontispiece by Pierre Bonnard
(deluxe edition), with additional
separate proofs of the cover and
frontispiece
page size: 21.8 x 18.5 (8 9/16 x 7 5/16)
Virginia and Ira Jackson
Collection, Promised Gift to
the National Gallery of Art

NO. 90

Henri de Toulouse-Lautrec
(French, 1864–1901)
Cover for Georges Clémenceau's
*Au pied du Sinaï*
(Henri Floury, Paris, 1898)
color lithograph on japan paper
(deluxe book edition)
Delteil 235; Wittrock 188
image: 26.3 x 41.3 (10 3/8 x 16 1/4)
National Gallery of Art, Gift of
Robert M. Walker, 1980.26.1

NO. 91A–B

Pierre Bonnard
(French, 1867–1947)
Paul Verlaine's *Parallèlement*
(Ambroise Vollard, Paris, 1900)
volume with 109 lithographs in
rose sanguine and 9 wood
engravings in black after Bonnard
on Holland paper
Bouvet 73
page size: 30 x 24.4 (11 13/16 x 9 5/8)
Virginia and Ira Jackson
Collection, Promised Gift to
the National Gallery of Art

NO. 92A–B

Pierre Bonnard
(French, 1867–1947)
Longus' *Daphnis et Chloé*
(Ambroise Vollard, Paris, 1902)
volume with 151 lithographs in
black on Holland paper
Bouvet 75
page size: 30 x 24 (11 13/16 x 9 7/16)
Virginia and Ira Jackson
Collection, Promised Gift to
the National Gallery of Art

NO. 93

Pierre Bonnard
(French, 1867–1947)
*Fille avec miroir* (Girl with
Mirror), c. 1902
black chalk
18.1 x 14.8 (7 1/8 x 5 13/16)
Virginia and Ira Jackson
Collection, Promised Gift to
the National Gallery of Art

NO. 94A–B

Pierre Bonnard
(French, 1867–1947)
Jules Renard's *Histoires naturelles*
(Ernest Flammarion, Paris, 1904)
volume with seventy photo-relief
illustrations
page size: 18.6 x 11.8 (7 5/16 x 4 5/8)
Virginia and Ira Jackson
Collection, Promised Gift to
the National Gallery of Art

NO. 95

Pierre Bonnard
(French, 1867–1947)
Study for *Le Cygne* (Swan),
c. 1904
brush and black ink
30.9 x 19.9 (12 3/16 x 7 13/16)
Virginia and Ira Jackson
Collection, Promised Gift to
the National Gallery of Art

NO. 96

Pierre Bonnard
(French, 1867–1947)
Poster announcing the publica-
tion in *Le Figaro* of Abel
Hermant's *Confession d'un homme
d'aujourd'hui*, 1903
color lithograph
Bouvet 78
60.7 x 41.2 (23 7/8 x 16 1/4)
Virginia and Ira Jackson
Collection, Promised Gift to
the National Gallery of Art

NO. 97

Pierre Bonnard
(French, 1867–1947)
*La Petite qui tousse* (The Girl
Who Coughs), 1890/1891
brush and black ink with
watercolor
27.8 x 36.5 (10 15/16 x 14 3/8)
Virginia and Ira Jackson
Collection, Promised Gift to
the National Gallery of Art

NO. 98

Pierre Bonnard
(French, 1867–1947)
*Young Girl (Berthe Schaedlin)*,
c. 1890
charcoal
24.2 x 10.6 (9 1/2 x 4 3/16)
Virginia and Ira Jackson
Collection, Promised Gift to
the National Gallery of Art

NO. 99

Pierre Bonnard
(French, 1867–1947)
*Pas redoublé*, 1891
brush and pen and black ink with
watercolor over graphite
38.9 x 29.7 (15 5/16 x 11 11/16)
Virginia and Ira Jackson
Collection, Promised Gift to
the National Gallery of Art

**NO. 100**

Maurice Denis
(French, 1870–1943)
Frontispiece for *La Damoiselle élue* (The Blessed Damsel), 1892
color lithograph
Cailler 30
43.9 x 23 (17⁵/₁₆ x 9¹/₁₆)
Virginia and Ira Jackson
Collection

**NO. 101**

Maurice Denis
(French, 1870–1943)
Cover for *Concerts du petit frère et de la petite soeur*
(André Rossignol, Paris, 1903)
color lithograph
Cailler 124
34.9 x 27.2 (13³/₄ x 10¹¹/₁₆)
Virginia and Ira Jackson
Collection

**NO. 102**

Henri-Gabriel Ibels
(French, 1867–1936)
Cover for *Les Mal Tournés*,
early 1890s
photo-relief with watercolor
stenciling
27 x 17.9 (10⁵/₈ x 7¹/₁₆)
Virginia and Ira Jackson
Collection, Promised Gift to
the National Gallery of Art

**NO. 103**

Henri-Gabriel Ibels
(French, 1867–1936)
Cover for *Salut, drapeau!*,
early 1890s
photo-relief with watercolor
stenciling
26.9 x 17.8 (10⁹/₁₆ x 7)
Virginia and Ira Jackson
Collection, Promised Gift to
the National Gallery of Art

**NO. 104**

Pierre Bonnard
(French, 1867–1947)
Claude Terrasse's *Petit solfège illustré*
(Libraries-Imprimeries réunies,
Ancienne Maison Quantin,
Paris, 1893)
volume with thirty-two color-
lithographic relief-prints, including
front and back covers (before
the regular edition)
page size: 21.3 x 28.5 (8³/₈ x 11¹/₄)
Virginia and Ira Jackson
Collection, Promised Gift to
the National Gallery of Art

**NO. 105**

Pierre Bonnard
(French, 1867–1947)
Study for cover for *Petit solfège illustré*, 1891/1893
brush and black ink and
watercolor over graphite
22.5 x 31.6 (8⁷/₈ x 12⁷/₁₆)
Virginia and Ira Jackson
Collection, Promised Gift to
the National Gallery of Art

**NO. 106 A – H**

Pierre Bonnard
(French, 1867–1947)
Claude Terrasse's *Petit solfège illustré*
(Libraries-Imprimeries réunies,
Ancienne Maison Quantin,
Paris, 1893)
volume with thirty-two color-
lithographic relief-prints, including
front and back covers
page size: 21.3 x 28.5 (8³/₈ x 11¹/₄)
Virginia and Ira Jackson
Collection, Promised Gift to
the National Gallery of Art

**NO. 107**

Pierre Bonnard
(French, 1867–1947)
Study for *Qu'est-ce qu'un solfège?*,
1891/1893
brush and black ink with red
chalk over graphite
19.2 x 27.9 (7⁹/₁₆ x 11)
Virginia and Ira Jackson
Collection, Promised Gift to
the National Gallery of Art

**NO. 108**

Pierre Bonnard
(French, 1867–1947)
Study for *Do Ré Mi*, 1891/1893
brush and black ink with
watercolor and graphite
20 x 27.3 (7⁷/₈ x 10³/₄)
Virginia and Ira Jackson
Collection, Promised Gift to
the National Gallery of Art

**NO. 109**

Pierre Bonnard
(French, 1867–1947)
Study for *Les Clés*, 1891/1893
brush and pen and black ink
with watercolor and graphite
20.5 x 28 (8¹/₁₆ x 11)
Virginia and Ira Jackson
Collection, Promised Gift to
the National Gallery of Art

**NO. 110**

Pierre Bonnard
(French, 1867–1947)
Study for *Gamme majeure*,
1891/1893
brush and pen and black ink
with watercolor over graphite
20.6 x 28.3 (8¹/₈ x 11¹/₈)
Virginia and Ira Jackson
Collection

**NO. 111**

Pierre Bonnard
(French, 1867–1947)
Study for *Gamme mineure* and
*Gamme majeure* (recto), 1891/1893
pen and black ink with red chalk
and graphite
image: 19.6 x 27.4 (7¹¹/₁₆ x 10¹³/₁₆)
Virginia and Ira Jackson
Collection, Promised Gift to
the National Gallery of Art

**NO. 112**

Pierre Bonnard
(French, 1867–1947)
Study for *Qu'est-ce que la mesure?*,
1891/1893
brush and black ink over graphite
8.4 x 28 (3⁵/₁₆ x 11)
Virginia and Ira Jackson
Collection, Promised Gift to
the National Gallery of Art

**NO. 113**

Pierre Bonnard
(French, 1867–1947)
Study for *Leçon sur les mesures composées*, 1891/1893
pen and black ink over graphite
22.2 x 27.8 (8³/₄ x 10¹⁵/₁₆)
Virginia and Ira Jackson
Collection, Promised Gift to
the National Gallery of Art

**NO. 114 A – B**

Pierre Bonnard
(French, 1867–1947)
Studies for *La Valse* (recto/verso),
1891/1893
pen and black ink over graphite
22.2 x 10.9 (8³/₄ x 4⁵/₁₆)
Virginia and Ira Jackson
Collection, Promised Gift to
the National Gallery of Art

**NO. 115**

Pierre Bonnard
(French, 1867–1947)
*Quadrille*, from *Petites scènes
familières*, 1895
lithograph in black on china
paper, with the artist's monogram
in red brushwork (proof)
Bouvet 24
image: 10.9 x 33.5 (4⁵/₁₆ x 13³/₁₆)
sheet: 21.7 x 33.5 (8⁹/₁₆ x 13³/₁₆)
Virginia and Ira Jackson
Collection, Promised Gift to
the National Gallery of Art

**NO. 116**

Pierre Bonnard
(French, 1867–1947)
*Rêverie*, from *Petites scènes
familières*, 1895
lithograph in black on china
paper (proof)
Bouvet 17
image: 18.2 x 12.9 (7³/₁₆ x 5¹/₁₆)
sheet: 34.8 x 20.3 (13¹¹/₁₆ x 8)
Virginia and Ira Jackson
Collection, Promised Gift to
the National Gallery of Art

**NO. 117**

Pierre Bonnard
(French, 1867–1947)
Claude Terrasse's *Petites scènes
familières, pour piano*
(E. Fromont, Paris, 1895)
music album with nineteen
lithographs and lithographic
cover in black
page size: 35.2 x 26.9 (13⁷/₈ x 10⁹/₁₆)
Virginia and Ira Jackson
Collection, Promised Gift to
the National Gallery of Art

**NO. 118**

Pierre Bonnard
(French, 1867–1947)
*Au cirque*, from *Petites scènes
familières*, 1895
lithograph in black on china
paper, with the artist's monogram
in red brushwork (proof)
Bouvet 23
12.5 x 33.1 (4¹⁵/₁₆ x 13¹/₁₆)
Virginia and Ira Jackson
Collection, Promised Gift to
the National Gallery of Art

**NO. 119**

Henri de Toulouse-Lautrec
(French, 1864–1901)
Cover for *Les Vieilles Histoires*
(G. Ondet, Paris, 1893)
lithograph in black reworked
with watercolor (proof)
Delteil 18; Wittrock 5 (2d state)
35.3 x 53.8 (13⁷/₈ x 21³/₁₆)
National Gallery of Art,
Rosenwald Collection,
1950.16.242

**NO. 120**

Henri de Toulouse-Lautrec
(French, 1864–1901)
*Pour toi!* (For You!)
(Kleinmann, Paris, 1893)
lithograph in black with
stencil coloring
Delteil 19; Wittrock 6
(1st edition)
37.9 x 27.3 (14¹⁵/₁₆ x 10³/₄)
*note:* image was later reduced in
size and issued with text as a
sheet-music cover in the album
*Les Vieilles Histoires*
National Gallery of Art, Rosen-
wald Collection, 1952.8.323

**NO. 121**

Henri de Toulouse-Lautrec
(French, 1864–1901)
*Le Petit Trottin* (The Little
Errand Girl)
(Kleinmann, Paris, 1893)
lithograph in black on
japan paper
Delteil 27; Wittrock 14
(1st edition)
31.7 x 25.1 (12¹/₂ x 9⁷/₈)
*note:* image was later issued
as a stencil-colored sheet-music
cover with added text
National Gallery of Art,
Rosenwald Collection, 1952.8.336

**NO. 122**

Pierre Bonnard
(French, 1867–1947)
Study for *Du pays tourangeau*, 1898
black chalk
31 x 20.6 (12³/₁₆ x 8¹/₈)
Virginia and Ira Jackson
Collection, Promised Gift to
the National Gallery of Art

**NO. 123**

Pierre Bonnard
(French, 1867–1947)
*Du pays tourangeau* (From
the Land of Touraine), from
*Répertoire des pantins*
(Mercure de France, Paris, 1898)
lithograph in black
Bouvet 49
32.6 x 24.9 (12¹³/₁₆ x 9¹³/₁₆)
Virginia and Ira Jackson
Collection, Promised Gift to
the National Gallery of Art

**NO. 124**

Pierre Bonnard
(French, 1867–1947)
*Malheureuse Adèle* (Unfortunate
Adele), from *Répertoire des pantins*
(Mercure de France, Paris, 1898)
lithograph in black
Bouvet 50
32.6 x 24.9 (12¹³/₁₆ x 9¹³/₁₆)
Virginia and Ira Jackson
Collection, Promised Gift to
the National Gallery of Art

**NO. 125**

Pierre Bonnard
(French, 1867–1947)
*Velas ou l'officier de fortune*
(Velas, or the Soldier of Fortune),
from *Répertoire des pantins*
(Mercure de France, Paris, 1898)
lithograph in black
Bouvet 51
32.5 x 24.7 (12¹³/₁₆ x 9³/₄)
Virginia and Ira Jackson
Collection, Promised Gift to
the National Gallery of Art

**NO. 126**

Pierre Bonnard
(French, 1867–1947)
*La Complainte de Monsieur Benoît*
(Monsieur Benoît's Lament),
from *Répertoire des pantins*
(Mercure de France, Paris, 1898)
lithograph in black
Bouvet 46
35 x 27.1 (13³/₄ x 10¹¹/₁₆)
Virginia and Ira Jackson
Collection, Promised Gift to
the National Gallery of Art

**NO. 127**

Pierre Bonnard
(French, 1867–1947)
*Berceuse obscène* (Obscene Lullaby),
from *Répertoire des pantins*
(Mercure de France, Paris, 1898)
lithograph in black
Bouvet 47
34.9 x 27 (13³/₄ x 10⁵/₈)
Virginia and Ira Jackson
Collection, Promised Gift to
the National Gallery of Art

**NO. 128**

Pierre Bonnard
(French, 1867–1947)
*Paysage de neige* (Snowy
Landscape), from *Répertoire
des pantins*
(Mercure de France, Paris, 1898)
lithograph in black
Bouvet 48
35.3 x 26.8 (13⁷/₈ x 10⁹/₁₆)
Virginia and Ira Jackson
Collection, Promised Gift to
the National Gallery of Art

NO. 129

Alfred Jarry
(French, 1873–1907)
*Ouverture d'Ubu Roi* (Overture
to *Ubu Roi*), from *Répertoire des
pantins*
(Mercure de France, Paris, 1898)
lithograph in black
35.1 x 27 (13 13/16 x 10 5/8)
Virginia and Ira Jackson
Collection, Promised Gift to
the National Gallery of Art

NO. 130

Alfred Jarry
(French, 1873–1907)
*Marche des polonais* (Polish
March), from *Répertoire des
pantins*
(Mercure de France, Paris, 1898)
lithograph in black
35.2 x 26.9 (13 7/8 x 10 9/16)
Virginia and Ira Jackson
Collection, Promised Gift to
the National Gallery of Art

NO. 131

Alfred Jarry
(French, 1873–1907)
*La Chanson du décervelage*
(The Debraining Song), from
*Répertoire des pantins*
(Mercure de France, Paris, 1898)
lithograph in black
35.2 x 26.9 (13 7/8 x 10 9/16)
Virginia and Ira Jackson
Collection, Promised Gift to
the National Gallery of Art

NO. 132

Pierre Bonnard
(French, 1867–1947)
Georges Courteline and Claude
Terrasse's *Panthéon-Courcelles*
music volume with lithographic
cover and title page in brown
(Paul Dupont, Paris, 1899)
Bouvet 57
page size: 28 x 19.2 (11 x 7 9/16)
Virginia and Ira Jackson
Collection, Promised Gift to
the National Gallery of Art

NO. 133

Abel-Truchet
(French, 1857–1919)
Theater program for *La Fumée,
puis la flamme*, 24 October 1895
color lithograph
23.9 x 30.7 (9 7/16 x 12 1/16)
Virginia and Ira Jackson
Collection

NO. 134

Edouard Vuillard
(French, 1868–1940)
Theater program for *Monsieur
Bute*; *L'Amant de sa Femme*; *La
Belle Opération*, 26 November 1890
photo-relief with watercolor
stenciling
image: 19.5 x 16.7 (7 11/16 x 6 9/16)
Virginia and Ira Jackson
Collection

NO. 135

Pierre Bonnard
(French, 1867–1947)
Birth announcement for
Marie-Louise Mellerio, 1898
lithograph in red
Bouvet 54
15.9 x 11.9 (6 1/4 x 4 11/16)
Virginia and Ira Jackson
Collection, Promised Gift to
the National Gallery of Art

NO. 136

Henri de Toulouse-Lautrec
(French, 1864–1901)
Menu for Société des
Indépendants (*La Modiste,
Renée Vert*), 1893
lithograph in green
Delteil 13; Wittrock 4
(1st edition)
51.4 x 32.2 (20 1/4 x 12 11/16)
National Gallery of Art,
Rosenwald Collection, 1952.8.316

NO. 137

Félix-Hilaire Buhot
(French, 1847–1898)
Baptismal commemoration
for Jean Buhot (*Baptême
japonais*), 1887
etching, aquatint, drypoint, and
liftground in black and brown
(proof)
Bourcard and Goodfriend
167, ii–iii/iii
plate: 21.3 x 12.7 (8 3/8 x 5)
sheet: 31.1 x 21.8 (12 1/4 x 8 9/16)
Helena Gunnarsson Buhot
Collection

NO. 138

Henri de Toulouse-Lautrec
(French, 1864–1901)
Cover for A. Arnould's
*Catalogue d'Affiches artistiques
(Débauche)*, 1896
color lithograph
Delteil 178; Wittrock 167
(2d edition)
28 x 38 (11 x 14 15/16)
National Gallery of Art,
Rosenwald Collection, 1952.8.432

# Bibliography

**Abélès, Luce, and Catherine Charpin.** *Arts incohérents, académie du dérisoire.* Exh. cat., Musée d'Orsay. Paris, 1992.

**Adhémar, Jean.** *Toulouse-Lautrec: His Complete Lithographs and Drypoints.* Translated from the Dutch by Elizabeth Willems-Treeman. 1964. Reprint ed. Secaucus, N.J., [1989].

**Adhémar, Jean, and Françoise Cachin.** *Degas: The Complete Etchings, Lithographs and Monotypes.* Translated from the French by Jane Brenton. London, 1974.

**Adriani, Götz.** *Toulouse-Lautrec: The Complete Graphic Works.* Translated from the German by Eileen Martin. London, 1988.

**The Artist and the Book, 1860–1960, in Western Europe and the United States.** 2d ed. Exh. cat., Museum of Fine Arts. Boston, 1972.

**Arwas, Victor.** *Belle Epoque: Posters and Graphics.* New York, 1978.

**Arwas, Victor.** *Berthon and Grasset.* New York, 1978.

**Baas, Jacquelynn.** "August Lepère and the Artistic Revival of the Woodcut in France, 1875–1895." Ph.D. diss., University of Michigan, 1982.

**Baas, Jacquelynn.** "The Origins of l'Estampe originale." *Bulletin of the University of Michigan Museums of Art and Archaeology* 5 (1983), 12–27.

**Baas, Jacquelynn, and Richard S. Field.** *The Artistic Revival of the Woodcut in France, 1850–1900.* Exh. cat., The University of Michigan Museum of Art. Ann Arbor, 1984.

**Bailly-Herzberg, Janine.** *Dictionnaire de l'estampe en France, 1830–1950.* Paris, 1985.

**Barker, Deborah,** ed. *Ritual and Reality: Prints of the Nabis.* Exh. cat., Spencer Museum of Art. Lawrence, Kans., 1979.

**Bernier, Georges.** *La Revue blanche.* Paris, 1991.

**Bouillon, Jean Paul.** *Félix Bracquemond, le réalisme absolu: l'oeuvre gravé, 1849–1859.* Geneva, 1987.

**Bouvet, Francis.** *Bonnard: The Complete Graphic Work.* Translated from the French by Jane Brenton. New York, 1981.

**Boyer, Patricia Eckert.** *Artists and the Avant-Garde Theater in Paris, 1887–1900: The Martin and Liane W. Atlas Collection.* Exh. cat., National Gallery of Art. Washington, 1998.

**Boyer, Patricia Eckert, and Phillip Dennis Cate.** *L'Estampe originale: Artistic Printmaking in France, 1893–1895.* Exh. cat., Van Gogh Museum. Amsterdam, 1991.

**Boyer, Patricia Eckert, and Elizabeth Prelinger.** *The Nabis and the Parisian Avant-Garde.* Exh. cat., Zimmerli Art Museum. New Brunswick, 1988.

**Boyle-Turner, Caroline,** ed. *The Prints of the Pont-Aven School: Gauguin and His Circle in Brittany.* Exh. cat., Rijksmuseum Vincent van Gogh. New York, 1986.

**Broido, Lucy.** *The Posters of Jules Chéret: Forty-six Full-color Plates and an Illustrated Catalogue Raisonné.* New York, 1992.

**Cailler, Pierre.** *Catalogue raisonné de l'oeuvre gravé et lithographie de Maurice Denis.* Geneva, 1968.

**Carey, Frances, and Antony Griffiths.** *From Manet to Toulouse-Lautrec: French Lithographs, 1860–1900.* Exh. cat., British Museum. London, 1978.

**Castleman, Riva, and Wolfgang Wittrock,** eds. *Henri de Toulouse-Lautrec: Images of the 1890s.* Exh. cat., The Museum of Modern Art. New York, 1985.

**Cate, Phillip Dennis.** *Charles Maurin (1856–1914).* Exh. cat., Lucien Goldschmidt. New York, 1978.

**Cate, Phillip Dennis.** "'La Plume' and Its 'Salon des cent.'" *Print Review* 8 (1978).

**Cate, Phillip Dennis,** ed. *Circa 1800: The Beginnings of Modern Printmaking, 1775–1835.* Exh. cat., Rutgers University Art Gallery. New Brunswick, 1981.

**Cate, Phillip Dennis,** ed. *The Graphic Arts and French Society, 1871–1914.* New Brunswick, 1988.

**Cate, Phillip Dennis, and Patricia Eckert Boyer.** *The Circle of Toulouse-Lautrec: An Exhibition of the Work of the Artist and His Close Associates.* Exh. cat., Zimmerli Art Museum. New Brunswick, 1985.

**Cate, Phillip Dennis, and Susan Gill.** *Théophile Alexandre Steinlen.* Exh. cat., Rutgers University Art Gallery. Salt Lake City, 1982.

**Cate, Phillip Dennis, and Sinclair Hamilton Hitchings.** *The Color Revolution: Color Lithography in France 1890–1900.* Exh. cat., Rutgers University Art Gallery. Santa Barbara and Salt Lake City, 1978.

**Cate, Phillip Dennis, and Marianne Grivel,** eds. *From Pissarro to Picasso, Color Etching in France: Works from the Bibliothèque Nationale and the Zimmerli Art Museum.* Exh. cat., Zimmerli Art Museum. New Brunswick, 1992.

**Cate, Phillip Dennis, and Mary Shaw,** eds. *The Spirit of Montmartre: Cabarets, Humor, and the Avant-Garde, 1875–1905.* Exh. cat., Zimmerli Art Museum. New Brunswick, 1996.

**Cherpin, Jean.** *L'Oeuvre gravé de Cézanne.* Arts et livres de Provence (Marseilles), no. 82 (1972).

**Crafton, Donald.** *Emil Cohl, Caricature, and Film.* Princeton, 1990.

**Crauzat, A. de.** *Steinlen: peintre-graveur et lithographie.* Paris, 1902.

**Dardel, Aline.** *"Les Temps nouveaux," 1895–1914.* Exh. cat., Musée d'Orsay. Paris, 1987.

**Delteil, Loÿs.** *Le Peintre-Graveur illustré.* 31 vols. Paris, 1906–1926.

**Dixmier, Elisabeth, and Michel Dixmier.** *L'Assiette au beurre, revue satirique illustrée.* Paris, 1974.

**Druick, Douglas, and Peter Zegers.** *La Pierre parle: Lithography in France 1848–1900.* Exh. cat., National Gallery of Canada. Ottawa, 1981.

**Dumas, Ann, and Guy Cogeval.** *Vuillard.* Exh. cat., Musée des Beaux Arts, Lyon. Paris, 1990.

*Edgar Chahine: la vie parisienne.* Essay by Gabriel P. Weisberg. Exh. cat., Smithsonian Institution. Washington, 1984.

*L'Estampe impressionniste.* Exh. cat., Bibliothèque Nationale. Paris, 1974.

*Eugene Bejot: graveur de Paris, 1867–1931.* Exh. cat., Musée Carnavalet. Paris, 1985.

*Le Fait divers.* Exh. cat., Musée Nationale des Arts et Traditions Populaires. Paris, 1982.

**Faxon, Alicia Craig.** *Jean-Louis Forain: A Catalogue Raisonné of Prints.* New York, 1982.

*Felix Bracquemond and the Etching Process: An Exhibition of Prints and Drawings from the John Taylor Arms Collection.* Exh. cat., The College of Wooster Art Center Museum and John Carroll University Fine Arts Gallery. [Wooster], 1974.

**Field, Richard S.** *Paul Gauguin: Monotypes.* Exh. cat., Philadelphia Museum of Art. [Philadelphia], 1973.

**Field, Richard S., Cynthia L. Strauss, and Samuel J. Wagstaff, Jr.** *The Prints of Armand Seguin, 1869–1903.* Exh. cat., Davidson Art Center, Wesleyan University. Middletown, Conn., 1980.

**Fields, Armond.** *Le Chat noir: A Montmartre Cabaret and Its Artists in Turn-of-the-Century Paris.* Exh. cat., Santa Barbara Museum of Art. Santa Barbara, 1993.

**Fields, Armond.** *George Auriol.* Catalogue raisonné by Marie Leroy-Crevecoeur. Layton, Utah, 1985.

**Fields, Armond.** *Henri Rivière.* Salt Lake City, 1983.

**Fisher, Jay McKean.** *Félix Buhot, peintre-graveur: Prints, Drawings, and Paintings.* Exh. cat., Baltimore Museum of Art. Baltimore, 1983.

**Fisher, Jay McKean.** *The Prints of Edouard Manet.* Exh. cat., International Exhibitions Foundation. Washington, 1985.

**Floyd, Philys.** *Seeking the Floating World: The Japanese Spirit in Turn-of-the-Century France.* Exh. cat., Sogo Museum of Art, Yokohama. Tokyo, 1989.

*Forgotten Printmakers of the Nineteenth Century.* Exh. cat., Kovler Gallery. Chicago, 1967.

**Fossier, François.** *Auguste Lepère ou le renouveau du bois gravé.* Exh. cat., Musée d'Orsay. Paris, 1992.

**Fossier, François.** *La Nébuleuse Nabie: les Nabis et l'art graphique.* Paris, 1993.

**Fossier, François,** ed. *Henri Rivière: graveur et photographe.* Exh. cat., Musée d'Orsay. Paris, 1988.

**Frèches-Thory, Claire, and Antoine Terrasse.** *The Nabis.* Paris, 1990.

**Georgel, Chantal.** *Les Journalistes.* Exh. cat., Musée d'Orsay. Paris, 1986.

**Gilmour, Pat,** ed. *Lasting Impressions: Lithography as Art.* Exh. cat., Australian National Gallery. Canberra, 1988.

**Ginestet, Colette de, and Catherine Pouillon.** Jacques Villon, *Les estampes et les illustrations, catalogue raisonné.* Paris, 1979.

**Goodfriend, James.** *Félix Buhot (1848–1898): Prints and Drawings.* New York, 1986.

**Gounot, Roger.** *Charles Maurin.* Exh. cat., Musée Crozatier du Puy. [Le Puy], 1978.

**Grad, Bonnie L., and Timothy A. Riggs.** *Visions of City and Country: Prints and Photographs of Nineteenth-Century France.* Exh. cat., Worcester Art Museum. Worcester, 1982.

**Guérin, Marcel.** *Catalogue raisonné de l'oeuvre gravé et lithographie d'Aristide Maillol.* 2 vols. Geneva, 1965.

**Guérin, Marcel.** *L'Oeuvre gravé de Gauguin.* 2 vols. Paris, 1927.

**Harris, Jean C.** *Edouard Manet, Graphic Works: A Definitive Catalogue Raisonné.* New York, [1970].

Harrison, Sharon R. *The Etchings of Odilon Redon: A Catalogue Raisonné*. New York, 1986.

Harthan, John. *The History of the Illustrated Book: The Western Tradition*. London, 1981.

Herbert, Robert L. *Peasants and "Primitivism": French Prints from Millet to Gauguin*. Exh. cat., Mount Holyoke College Art Museum. South Hadley, Mass., 1995.

Hogben, Carol, and Rowan Watson, eds. *From Manet to Hockney: Modern Artists' Illustrated Books*. Exh. cat., Victoria and Albert Museum. London, 1985.

Ives, Colta Feller. *The Great Wave: The Influence of Japanese Woodcuts on French Prints*. Exh. cat., Metropolitan Museum of Art. New York, 1974.

Ives, Colta Feller, et al. *Pierre Bonnard: The Graphic Art*. Exh. cat., Metropolitan Museum of Art. New York, 1989.

*Le Japonisme*. Exh. cat., Galeries nationales du Grand Palais. Paris, 1988.

Kleeblatt, Norman L., ed. *The Dreyfus Affair*. Berkeley, 1987.

Kornfeld, Eberhard W., and P. A. Wick. *Catalogue raisonné de l'oeuvre gravé et lithographié de Paul Signac*. Bern, 1974.

Kostenevitch, Albert. *Bonnard and The Nabis*. Bournemouth, 1996.

Leberruyer, Pierre. *Le Peintre-Graveur aquafortiste: Félix Buhot (1847–1898)*. Rennes, 1979.

Le Men, Ségolène. *Seurat and Chéret: le peintre, le cirque et l'affiche*. Paris, 1999.

*La Lithographie en France des origines à nos jours*. Catalogue by Claude Bouret and Blandine Bouret. Exh. cat., Fondation nationale des arts graphiques. Paris, [1982?].

Mauner, George L. *The Nabis: Their History and Their Art, 1888–1896*. New York, 1978.

Mayor, A. Hyatt. *Prints and People: A Social History of Printed Pictures*. New York, 1971. Reprint ed. Princeton, 1980.

Mellerio, André. *Odilon Redon*. Paris, 1913.

Melot, Michel. *The Impressionist Print*. New Haven, 1996.

Melot, Michel, ed. *The Graphic Works of the Impressionists: Manet, Pissarro, Renoir, Cézanne, Sisley*. New York, 1972.

Millman, Ian. *Georges de Feure*. Tokyo, 1990.

Millman, Ian. *Georges de Feure, 1868–1945*. Exh. cat., Van Gogh Museum. Amsterdam, 1993.

Mongan, Elizabeth, et al. *Paul Gauguin: Catalogue Raisonné of His Prints*. Bern, 1988.

*Nabis, 1888–1900*. Exh. cat., Réunion des musées nationaux. Paris, 1993.

*Nabis, 1888–1900: Bonnard, Vuillard, Maurice Denis, Vallotton....* Exh. cat., Kunsthaus Zürich. Munich, 1993.

Newman, Sasha M. *Felix Vallotton*. Exh. cat., Yale University Art Gallery. New York, 1991.

Oberthür, Mariel. *Cafés and Cabarets of Montmartre*. Salt Lake City, 1984.

Oberthür, Mariel. *Le Chat noir, 1881–1897*. Exh. cat., Musée d'Orsay. Paris, 1992.

Palmer, Tony. *L'Estampe moderne*. Exh. cat., Australian National Gallery. Canberra, 1983.

Porzio, Domenico, ed. *Lithography: Two Hundred Years of Art, History, and Technique*. New York, 1983.

Prelinger, Elizabeth Ann. "The Symbolist Print." Ph.D. diss., Harvard University, 1987.

Ray, Gordon N. *The Art of the French Illustrated Book, 1700 to 1914*. 2 vols. Exh. cat., Pierpont Morgan Library. New York, 1982.

Rearick, Charles. *Pleasures of the Belle Epoque: Entertainment and Festivity in Turn-of-the-Century France*. New Haven, 1985.

Reed, Sue Welsh, ed. *Edgar Degas: The Painter as Printmaker*. Exh. cat., Museum of Fine Arts. Boston, 1984.

Riggs, Timothy A. *The Print Council Index of Oeuvre-Catalogues of Prints by European and American Artists*. New York and London, 1983.

Roger-Marx, Claude. *L'Oeuvre gravé de Vuillard*. Monte Carlo, 1948.

Rutten, R., and H. Drescher, eds. *Die politische Lithographie im Kampf und die Pariser Kommune 1871*. Exh. cat., Württembergischer Kunstverein. Stuttgart, 1976.

Salomon, Jacques. *Introduction à l'oeuvre gravé de K.X. Roussel*. Paris, 1968.

Schiefler, Gustav. *Verzeichnis des graphischen Werks Edvard Munchs, bis 1906*. Berlin, 1907. Reprint Oslo, 1974.

Seguin, Jean-Pierre. *Maurice Dumont, 1869–1899: peintre-graveur, illustrateur, poète et éditeur de L'Epreuve*. Catalogue by Anne Bonafous-Murat and Arsène Bonafous-Murat. Exh. cat., Bibliothèque Historique de la Ville de Paris. Paris, 1991.

Seigel, Jerrold. *Bohemian Paris: Culture, Politics, and the Boundaries of Bourgeois Life, 1830–1930*. New York, 1986.

Shapiro, Barbara S. *Camille Pissarro: The Impressionist Printmaker*. Exh. cat., Museum of Fine Arts. Boston, 1973.

Silverman, Debora L. *L'Art Nouveau in Fin-de-Siècle France: Politics, Psychology, and Style*. Berkeley, 1989.

Söderberg, Rolf. *French Book Illustration, 1880–1905* [= Stockholm Studies in History of Art 28] (Stockholm, 1977).

Stevens, Mary Anne. *Post-Impressionist Graphics: Original Prints by French Artists, 1880–1903*. Exh. cat., Arts Council of Great Britain. London, 1980.

Sullivan, Michael. *The Meeting of Eastern and Western Art*. Berkeley, 1989.

**Terrasse, Antoine.** *Pierre Bonnard, Illustrator: A Catalogue Raisonné.* New York, 1989.

**Thomson, Belinda.** *The Post-Impressionists.* Oxford, 1983.

**Toulouse-Lautrec: les estampes et les affiches de la Bibliothèque nationale/ Toulouse-Lautrec: Prints and Posters from the Bibliothèque Nationale.** Exh. cat., Bibliothèque Nationale and Queensland Art Gallery. Brisbane, Australia, 1991.

**Ukiyo-E Prints and the Impressionist Painters: Meeting of the East and West.** Exh. cat., Sunshine Museum. Tokyo, 1979.

**Vallotton, Maxime, and Charles Goerg.** *Félix Vallotton, catalogue raisonné de l'oeuvre gravé et lithographié: Catalogue Raisonné of the Printed Graphic Work.* Geneva, 1972.

**Van Deputte, Jocelyne.** *Le Salon des cent: 1894–1900, Affiches d'artistes.* Exh. cat., Musée Carnavalet. Paris, 1994.

**Waller, Bret, and Grace Seiberling.** *Artists of the Revue Blanche: Bonnard, Toulouse-Lautrec, Vallotton, Vuillard.* Exh. cat., Memorial Art Gallery, University of Rochester. Rochester, 1984.

**Wechsler, Judith.** *A Human Comedy: Physiognomy and Caricature in Nineteenth-Century Paris.* Chicago, 1982.

**Weisberg, Gabriel P.** *Art Nouveau Bing: Paris Style 1900.* Exh. cat., Smithsonian Institution. New York, 1986.

**Weisberg, Gabriel P.** *Images of Women: Printmakers in France from 1830 to 1930.* Exh. cat., Utah Museum of Fine Arts. Salt Lake City, 1977.

**Weisberg, Gabriel P.** *Rediscovered Printmakers of the Nineteenth Century.* Exh. cat., Merrill Chase Galleries. Chicago, 1978.

**Weisberg, Gabriel P.** *Social Concern and the Worker: French Prints from 1830–1910.* Exh. cat., Utah Museum of Fine Arts. Salt Lake City, 1973.

**Weisberg, Gabriel P.** "Théophile Steinlen and Louis Legrand: *Contrasts in Social Ideology.*" *The Tamarind Papers* 8, 1–2 (1985).

**Weisberg, Gabriel P.**, et al. *Japonisme: Japanese Influence of French Art 1854–1910.* Exh. cat., The Cleveland Museum of Art. Cleveland, 1975.

**Wentworth, Michael Justin.** *James Tissot: Catalogue Raisonné of His Prints.* Exh. cat., The Minneapolis Institute of Arts. Minneapolis, 1978.

**Wittrock, Wolfgang.** *Toulouse-Lautrec: The Complete Prints.* 2 vols. London, 1985.

# Select Chronology
## of Artists' Prints in France

**1862 – 1867** *La Société des aquafortistes* [1, 4]

**1869** *Sonnets et eaux-fortes* [1]

**1873 – 1876** *Paris à l'eau-forte* [4]

**1874** Edouard Manet's first and only color lithograph, *Le Polichinelle*

**1875** Charles Gillot's adaptation to relief photographic printing of "Gillotage," a nonphoto relief process

Manet's *Le Corbeau*, album of four transfer lithographs with text [2]

**1878** Sarah Bernhardt's *Dans les nuages*, illustrated with a photo-relief process after drawings by Georges Clarin [6]

**1879** Edgar Degas' conceptualization of the never-realized publication *La Jour et la nuit* [1, 4]

Odilon Redon's *Dans le rêve*, the first of ten albums of black and white lithographs [2]

**1881** Freedom of the press laws end government censorship of journals

**1882** La Société des artistes lithographes français [3]

*Le Chat noir* [5] and *L'Art moderne* [4, 5]

**1883** Félix Buhot's *Dix eaux-fortes, japonisme*, with cover etching by Henri Guérard [2]

*Histoire des quatre fils Aymon*, illustrated by Eugène Grasset using chromotypogravure, Charles Gillot's new color photo-relief printing process [6]

**1884** *Le Courrier français* [4, 5]

**1886** *La Revue indépendante* [4]

**1888** Auguste Lepère's first album of *L'Estampe originale* [1, 3]

**1889** Lepère's second album of *L'Estampe originale* [1, 3]

First exhibition of the Société des peintres-graveurs [3]

*La Plume* [4, 5]

The Groupe impressioniste et synthétiste exhibition at the Café Volpini on the fairgrounds of the Paris International Exposition includes Paul Gauguin's series of ten zincographs (lithographs on zinc plates) and Emile Bernard's album *Les Bretonneries*, comprising six hand-colored zincographs [2]

**1890** Maximilien Luce's *Le Petit betting*, an album of eight black and white lithographs [2]

*Zé' Boïm*, with cover illustration by José Roy, is censored [6]

Victor Joze's *Lever de rideau*, the first book in his *La Ménagerie sociale* series [6], and *L'Homme à femmes*, with cover illustrated with photo-relief process after a drawing by Georges Seurat [6]

**1891** Pierre Bonnard's poster for *France-Champagne* (commissioned in 1889), soon to be followed by the first posters by Henri de Toulouse-Lautrec (1891), Maurice Denis (1892), and Henri-Gabriel Ibels (1892)

The Ecole des Beaux-Arts organizes the first comprehensive exhibitions of the history of Japanese prints and the history of French lithography

**1891 – 1900** *Gil Blas illustré*, with color photo-relief illustrations [5]

**1891 –** *La Revue blanche* [4, 5]

**1892** Ibels' *L'Amour s'amuse*, an album of four color lithographs [2]

The first of seven albums of *Les Peintres-Lithographes* [1, 3]

Joze's *La Reine de joie*, with color-lithographic cover by Bonnard and poster by Toulouse-Lautrec [6]

**1893** Charles Dulac's *Suite de paysages*, an album of eight color lithographs [2]

André Gide's *Voyage d'Urien*, with two-color lithographic illustrations by Denis [6]

Edouard Duchatel's *Traité de lithographie artistique*, a practical guide to lithography for artists

*Le Café-Concert*, an album published by André Marty with eleven black and white lithographs each by Ibels and Lautrec [1]

Claude Terrasse's *Petit solfège illustré*, a children's music book with illustrations by Bonnard printed from relief plates [6]

**1893 – 1894** Georges Darien's journal *L'Escarmouche*, illustrated with photo-relief reproductions of lithographs by such Nabis as Bonnard and Félix Vallotton, as well as Toulouse-Lautrec and Hermann-Paul [5]

*Le Chambard*, with stencil-colored photo-relief illustrations primarily after lithographs by Théophile Alexandre Steinlen [5]

**1893 (March) – 1895** Marty's *L'Estampe originale*, nine quarterly multi-artist albums, published with a total of ninety-four prints in a variety of media by seventy-four artists [1]

**1894** Dulac's *Cantique des créatures*, an album of nine color lithographs [2]

Lautrec's *Yvette Guilbert*, an album of sixteen lithographs with text by Gustave Geffroy and published by Marty [2]

Joze's *Babylone d'Allemagne*, with color lithographic cover and poster by Lautrec [6]

Vallotton's *Paris intense*, an album of seven black and white zincographs [2]

**1894 – 1895** Maurice Dumont's *L'Epreuve*, a series of twelve albums of prints in various media by sixty artists [1]

**1894, 1895** Hermann-Paul's *La Vie de Monsieur Quelconque* and *La Vie de Madame Quelconque*, two albums of ten black and white lithographs each [2]

**1894 – 1901** Salon des cent, a series of exhibitions sponsored by *La Plume*, which often exhibited avant-garde prints such as Lautrec's *Elles* album and commissioned artists' posters

**1895** *Dans la rue*, with color-lithographic cover by Steinlen and photo-relief text illustrations after his drawings [6]

Georges Montorgueil's *Demi-Cabot*, with photo-relief illustrations after drawings by Ibels [6]

*Album de La Revue blanche*, album of twelve lithographs that had previously appeared in the journal; cover by Bonnard [1]

**1895 – 1896** Loÿs Delteil's *L'Estampe moderne*, five monthly albums (with text) of five, mostly black and white, lithographs [2]

Alfred Jarry's and Remy de Gourmont's journal *L'Ymagier* [4]

**1895 – 1898** Hermann-Paul's nonsense "journal" *Le Fond de bain*, with illustrations and text printed lithographically

**1896** Paul Fort's journal *Le Livre d'art* [4]

Jules Renard's *Maîtresse*, with photo-relief illustrations after drawings by Vallotton [6]

Octave Uzanne's *Badauderies parisiennes: les rassemblements, physiologies de la rue*, with cover design, thirty full-page illustrations, and vignettes by Vallotton all printed from relief plates [6]

Toulouse-Lautrec's *Elles*, an album of eleven color lithographs [2]

Marty's *Etudes des femmes*, a series of four multi-artist albums with three lithographs each [1]

Ambroise Vollard's *Album des peintres-graveurs*, an album of twenty-two prints in a variety of media by twenty artists [1]

**1896 – 1897** Marc Mouclier's nonsense "journal" *L'Omnibus de Corinthe*, with the illustrations and text for its nine issues printed lithographically

**1897** Vollard's *Album d'estampes originales de la Galerie Vollard*, with thirty-two prints in a variety of media by thirty-two artists [1]

Vallotton's *Intimités*, an album of ten woodcuts published by *La Revue blanche* [2]

Joaquim Sunyer Miro's *Les Soliloques du pauvre*, an album of eight color lithographs accompanying text by Jehan Rictus [2]

*L'Image*, illustrated with wood engravings and woodcuts [4]

**1897 – 1899** Roger Marx's journal *L'Estampe et l'affiche*

*L'Estampe moderne*, a series of twenty-four albums with four prints each in a variety of media by numerous artists [1]

Zo d'Axa's anarchist journal *La Feuille*, illustrated with photo-relief, sometimes stencil-colored, reproductions of lithographs by Steinlen and Hermann-Paul [5]

**1898** Georges Clémenceau's *Au pied du Sinaï*, with cover and ten black and white lithographic illustrations by Lautrec [6]

Lautrec's *Yvette Guilbert*, an album with cover and eight black and white lithographs [2]

André Mellerio's *La Lithographie en couleurs*, a book on contemporary artistic color lithography with color lithographic cover and frontispiece by Bonnard, published by *L'Estampe et l'affiche*

Peter Nansen's *Marie*, a novel with photo-relief illustrations by Bonnard and published by *La Revue blanche* [6]

**1899** Jules Renard's *Histoires naturelles*, with cover and twenty-two black and white lithographs by Lautrec [6]

Pierre Bonnard's *Quelques aspects de la vie de Paris*, an album of twelve color lithographs published by Vollard [2]

Edouard Vuillard's *Paysages et intérieurs*, an album of twelve color lithographs published by Vollard [2]

Denis' *Amour*, an album of twelve color lithographs published by Vollard [2]

*Germinal*, an album of twenty prints in a variety of media by twenty artists [1]

The pro-Dreyfus album *Hommage au Colonel Picquart*, with twelve black and white lithographs by various artists and a list of more than thirty thousand Picquart supporters [1]

**1900** Paul Verlaine's *Parallèlement*, illustrated with lithographs by Pierre Bonnard and published by Vollard [6]

Jarry's *Almanach illustré du Père Ubu*, with illustrations by Bonnard printed from relief plates and published by Vollard [6]

**1902** Henri Rivière's *Les trente-six vues de la tour Eiffel*, a bound album of thirty-six color lithographs [2]

**KEY**

[1]  **multi-artist print publication**

[2]  **single-artist print publication**

[3]  **print society / exhibition**

[4]  **journal with prints**

[5]  **journal illustrated with artists' photo-relief images**

[6]  **significant illustrated book**

# Index

# Contents

The exhibition was organized
by the National Gallery of Art,
Washington.

*Exhibition Dates*
National Gallery of Art
22 October 2000 through
25 February 2001

Copyright © 2000. Board of Trustees,
National Gallery of Art, Washington.
All rights reserved.

The book was produced by the
Editors Office, National Gallery
of Art.

Susan Higman, *Editor*
Wendy Schleicher Smith, *Designer*

Index prepared by Deborah E. Patton,
Baltimore, MD

Typeset by Artech Graphics II,
Baltimore, MD

Printed by Arnoldo Mondadori
Editore, Verona, Italy

Paperbound edition
ISBN 0-89468-277-6

Clothbound edition
ISBN 0-85331-794-1

*Library of Congress*
*Cataloging-in-Publication Data*

Cate, Phillip Dennis.
Prints abound: Paris in the 1890s:
from the collections of Virginia
and Ira Jackson and the National
Gallery of Art / Phillip Dennis Cate,
Gale B. Murray, Richard Thomson.
    p.    cm.
Catalog of an exhibition held at the
National Gallery of Art, Washington,
D.C., Oct. 22, 2000 – Feb. 25, 2001.
Includes bibliographical references
and index.
1. Prints, French – France – Paris –
Exhibitions. 2. Prints – 19th century –
France – Paris – Exhibitions. 3. Jackson,
Virginia (Virginia Hartle) – Art collec-
tions – Exhibitions. 4. Jackson, Ira –
Art collections – Exhibitions. 5. Prints –
Private collections – United States –
Exhibitions. I. Murray, Gale Barbara,
1945 – II. Thomson, Richard, 1953 –
III. National Gallery of Art (U.S.)
IV. Title

NE649.P3 C37 2000
769.944'09'034074753 — dc21

00-033261
CIP

*British Library*
*Cataloguing-in-Publication Data*

A catalogue record for this book is
available from the British Library.

Clothbound edition
first published in 2000
by Lund Humphries
Gower House
Aldershot
Hampshire GU11 3HR
UK

Lund Humphries is part
of Ashgate Publishing

Ashgate US office:
Ashgate Publishing Company
131 Main Street
Burlington, VT 05401

Distributed to the book trade
in North America by
Antique Collectors' Club
Market Street Industrial Park
Wappingers Falls, NY 12590
USA

# Prints Abound

## PARIS IN THE 1890S

**From the Collections of**

**Virginia and Ira Jackson**

**and the National Gallery of Art**

PHILLIP DENNIS CATE — GALE B. MURRAY — RICHARD THOMSON

NATIONAL GALLERY OF ART, WASHINGTON — LUND HUMPHRIES, LONDON

# Prints Abound

PARIS IN THE 1890S